DRUMLANRIG

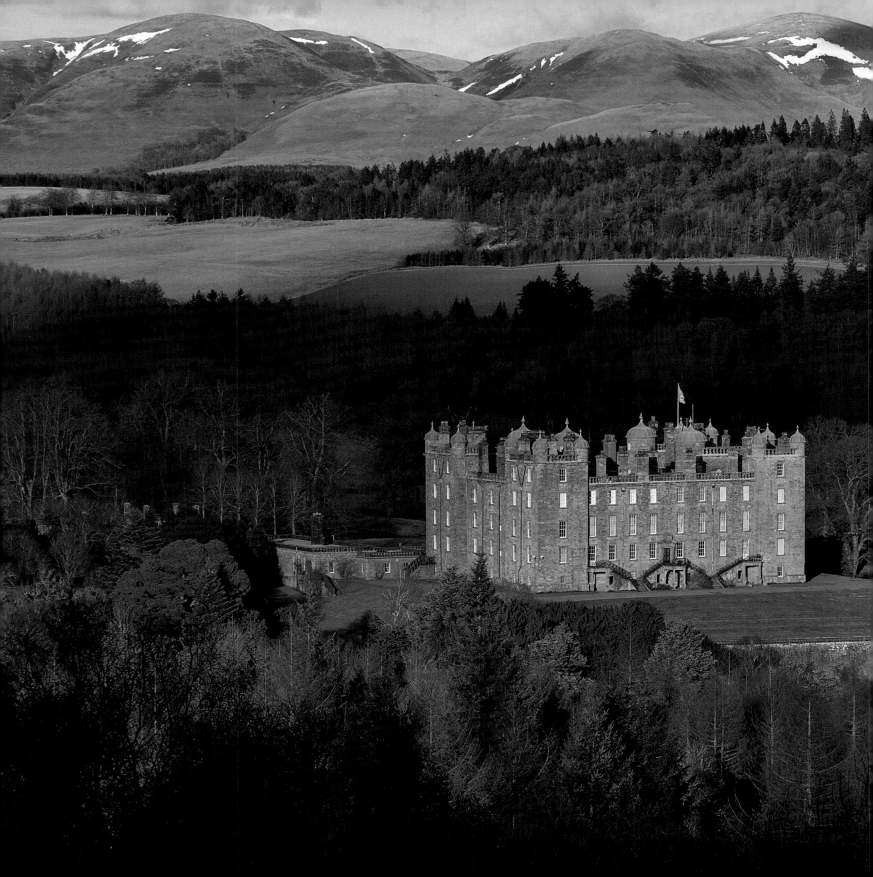

*'Drumlanrig, like Chatsworth in Darbyshire,
is like a fine picture in a dirty grotto…
'tis environed with mountains, and that of the
wildest and most hideous aspect in all
the south of Scotland…
But that which was more surprising than
all the rest, was to see a palace so glorious,
gardens so fine, and every thing
so truly magnificent, and all in a wild,
mountainous country,
the like we had not seen before…'*

Daniel Defoe
A Tour Thro' the Whole Island of Great Britain
Letter XII, Vol 3, 1726

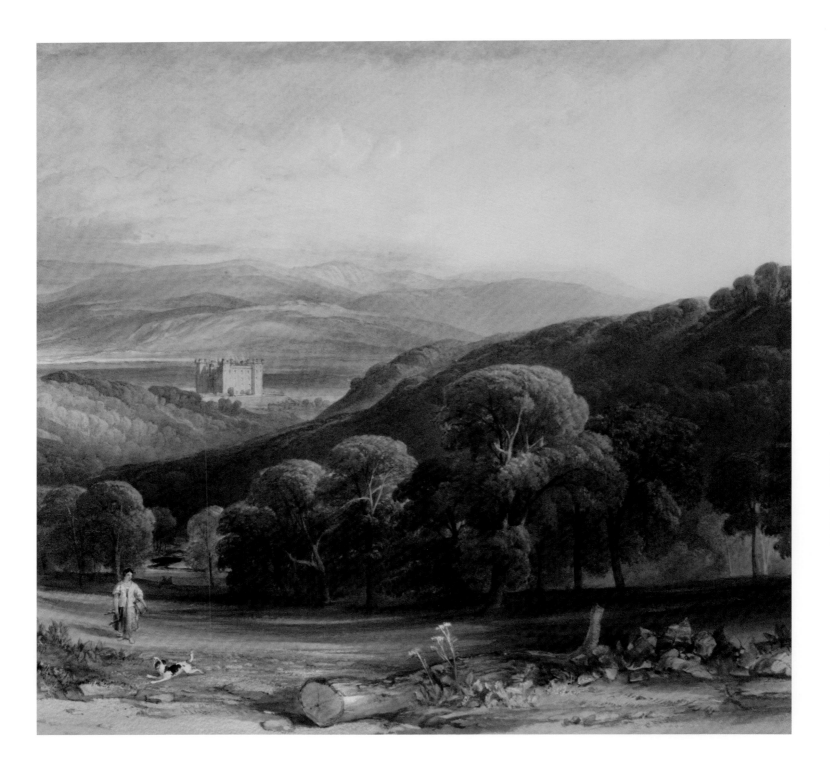

DRUMLANRIG

The Castle, its People and its Paintings

To the memory of
John, 9th Duke of Buccleuch and 11th Duke of Queensberry, KT
1923–2007

INTRODUCED BY RICHARD, DUKE OF BUCCLEUCH AND QUEENSBERRY
EDITED BY JOHN MONTAGU DOUGLAS SCOTT
PHOTOGRAPHS BY FRITZ VON DER SCHULENBURG

Foreword

Welcome to Drumlanrig. For at least six hundred years my Douglas forebears have had a foothold in the Nith Valley in Dumfriesshire, and for over three centuries this castle has been one of our family homes. For us it stirs the most powerful feelings of contentment. It embraces us in the surround of its hills, evoking a gamut of memories from happy to sad. I hope it is as captivating for you as it is for us, that you will find yourself absorbed in the subtlety of the pale pink stone and its delicate carvings, engaged by the serenity of Rembrandt's *An Old Woman Reading*, and intrigued by the thought of the people who contrived to create this magical place.

Drumlanrig is constantly changing. Portraits, like people, move from room to room, furniture finds a more sympathetic corner, new acquisitions need to be found a home, fresh eyes see new aesthetic or historical links. This book gives you a snapshot, for the most part through the eyes of a wonderful and thoughtful photographer, Fritz von der Schulenburg, who visited the Castle in 2010, and through the painstaking research since then by our inspired Archivist, Crispin Powell. It does not purport to be a guidebook in the traditional sense but instead gives you a glimpse of a great house and those who have lived in it.

Richard, Duke of Buccleuch and Queensberry

OPPOSITE *Drumlanrig's romantic North Front painted in 1953 by Felix Kelly, a fashionable artist and a popular guest in post-war years, when summer's end would herald a succession of lively house parties*
PREVIOUS PAGES *William Leighton Leitch, Queen Victoria's watercolour tutor, painted this view in 1843–44*
OVERLEAF *Walter Dalkeith's photograph, taken in 2019 from across the Nith Valley, catches the Castle's silvery domes, pink sandstone walls and the woods in all their autumn glory*

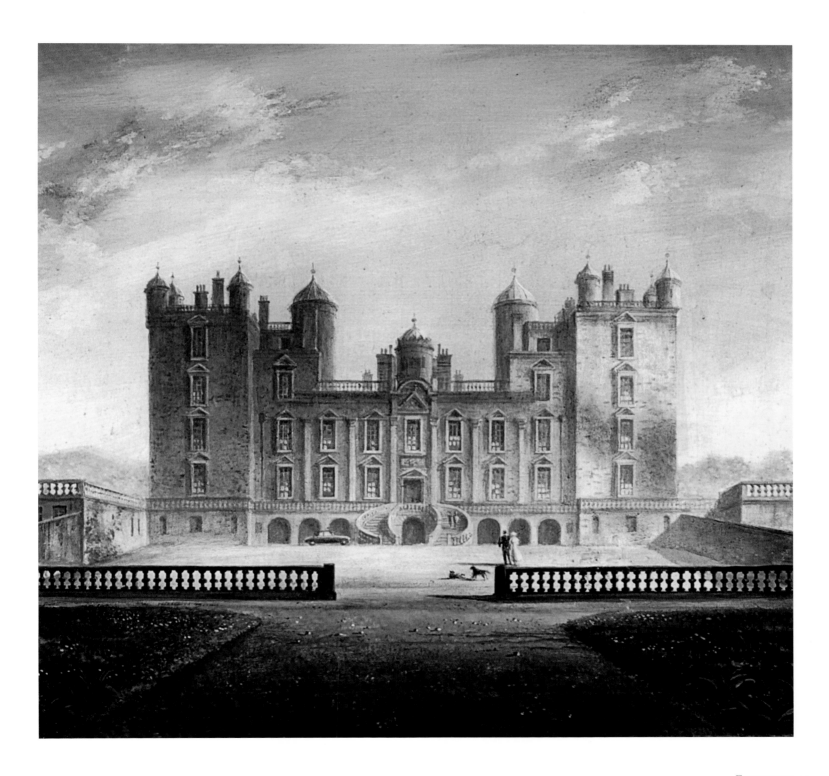

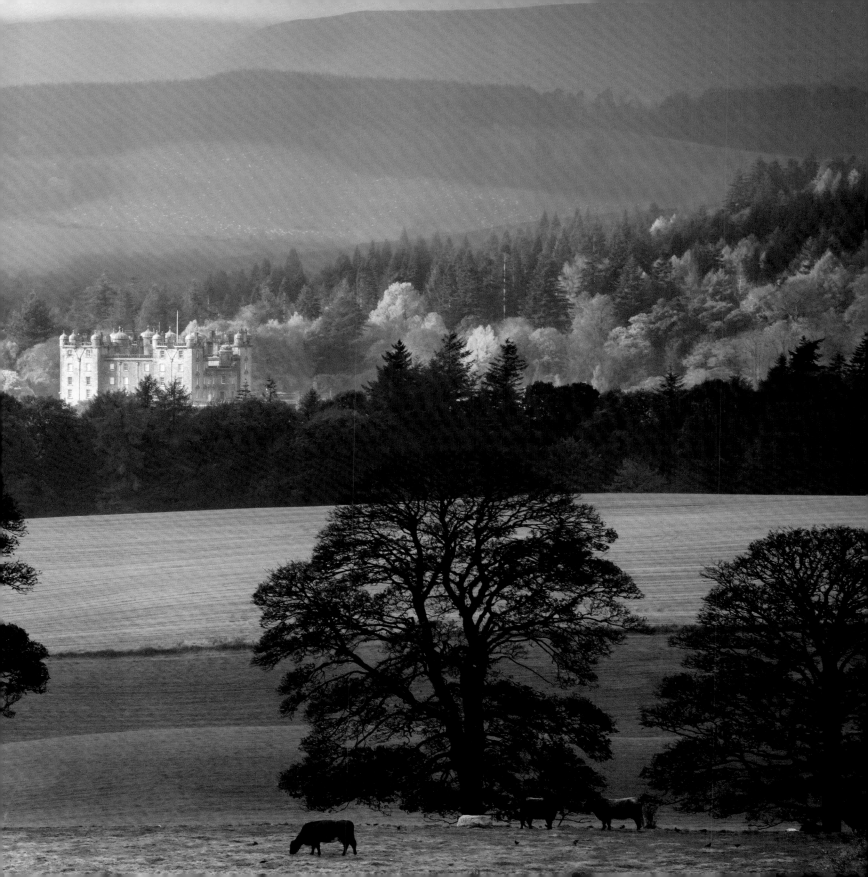

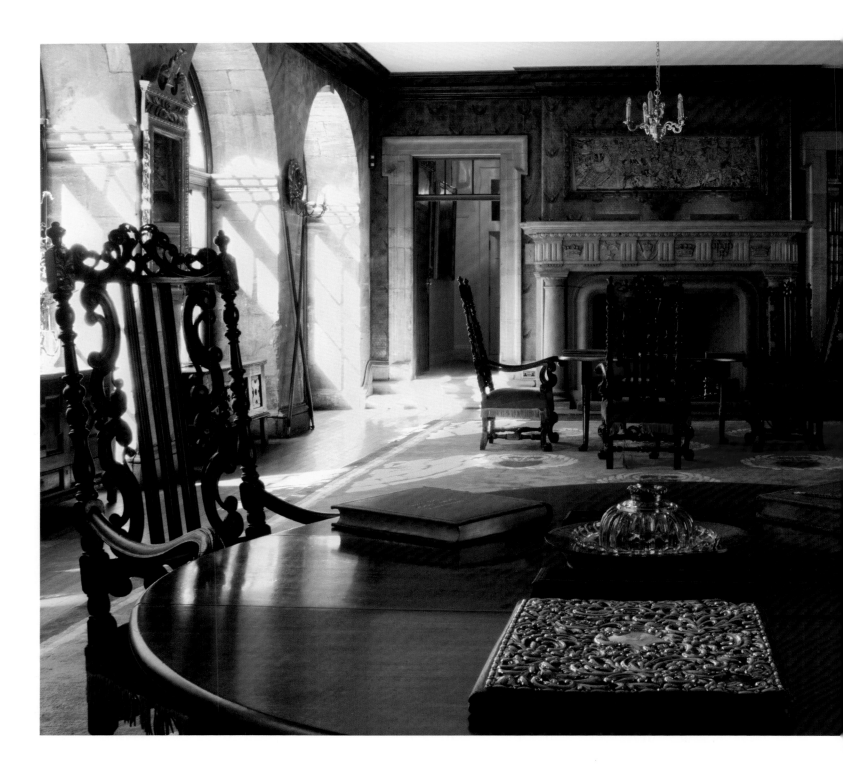

Contents

THE FRONT HALL
Every room at Drumlanrig is bathed in light, even the north-facing Front Hall, thanks to the inner Courtyard – a quadrangle – around which the Castle was built

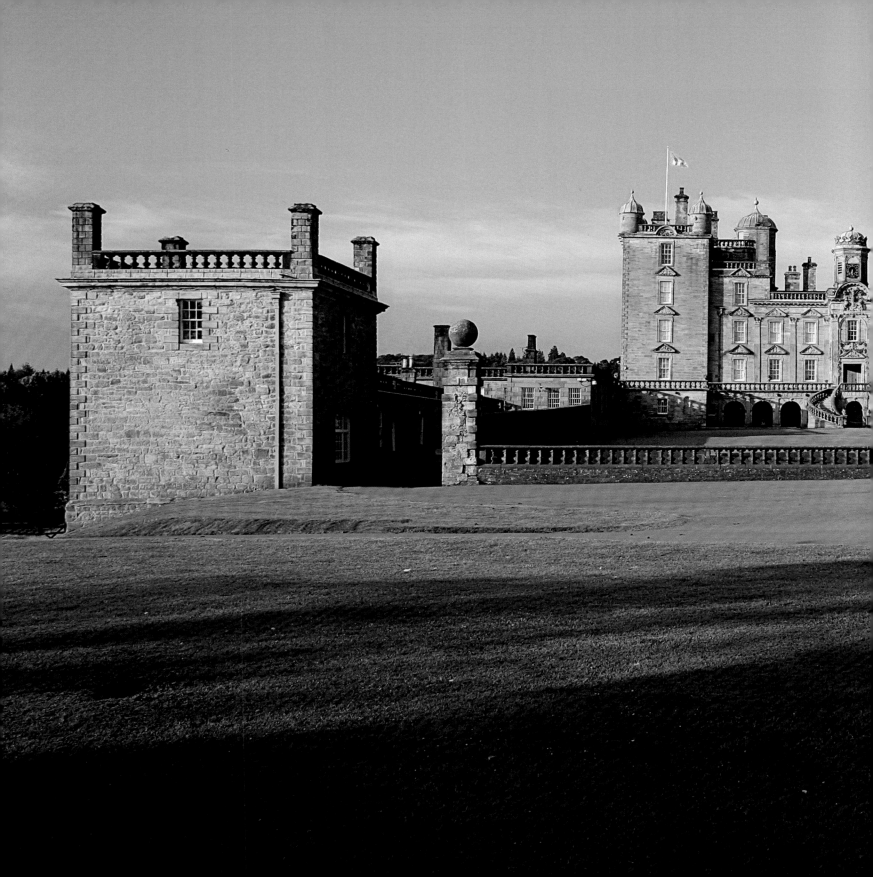

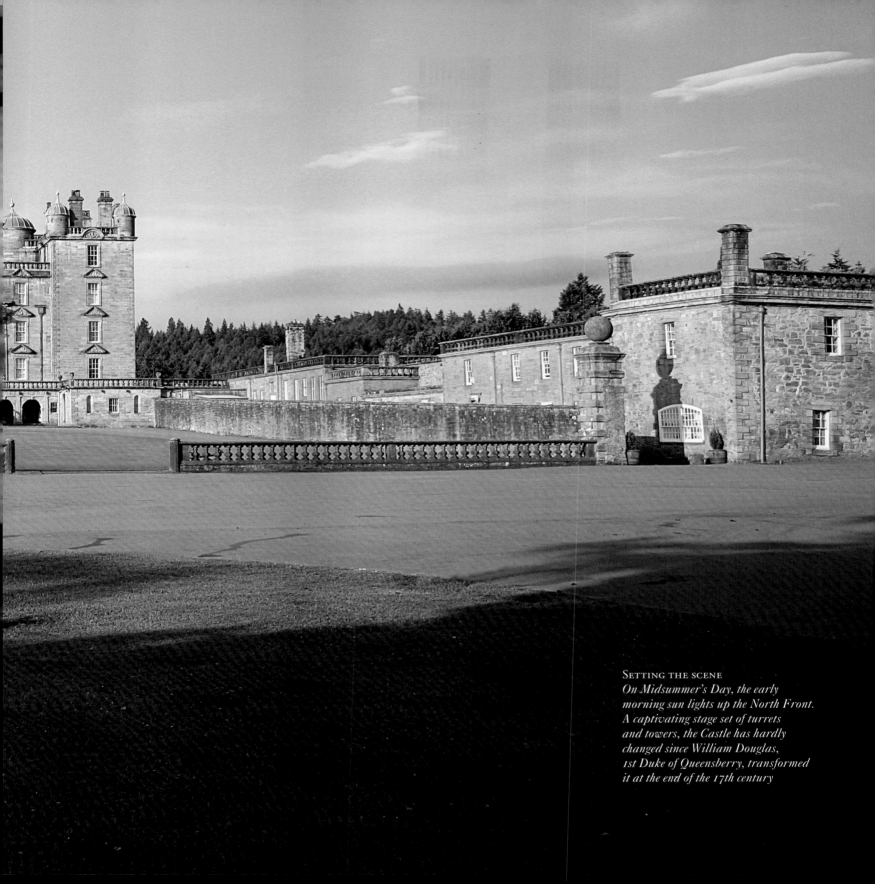

SETTING THE SCENE
*On Midsummer's Day, the early
morning sun lights up the North Front.
A captivating stage set of turrets
and towers, the Castle has hardly
changed since William Douglas,
1st Duke of Queensberry, transformed
it at the end of the 17th century*

Drumlanrig and the Dukes of Queensberry

Taking more than a decade to build from 1675, today's house was superimposed on a 14th-century Douglas stronghold by William Douglas, 1st Duke of Queensberry. The present Duke looks back on the Castle's history and finds that his ancestor's vision has continued to shine throughout the fluctuations of fortune and taste

T he many strands of the Douglas family have for centuries been woven through the tapestry of Scottish life, politics and geography. The distinctive family crest – a heart in various guises, but here at Drumlanrig with wings – derives from the loyal promise made to Robert the Bruce by the great Sir James, known as the Black Douglas, that when the King died he would take his heart on a crusade. That forlorn venture ended in disaster in 1330 beneath the Moorish stronghold of Teba in Spain. Surrounded, Douglas sought to inspire his small band of Scots, hurling the casket containing the heart into the midst of the enemy with the battle cry 'Forward, Brave Heart!' The gesture was made in vain. He and almost all his followers perished, but the casket found its way back to its present resting place in Melrose Abbey,

The winged heart of the Douglas crest derives from Sir James Douglas's cry, 'Forward, Brave Heart!', as he fell fighting the Moors in 1330 on his way to the Holy Land with the heart of Robert the Bruce

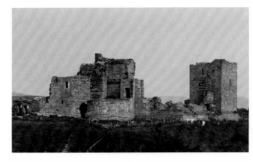

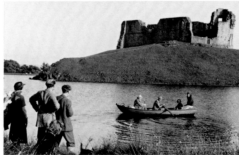

FAMILY REDOUBTS
ABOVE *The Douglas stronghold of Morton Castle, seen here in a 1939 family photograph, stands on a loch across the Nith Valley from Drumlanrig. Built in the 13th century, with an enclosed deer park, it was used as a hunting lodge until 1714*
TOP *The 2nd Earl of Queensberry acquired nearby Sanquhar Castle in 1639. He bought it from the Crichton family, ruined by the expense of a visit from King James in 1617. His son, the future 1st Duke (opposite), spent large sums on Sanquhar in the 1670s to make it his 'informal' residence for when he was not 'on show' at Drumlanrig*

and the story has since been a defining part of family history.

Ancient charters tell us that people called Douglas held land around Drumlanrig from 1388 or earlier. Over the subsequent three centuries, they created or acquired several strongholds within a 20-mile radius, at Tibbers, Morton and, most particularly, Sanquhar to the north. Their fortunes fluctuated in the era of relative lawlessness and intermittent strife, either with English invaders or competing clans, that ended only with the unification of the thrones in 1603 in the figure of James VI of Scotland and I of England.

In 1633 Sir William Douglas, the 9th Douglas in succession to live at the Castle, was made Earl of Queensberry, taking his title from the most southerly of the Lowther Hills to the east of the Castle. It was in the reign of Charles II, however, that the family fortunes were put on a firm footing by William's grandson, the 3rd Earl, who succeeded his father in 1671 and forged a career in Scottish politics as one of the Lords of the Treasury. In 1682 he was made a marquess and, just two years later, became the 1st Duke of Queensberry. To accompany his new-found wealth and status, he conceived a magnificent new house, a cross between a castle and a grand mansion, which is essentially the Drumlanrig we see today. As one contemporary put it, 'He had a desire for prestige in stone.'

His son James, who succeeded him as 2nd Duke in 1695, was an equally significant

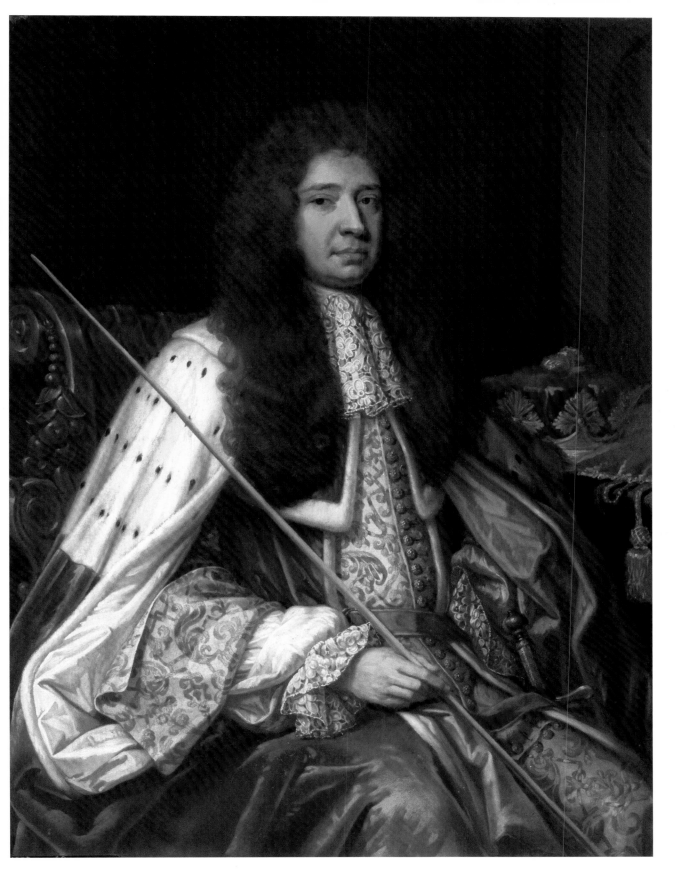

LEFT SIR GODFREY
KNELLER (1646–1723)
**William Douglas,
1st Duke of Queensberry
(1637–95), 1685**
*A portrait of the 1st Duke,
resplendent in his peer's
robes. Sir William
Douglas rose rapidly
to power after the
Restoration, succeeding
the Duke of Lauderdale,
who died in 1682, as the
most powerful man in
Charles II's Scotland.
In 1675 he embarked on
building the Drumlanrig
Castle we see today. He
was created 1st Duke of
Queensberry in 1684 and
is seen here holding the
white staff of office of the
Lord High Treasurer,
with a ducal coronet on
the table. Kneller's bills
for painting the Duke and
his son Lord Drumlanrig
(later 2nd Duke) –
£57.16s and £20 – are
still in the Archives*

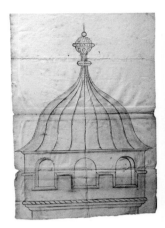

Early plans

Foreshadowing the Castle we know today are plans found in the Archives, drawn up for the 1st Earl of Queensberry between 1608 and 1618. They include a drawing for an exotic ogee turret. The 1608 plan below (with north on the left) shows a courtyard, four spiral staircases and the square Northwest corner tower (later there were four). What did the 1st or 2nd Earl actually build? Plenty, to judge by a discarded lintel carved with the earl's coronet and the year 1644 (page 28), a prestigious final touch. Cromwell's army would set the building alight in 1650

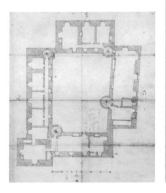

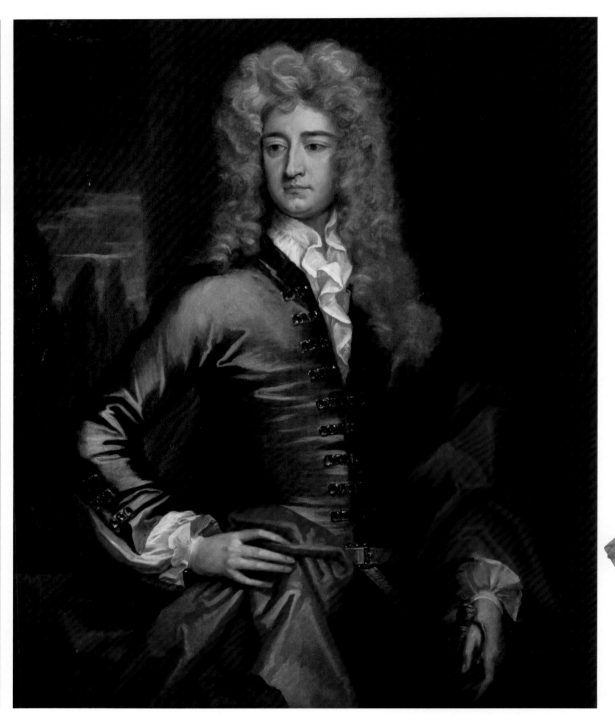

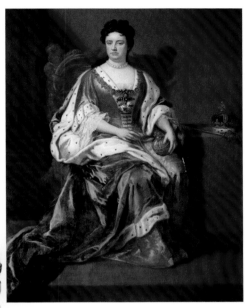

politician. When William of Orange invaded to overthrow King James II in the 'Glorious Revolution', James, then Earl of Drumlanrig, caused a sensation by joining the Dutch Prince shortly after he landed at Torbay in 1688, at considerable risk to his life. One contemporary wrote that he was 'the first Scotsman that deserted over to the Prince' and labelled him the 'Proto-Rebel'.

Later, when he was Duke, his dealings on behalf of the Crown with the Scottish Parliament were rarely straightforward, with much bitterness and politicking, particularly over the succession to Queen Anne. He is known as 'the Union Duke', for his crucial and determined role in advancing the Act of Union that united the Scottish and English parliaments in 1707, believing as he did that it would be in the interests of both countries. For this he was rewarded with a further title, Duke of Dover, and from 1709 until his death in 1711 he was Secretary of State for Scotland.

James and his younger brother, William (later Earl of March), had done the Grand Tour, setting off at the ages of 18 and 16, respectively, for two-and-a-half years of travel in France and Italy, despite James being kept to his room in Paris for two months by a bowel condition that would plague him all his life. The influence of the considerable time the brothers spent in Rome is seen most clearly in the design of the family vault at Durisdeer Church, whose barley-sugar columns are echoes of Bernini's great *baldacchino*

OPPOSITE SIR JOHN BAPTIST MEDINA (1646–1723)
James Douglas, 2nd Duke of Queensberry and 1st Duke of Dover (1662–1711)
From William of Orange's 'Proto-Rebel' supporter to Queen Anne's 'Union Duke', the political career of the 2nd Duke would, in Defoe's words, 'require a history rather than a bare mention'. It was he who persuaded Scotland to accept the Act of Union
ABOVE *Kneller's portrait of Queen Anne, who rewarded the 2nd Duke with the dukedom of Dover*
LEFT *The commission authorising the 2nd Duke to hold the Scottish Parliament in 1703*
BELOW RIGHT *Duke James and Duchess Mary's memorial in Durisdeer's parish church (page 203)*

SCOTLAND
Edinburgh · *Dalkeith*
Glasgow
Clyde THE BORDERS
Tweed
Sanquhar · *Bowhill* · Selkirk
Ayr
Durisdeer
Drumlanrig ■ Morton
Nith Thornhill
Dumfries
ENGLAND
Stranraer · *Solway Firth*
Carlisle · 20 miles

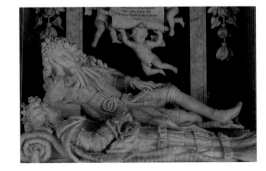

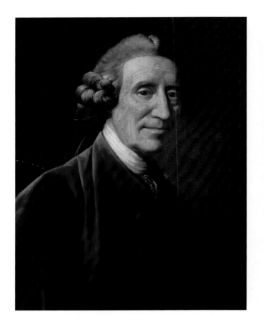 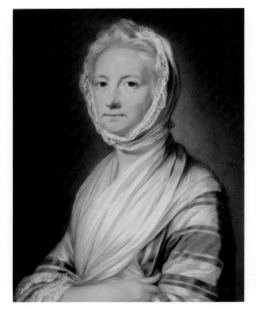 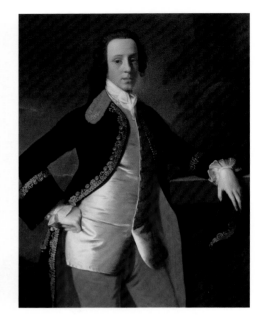

in St Peter's. Although he died at his London house in Albemarle Street, he was brought back to Drumlanrig to be buried beside his wife, who had predeceased him by two years, below John van Nost's magnificent memorial to the couple.

Charles, 3rd Duke of Queensberry, was married to one of the more interesting figures in the family's history, Catherine Hyde. Kitty, as she was generally known, was both a generous patron of the arts and a formidable freethinker. Most notably, she took up the cause of John Gay, the poet and author of *The Beggar's Opera*, which was dedicated to her and for which she and her husband were banned from Court. They subsequently spent considerable time at Drumlanrig, and the elaborate gardens of the 1730s and '40s are a consequence. Although allowed to return to Court in due course, she was always a controversial figure. Horace Walpole, whose London house at Strawberry Hill was across the river from them, wrote, 'Thank God the Thames is between me and the Duchess of Queensberry.'

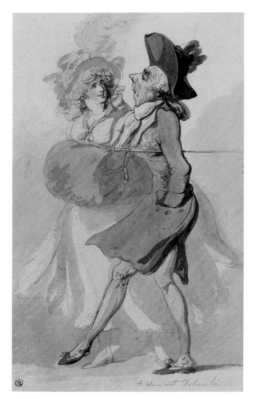

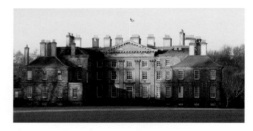

ABOVE *Dalkeith Palace, near Edinburgh, the main Buccleuch residence until the First World War*
TOP ROW *Charles, 3rd Duke of Queensberry, by William Hoare of Bath; a pastel of his Duchess, Kitty, by Katherine Read, 1776; the future 4th Duke, Old Q, when Earl of March, by Allan Ramsay, 1742*
LEFT *Old Q, Rowlandson's 'Worn-out Debauchée'*
OPPOSITE HENRI-PIERRE DANLOUX (1753–1809)
The family of Henry Scott, 3rd Duke of Buccleuch, in the grounds of Dalkeith, 1798
In this portrait, now at Bowhill (the family house in the Borders), Duke Henry – the first Scott Duke of Queensberry – poses with Duchess Elizabeth, the Montagu heiress, in front of Adam's Montagu Bridge. Far right is his heir, Charles; his daughter Caroline, far left, married the future Marquess of Queensberry

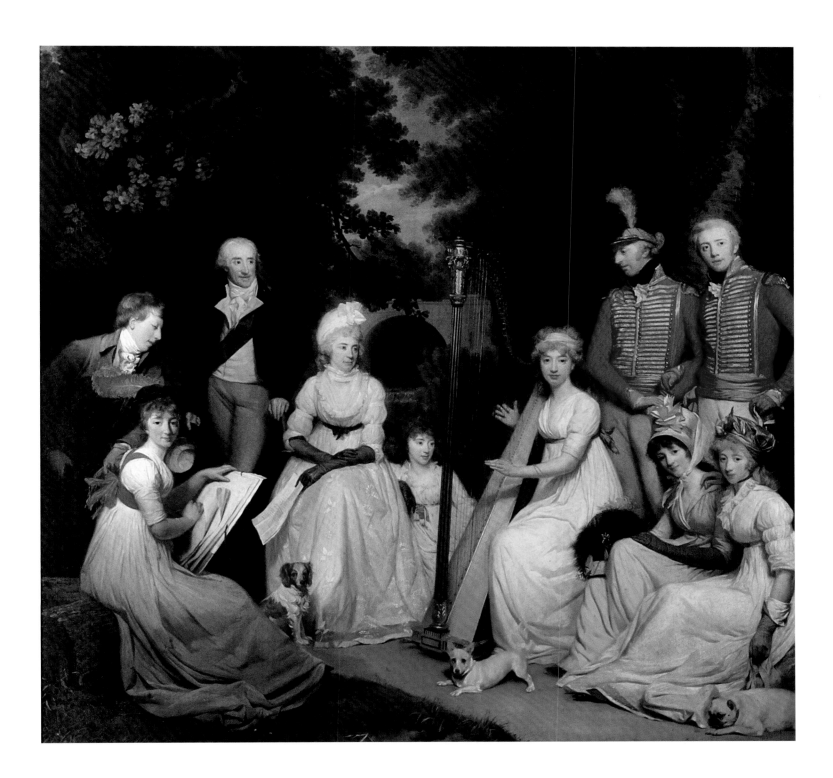

Neither of the two sons of Charles and Kitty survived them, and as a result the inheritance passed to a cousin, William, Earl of March, who became the 4th Duke of Queensberry. Known to history as 'Old Q', he was a colourful character, renowned as a gambler and lecher. He milked his great inheritance, incurring the wrath in verse of both Burns and Wordsworth for cutting down his magnificent woodlands. Drumlanrig itself was left in a sorry state, its roof leaking badly. When he died in 1810, it was without any recognised legitimate heir, although in his own view he had at least a daughter, Maria Fagniana, to whom he gave the considerable fortune on which the great Wallace Collection of art and furniture in London would be founded.

Thus the titles moved sideways again, but this time the dukedom of Queensberry was to pass through a female line, thanks to the marriage of the 2nd Duke's daughter Lady Jane Douglas to Francis, 2nd Duke of Buccleuch, back in 1720. The Buccleuch

dukedom had been created by Charles II for his eldest illegitimate son, James, Duke of Monmouth, who married Anna, Countess of Buccleuch, a Scottish heiress. Francis and Jane Douglas's grandson Henry, 3rd Duke of Buccleuch, inherited both the ducal title and the bulk of the Queensberry estates.

On the other hand, the slightly older title of Marquess of Queensberry, earned by the 1st Duke of Queensberry in 1682, required a male descent, so it passed to a Sir James Douglas, Henry's son-in-law. James had married the vivacious Lady Caroline Scott

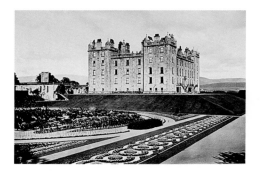

OPPOSITE *The Castle and gardens on a wintry day, November 1901. It had taken a century for the woods to recover from the mass felling ordered by Old Q to pay off his gambling debts*
BELOW LEFT *The elaborate West Garden, 1883*
BOTTOM LEFT *Walter Francis, 5th Duke of Buccleuch, in 1861. Queen Victoria appointed him president of the Royal Horticultural Society in 1862 as successor to the late Prince Albert*

THE RESTORATION OF THE HORSESHOE STAIRCASE
BELOW *This fine staircase, a striking backdrop to generations of photographs, is said to be inspired by a visit to the Loire in 1681 by the 1st Duke of Queensberry's elder sons. It collapsed thanks to Old Q's neglect and was replaced by an ugly straight staircase before being reinstated by the clerk of works, Charles Howitt, in 1860 for Walter Francis's Duchess, Charlotte Anne. This 1865 photograph shows their son Lord Henry Scott, later Lord Montagu of Beaulieu (far left), and his new bride, Cecily Stuart-Wortley-Mackenzie (centre). In the foreground (knitting) are Lady Ann Marsham (left) and Henry's sister Lady Margaret*

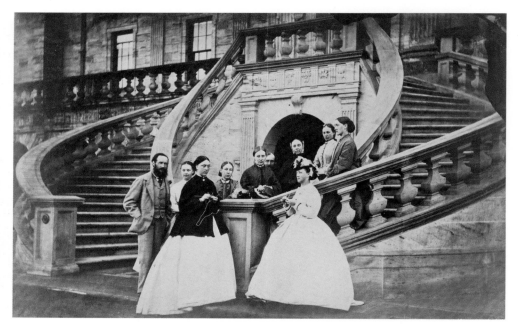

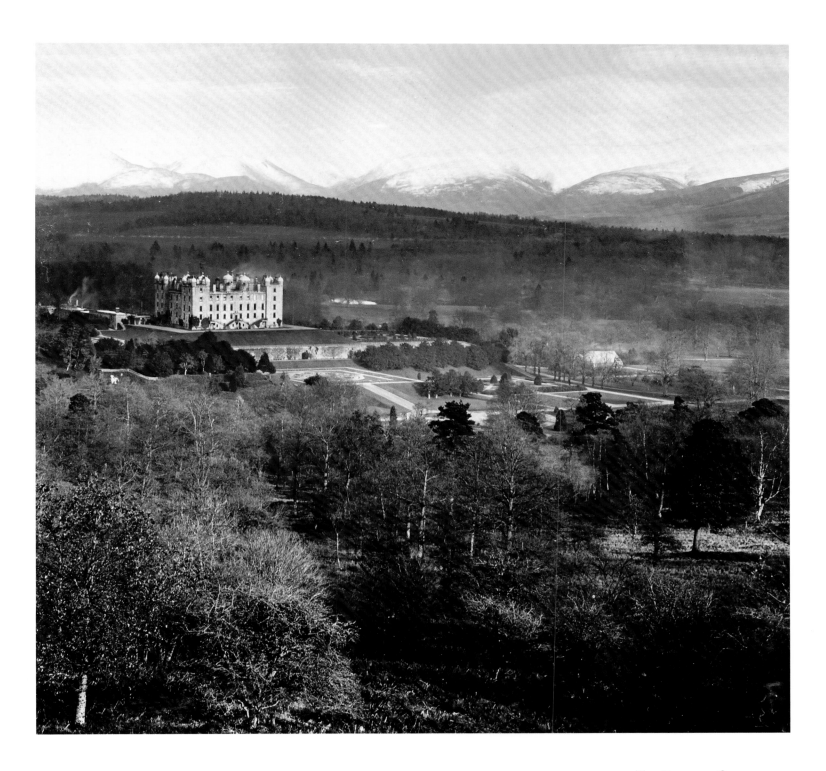

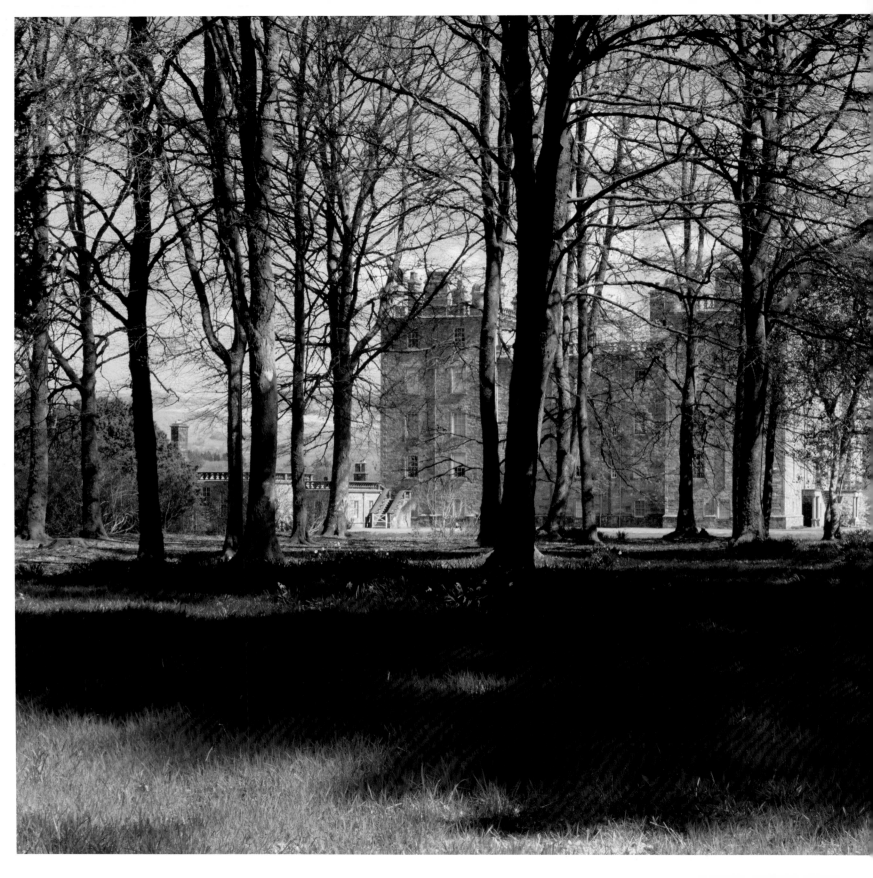

seen sketching in Danloux's family portrait (page 19). With the title of Marquess went a much smaller estate, near Annan, just north of the border on which was built a fresh family seat, Kinmount. From that point on, the Marquesses of Queensberry have had their own separate and interesting history, which encompasses the creation of the famous rules of boxing and the notorious friendship of Lord Alfred Douglas and Oscar Wilde.

Henry, 3rd Duke of Buccleuch and 5th Duke of Queensberry, lived to enjoy his dual dukedom for just two years. It was left to his son Charles, 4th and 6th Duke, and his grandson Walter Francis, 5th and 7th Duke, to undertake Drumlanrig's restoration and its transformation internally, with the addition of furniture and paintings from the enormous Buccleuch collection. This work embraced the creation of gardens in the Victorian manner, with acres of greenhouses providing bedding plants and exotic fruits and vegetables on an astonishing scale, only relatively modest traces of which remain.

Sir Walter Scott, a Buccleuch kinsman whose life overlapped with the three Dukes, seems to have had an early hand in the transformation of Drumlanrig. His deepest friendship was with Charles, 4th Duke of Buccleuch, and Harriet, his wife, until her early death. They were contemporaries and their paths crossed constantly and in so many ways. It was on Scott's advice that Charles turned the Great Gallery of the North Front into bedrooms. It was also Scott, a great planter, who encouraged the reversal of Old Q's destruction of the woodlands. In 1826, six years after

Charles's death, Scott was astonished at the speed with which his friend's '1200 acres of plantations' were 'repairing the devastations of old Q'.

The scale of activity throughout the 19th century is all the more remarkable given that the principal homes of the family were Dalkeith Palace, just outside Edinburgh, and Montagu House in London.

This remained the case until the First World War, when both those houses were closed permanently and their contents gradually dispersed among the other three: Bowhill, Drumlanrig and Boughton.

Drumlanrig served as an auxiliary hospital during the war, and it was only in the 1920s, with Walter, 8th and 10th Duke, and his wife, Mary, known as Mollie, that it emerged as a favourite family home. During the Second World War the Duke and Duchess made it their principal base, notwithstanding that a large part of it had been given over to an Edinburgh girls' boarding school, St Denis.

For them and for their son, Johnnie, father of the present Duke, and his wife, Jane, Drumlanrig had a strong magnetic pull. Their deep knowledge and love of the working rural estates, farms and woodlands that surround the Castle are perhaps one of the keys to that attachment. During their stewardship, and particularly in the past half-century, a huge programme of restoration and conservation work has ensured that this historic building is well set for the centuries ahead.

The Castle's pink walls viewed through the trees in springtime. Unseen here, a large formal garden and an old bowling green lie between the Castle and the woods

Drumlanrig's Dukes

Since William Douglas, 1st Duke of Queensberry, conceived the grand plan for his palace in Dumfriesshire, 11 Dukes have been responsible for its upkeep. And there has been just one bad penny amongst them

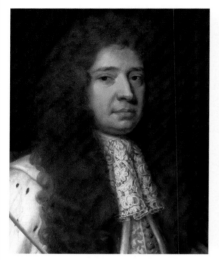

WILLIAM, 1ST DUKE OF QUEENSBERRY (1637–95) *The ambitious Duke who created today's Castle, by Sir Godfrey Kneller*

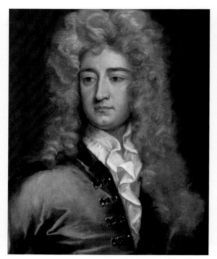

JAMES, 2ND DUKE OF QUEENSBERRY (1662–1711) *The famous 'Union Duke' – 'a complete courtier' – by Sir John Medina*

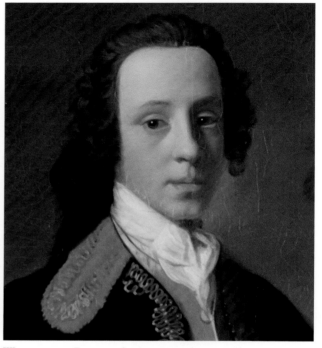

WILLIAM, 4TH DUKE OF QUEENSBERRY (1725–1810) *The notorious Old Q, painted by Allan Ramsay in 1742. A cousin of the 3rd Duke, he felled the woods and left the Castle in a ruinous state*

The 1st Duke, Scotland's Lord High Treasurer, is said to have been appalled at the soaring costs of building Drumlanrig. But he had time to enjoy his palace: ousted from office by James II's Catholic party, he retired to his estates for the last nine years of his life. The 2nd Duke, known as 'the Union Duke' for his part in the Act of Union, added the Great Oak Staircase. The 3rd Duke built a vast garden but lost both his heirs. His gambling cousin the Earl of March, Old Q, became the 4th Duke. By the time his Scott cousin Henry, 3rd Duke of Buccleuch, became 5th Duke of Queensberry in 1810, the house was barely watertight. His descendants restored the house, and love it and live in it to this day.

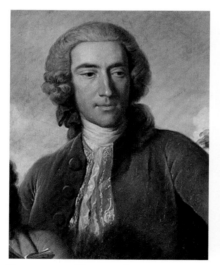

CHARLES, 3RD DUKE OF QUEENSBERRY (1698–1778) *by George Knapton. A highly cultivated man, he created the gardens*

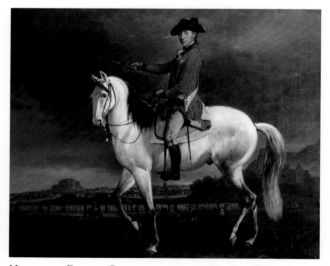

HENRY, 3RD DUKE OF BUCCLEUCH AND 5TH DUKE OF QUEENSBERRY (1746–1812), *painted by Martin Ferdinand Quadal in 1780. Henry inherited the dukedom of Queensberry through his grandmother in 1810*

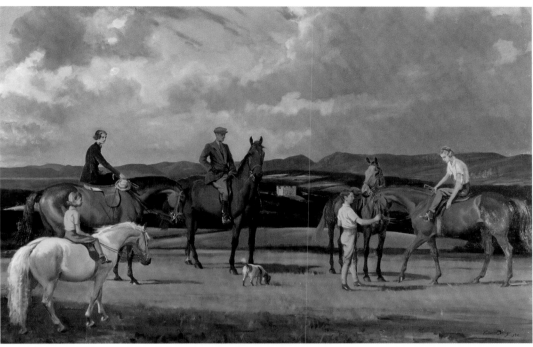

JOHN, THE 7TH AND 9TH DUKE (1864–1935) *by Sir George Reid. A naval career was cut short when his brother was killed stalking*

WALTER, 8TH AND 10TH DUKE, AND FAMILY IN 1938, *by Edward Seago with Drumlanrig in the distance. From left: Caroline (later Lady Caroline Gilmour) on her Shetland pony, Bridget; Duchess Mollie riding side-saddle; Duke Walter; Johnnie (future 9th and 11th Duke); Elizabeth (later Duchess of Northumberland) on Threepenny*

JOHNNIE, LORD ESKDAILL, THE FUTURE 9TH AND 11TH DUKE (1923–2007), *painted in 1929 aged six by Charles Edmund Brock*

JOHNNIE, THE 9TH AND 11TH DUKE, WITH HIS FATHER, WALTER, 8TH AND 10TH DUKE *The 9th and 11th Duke joined the Navy in 1942. His father was a colonel in the King's Own Scottish Borderers*

RICHARD, 10TH AND 12TH DUKE (B. 1954) *John Ward RA painted the present Duke in 1981 when he was Earl of Dalkeith*

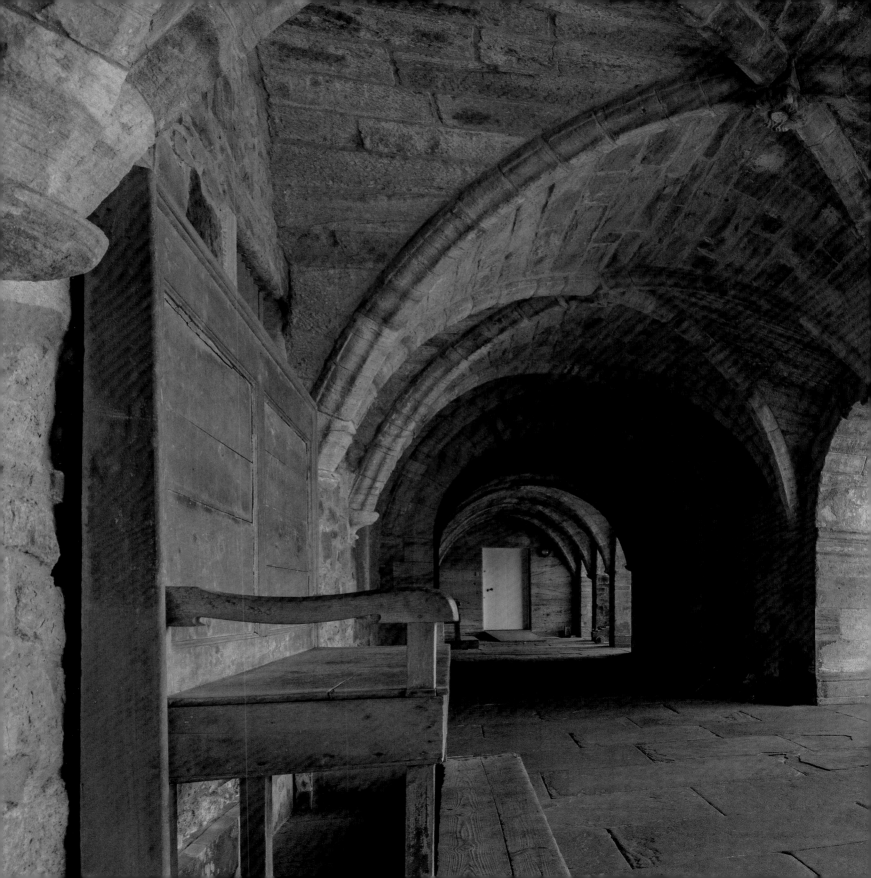

How today's Castle was built

Drumlanrig emerged fully formed from a phenomenal burst of building in the 1680s. But as the Castle's Archives give up their secrets, it is clear that the Douglases, lords of Drumlanrig, had long been looking to Renaissance Europe

Scottish architectural history has been much enlivened by fresh thinking in recent years about the appropriateness of the term 'castle'. The tendency to link any castellated building with endemic warfare and limited civilisation is now being seen as reflecting a Victorian slant on Scottish history that stemmed largely from the novels and poems of Sir Walter Scott. Instead, there is growing awareness of the extent to which Scotland and its nobility were exposed to the ideas of the Renaissance and classicism and were less subject – except perhaps in the borderlands – to the threat of repeated violence. We now know that major buildings were more akin to mansion houses or French châteaux.

Drumlanrig fits this pattern. Although there were earlier castles on the site, including one

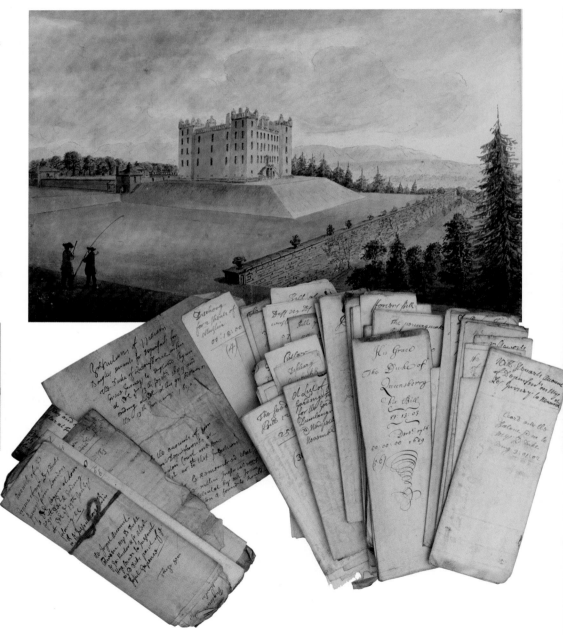

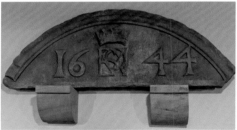

mentioned in 1429 – confirmed by a deep well in the courtyard – we have no idea of their appearance. However, inventories at the death of James, 7th Lord of Drumlanrig, in 1578, talk of him having 'beildet the haill house and pallice of Drumlanrig', and a few decades later plans in the Charter Room show how this building was to be enlarged

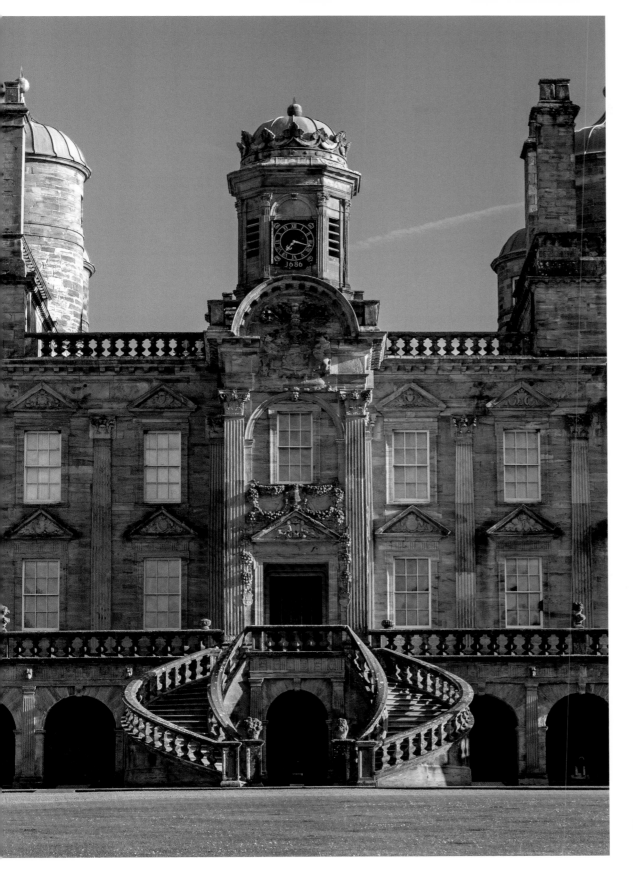

THIS PAGE, LEFT *The evening sun catches the Clock Tower above the Queensberry coat of arms marking the Castle's entrance. The balustrades follow the curve of the stairs in a textbook exercise in geometry. Adding a nuance to the play of light and shadow, the carved balusters on the roof and terrace are set at 45 degrees*
BELOW *One of the pair of armorial shields flanking the portal*

OPPOSITE PAGE, TOP *The Castle c.1750 by John Clerk of Eldin (1728–1812), the polymath 7th son of Sir John Clerk of Penicuik, and Robert Adam's brother-in-law*
BOTTOM *Bills from the 1st Duke's shopping trips to England in 1685–90 to furnish the Castle*
LEFT *This 1644 lintel, unearthed in the gardens, is evidence of building by the 2nd Earl before Cromwell's army attacked Drumlanrig in 1650*

PREVIOUS PAGES *The wall of the vaulted arcade below the terrace survives from the earlier castle*

between 1615 and 1622. It is probably no coincidence that James VI and I was entertained there by William, the future 1st Earl of Queensberry, in 1617.

There seems to have been a further remodelling in 1644, undertaken by James, the 2nd Earl, but his support of the King during the Civil War proved disastrous – the Castle was set alight by Parliamentary forces under Colonel Gilbert Kerr in 1650.

It was his son William, the 3rd Earl and future 1st Duke, who built the Castle largely as we see it today. Sadly, no plans and few accounts survive, and we can only speculate about who influenced the architecture.

Some aspects may have been carried through from the previous building, especially at the lower levels. The archives show that advice was sought both from Sir William Bruce, described by Sir John Clerk of Penicuik in 1717 as 'the chief introducer of Architecture in this country', and from Robert Mylne, who built a bridge over the Nith in 1673. However, it is the name of Mylne's

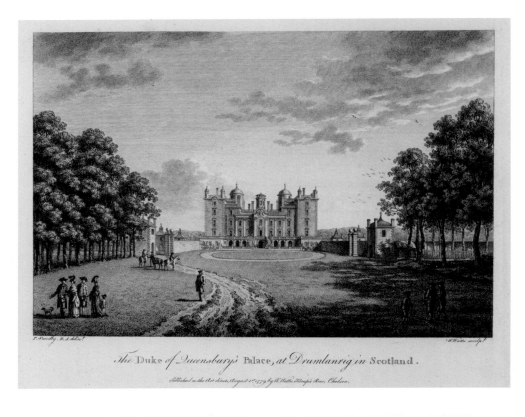

The Duke of Queensbury's Palace, at Drumlanrig in Scotland.

Published as the Act directs, August 1st 1779 by W. Watts, Kemp's Row, Chelsea.

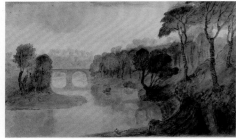

ABOVE *The Nith, by John Clerk of Eldin, c.1750*
TOP *Paul Sandby drew the Castle in 1747 for the Ordnance Survey of Scotland. Clerk was his guide*
RIGHT *John Rocque's 1739 survey of the 3rd Duke of Queensberry's new avenues was copied by the Crawford brothers for the 4th Duke of Buccleuch in 1818 when he was restoring Drumlanrig*
LEFT *The Drumlanrig Bridge today – upstream the river becomes craggy and spectacular*

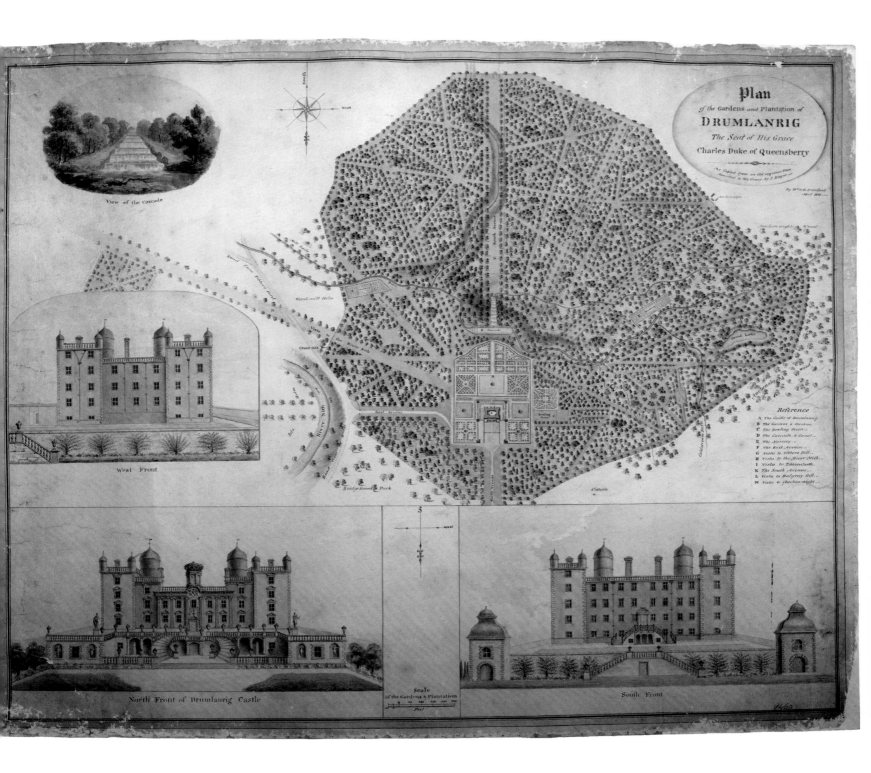

View of the Cascade

Plan
of the Gardens and Plantation of
DRUMLANRIG
The Seat of His Grace
Charles Duke of Queensberry

Reference

A The Castle of Drumlanrig
B The Gardens & Orchards
C The Bowling Green
D The Cascade & Canal
E The Nursery
F The East Avenue
G Vista to Tibbers Hill
H Vista to the River Nith
I Vista to Tibbersholm
K The South Avenue
L Vista to Bulgrey Hill
M Vista to Auchen-night

West Front

North Front of Drumlanrig Castle

Scale
of the Gardens & Plantation

Feet

South Front

son-in-law James Smith, Surveyor of the King's Works, that appears most frequently in the papers relating to the rebuilding. The Duke had appointed him to this prestigious post in 1683, although work had already commenced in 1679 on the Northeast Tower.

Just as important was the builder, one William Lukup, Master of Works at Drumlanrig, who stands, tools in hand, within a castle doorway on the tomb of four of his children in the churchyard at Durisdeer (page 204). In 1684 he sent in an account for £36,000 'for building the south and west quarters of the Castle of Drumlanrig conforming to the indentures'. This astronomical sum, more than £4 million today, was paid off in instalments including, in kind, '50 bolls of meal'.

Three sides of the building are of simple, rough-hewn rubble, but the North Front is a breathtaking stage set of dressed stone, giant pilasters, swags of fruit and spooky faces. The Clock Tower, crowned by a ducal coronet, stands like a *tempietto* above a huge coat of arms. The inspiration, suggests the art historian Cristina González-Longo, was Michelangelo's Palazzo Senatorio in Rome, with its fluted pilasters and central clock tower, hallmark of a civic building rather than a residence. The geometry of the staircase balustrades, she points out, is true to Caramuel de Lobkowitz's treatise *Architectura Obliqua*.

The date on the clock face, 1686, coincides with documents detailing a visit by two Dutchmen, Peter Paul Boyse and Cornelis van Nerven, stone carvers working around this time at Kinross, another great Scottish house. The sense of a stage set is reinforced by the Horseshoe Staircase and elaborate portico, which led originally not into the entrance hall but into an open loggia and the large internal courtyard. The main door to the house was directly opposite, in the south-facing block.

Fitting out the Castle had begun in 1684, even though the North Front was yet to be

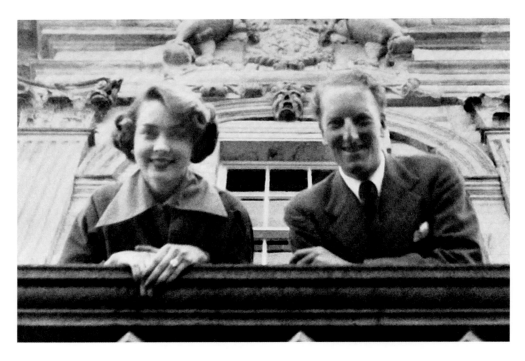

completed. There are records of 143 hired carts loaded with wooden wainscoting being taken from Leith to Drumlanrig from November 17, 1684 until November 26, 1685, 'conforming to Andrew Fairservice carter his discharge thereof' and a further 154 carts the following year.

By the summer of 1688 convoys of furniture and fixtures were being moved from Edinburgh to the Castle. The Duke went to fashionable London craftsmen such as Gerrit Jensen and his successor as royal cabinetmaker, John Gumley, as well as Edinburgh men such as John Scott of Canongate. Sadly, little of this furniture survives. Duke William is supposed to have rued his extravagance and protected his bundle of accounts with the curse, 'The Devil pike out his eye, who looks herein.'

Drumlanrig has remained remarkably unchanged since that great rush of building, although, in the 19th century, when Old Q's dilapidations were being put right, the

north-facing Gallery, which ran the entire length of the first floor, was unfortunately divided into bedrooms. The loggia below it was also glazed to create a new Front Hall.

In 1840 new service ranges were added in the orange-tinted stone of Dumfries, linking to forward pavilions on either side of the main entrance front. This stone is not unattractive in itself, but it compares unfavourably with the magical qualities of the local Drumlanrig stone, which is crystalline in character, so that its subtle pale pinkness takes on the mantle at times of a grey, dreich, damp day and at others of a mellow golden midsummer evening. For many people the stone seems to define Drumlanrig, enabling it to float almost mystically in its mountain setting.

ABOVE *The present Duke's parents look down from the top of the Horseshoe Staircase at the time of their engagement in 1952*
OPPOSITE *The vaulted porch under the Clock Tower frames a view of the lime avenue*

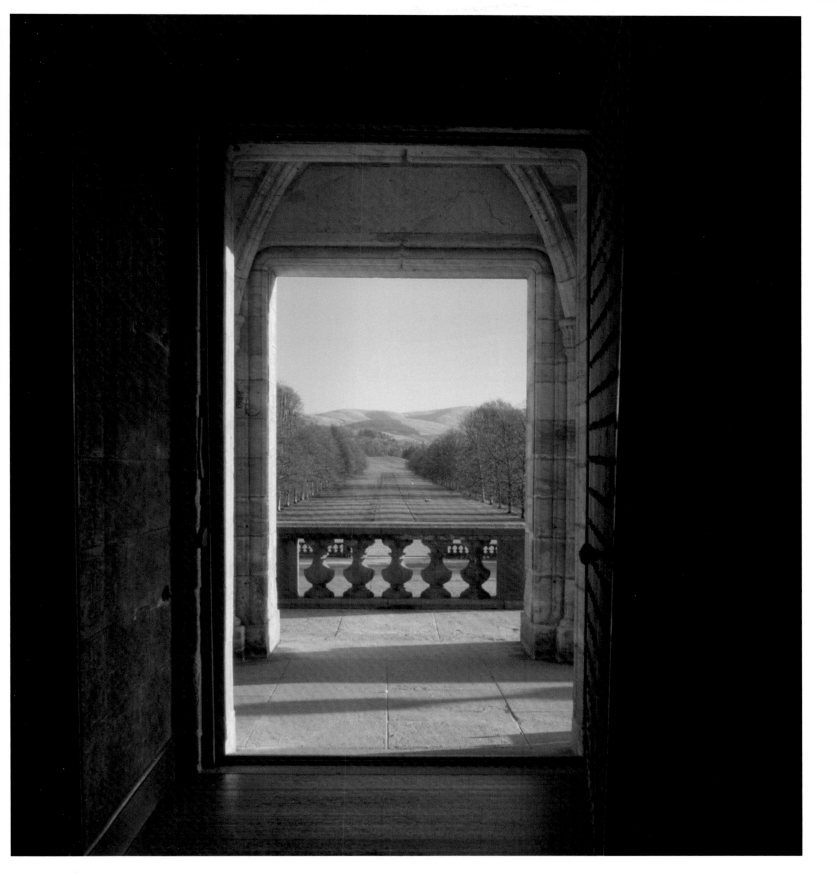

The Front Hall

Once a forbidding entrance, the Front Hall is now a warm, welcoming space with unexpected touches

Today the hospitable Front Hall provides a very different welcome from the one a 17th-century visitor would have received. Then it was but a staging post on the way to the front door across the internal courtyard, an open loggia whose draughtiness the Victorians found too daunting. Thankfully, they installed glazing.

The great oak door is reinforced with a massive iron yett, or grille, that provides a happy children's climbing frame but would rarely have been used in anger. For all its castellations, large windows show

RIGHT *The studded oak front door and 'the great iron gate' made for the 1st Duke by James Horn of Kirkcaldy opens into a hall of curiosities. There are visitors' books, James II ebonised chairs, an old bagatelle table for the game of 'trou madame' and, above the fire, needlework from the time of Mary, Queen of Scots*
BELOW *Looking back down the Hall, with its carpet bearing the Queensberry crest, woven by Craigie Stockwell. The bronze statuette of Giambologna's 'Rape of the Sabines' on the table is attributed to John van Nost, who carved the Queensberry memorial in Durisdeer*

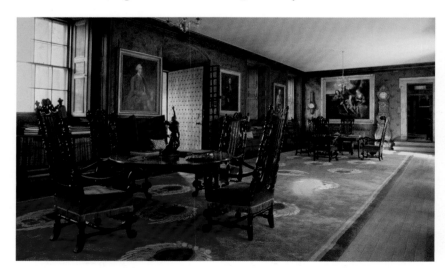

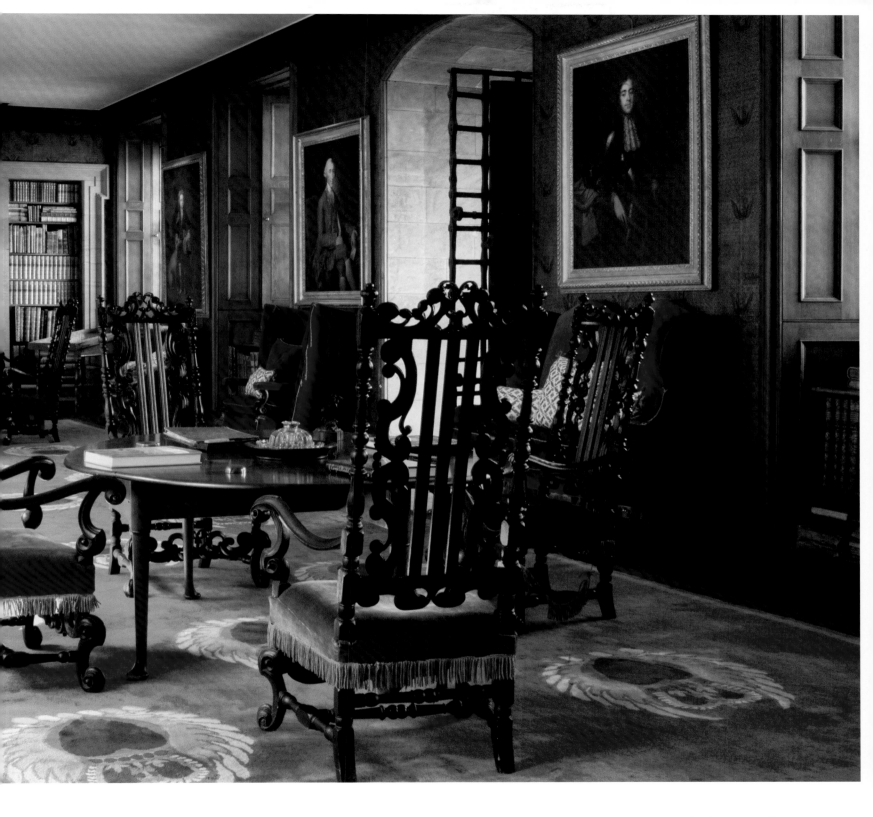

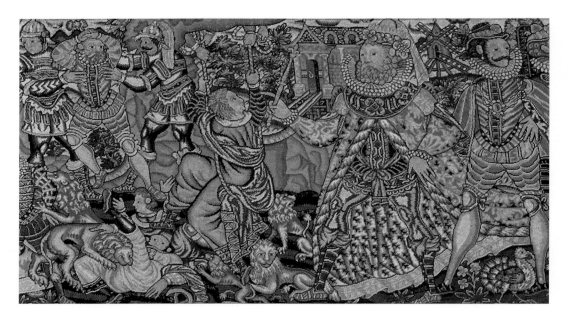

that this was a building for civilised living rather than a military stronghold.

The great fireplace, added as an aggrandisement in 1875, is something of a deceit, its frame a piece of skilful carpentry rather than the work of a stonemason. Winged Douglas hearts are emblazoned across the 1882 wall covering, often described as leather but in fact the work of the English wallpaper manufacturers Cowtan & Sons. Hearts also adorn the carpet, commissioned by the present Duke's father, its vivid shade of red impervious to passing feet and dirty boots.

An exceptional Louis XV grandfather clock provides the time for arriving or departing guests, or more particularly the shooting parties that would head off into the surrounding hills. On their return they would sit down at the tables to an abundant afternoon tea.

Dominating one end of the room is a touching conversation piece by George Knapton, of Charles, 3rd Duke of

Queensberry, with his wife, Kitty, and their two sons. The way their hands and gazes link reminds us, poignantly, that neither of the boys survived his parents.

Kitty's support for John Gay, author of *The Beggar's Opera*, satirising Robert Walpole and the government of George II, came at a social cost. Walpole made sure that Gay's follow-up opera, *Polly*, condemning the slave trade, was banned. Kitty and the Duke were themselves banned from court for objecting. They duly left London, and Kitty, unrepentant, continued her unconventional life, supporting artists and musicians.

Almost invisible by comparison at the opposite end of the room is a fascinating piece of 16th-century needlework, once attributed to Mary, Queen of Scots, telling the story of Daniel in the Lions' Den. In 1855 the panel was rescued from a lumber room at Wemyss Castle – the setting for the Queen's first meeting with Lord Darnley in 1565 – and given to Lady John Scott, the 5th Duke's sister-in-law. The Duke and Lady John, who was renowned for composing the song 'Annie Laurie', were keen collectors of Scottish treasures. Lady John had a wooden frame made by one of the Warwick Woodcarvers active in Warwick until the First World War. It is inscribed with the words 'Marie Stuart Queen of Scotland' and carved with the chain of the Order of the Thistle.

Two other portraits (both overleaf) catch the eye here. The 'unfortunate' Duke of Monmouth and Buccleuch, an ancestor, was beheaded by James II of Scotland and VII of England in 1685. Kneller's portrait of the Moroccan envoy to Queen Anne's court, seems somewhat anomalous in faraway Scotland.

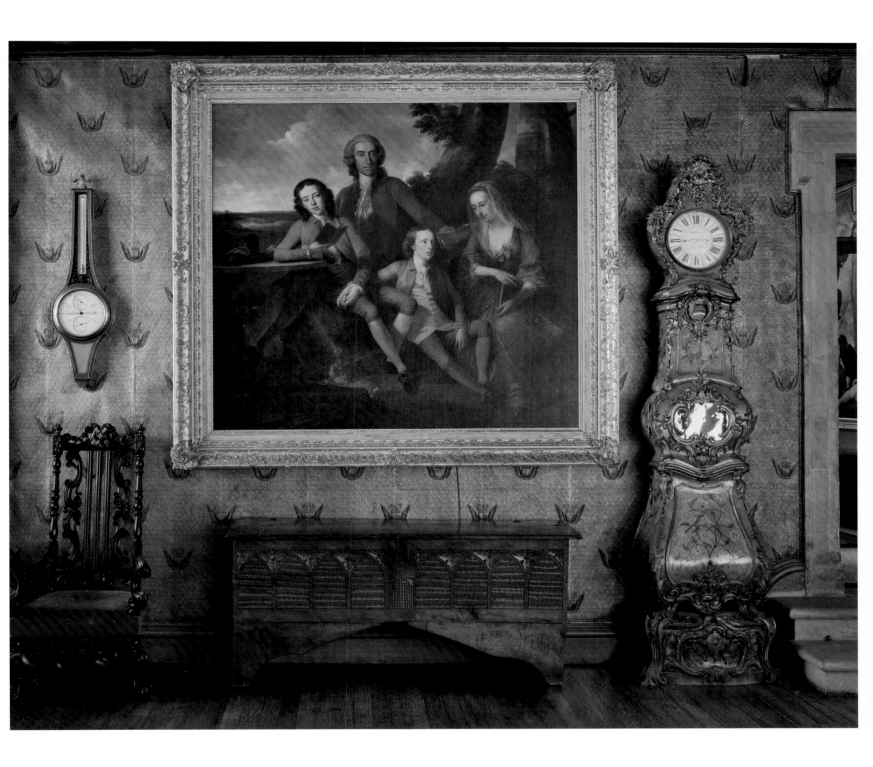

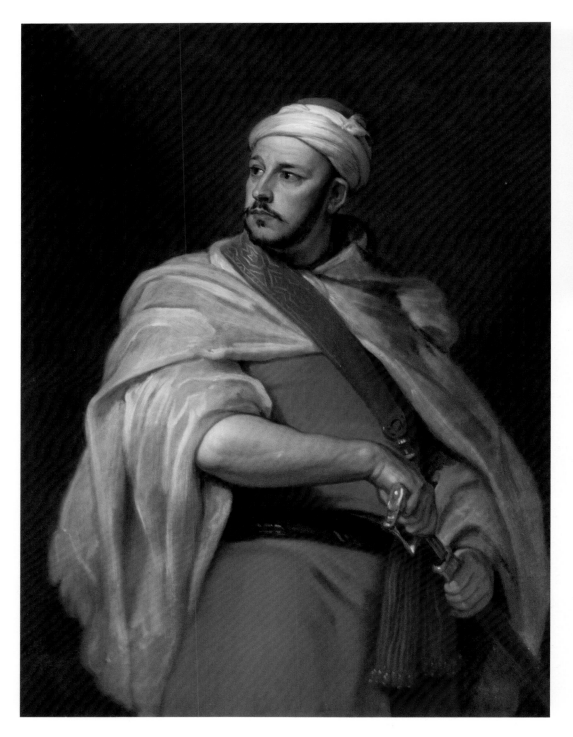

ABOVE ATTRIBUTED TO
WILLIAM WISSING (1656–87)
**James, Duke of Monmouth and
1st Duke of Buccleuch (1649–85)**
*The favourite son of Charles II, James
Crofts married Anna Scott, Countess of
Buccleuch, in 1663 when they were 14 and
12 respectively. Often dismissed as foolhardy
– his attempt to usurp James II cost him
his head – he was in fact an engaging and
brilliant leader of men, bringing efficiency
and professionalism to the English army*

LEFT SIR GODFREY KNELLER (1646–1723)
The Moroccan Ambassador, 1709
*The 2nd Duke of Queensberry bought this
portrait soon after it was painted: it is in
the Castle inventory of 1712. Ahmed Ibn
Ahmed, Quadran-Nasir, 'The Andalusian',
was the envoy of the powerful Emperor
Moulay Ismail Ibn Sharif of Morocco
to the court of Queen Anne. He arrived
in London in April 1706 to discuss peace
and trade. Negotiations were scuppered
when Moroccan corsairs attacked
English vessels in the Mediterranean*

ABOVE THOMAS HUDSON (1701–79)
Charles, 3rd Duke of Queensberry and 2nd Duke of Dover (1698–1778)
The urbane Duke Charles, a man of the Enlightenment and patron of the arts, wears a gold-edged grey suit and holds a letter addressed to him in London

RIGHT THE LOGGIA ARCHES
Sunlight pours into the Front Hall from the Courtyard through the original loggia arches, now glazed. Scottish giltwood mirrors hang between the windows. The oak coffers are full of rugs and other essentials for picnics. The door at the far end once led to the 1st Duke's apartment

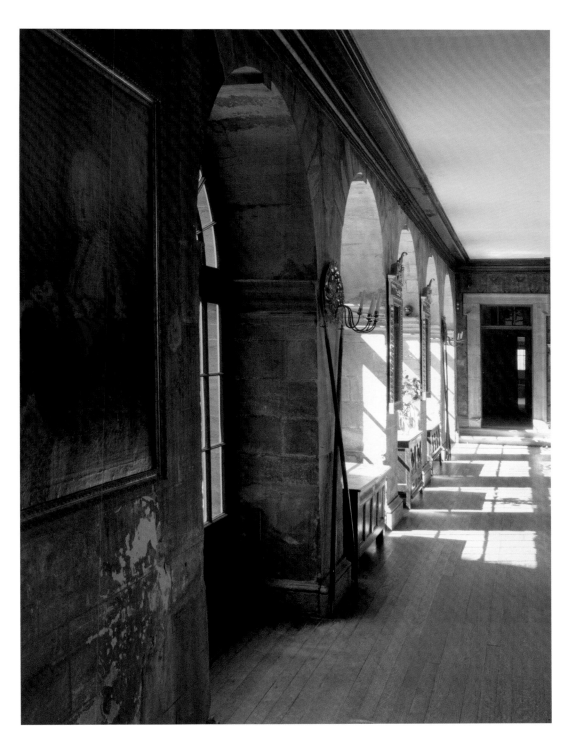

The Courtyard

On the 1st Duke's processional way from the North Front and up to the state rooms, the Courtyard played a central role

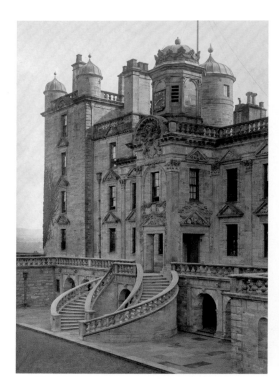

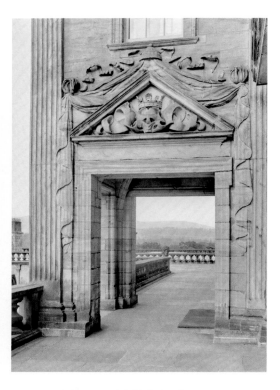

Drumlanrig was a theatrical stage set where the 1st Duke could impress his grandee guests. The act of arriving was an elaborate progress. Visitors would sweep up the Horseshoe Staircase to the vaulted portal under the Clock Tower, where a broad terrace stretching the length of the North Front created the perfect gallery from which to enjoy the spectacle of arriving guests. The portal led to a loggia open on one side that faced another grand doorway across the Courtyard. This in turn opened into the original entrance hall, where the Oak Staircase led up to an enfilade of state rooms.

After the loggia was enclosed in Victorian times, the Courtyard's central role in this ducal progress was forgotten. Walter Francis, 5th Duke,

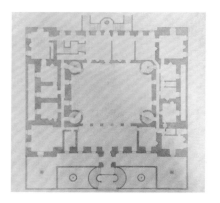

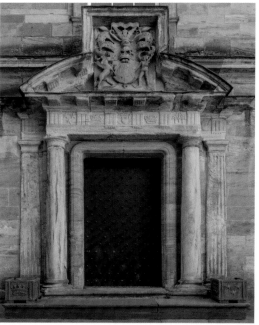

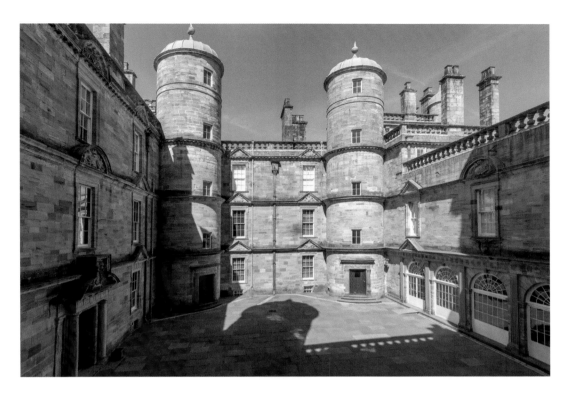

LEFT *A turret casts a dramatic shadow across the Courtyard. The 9th Duke's plan to install tent-like roofing for staged performances proved impractical*

OPPOSITE, TOP ROW *The North Front, in 'Country Life', 1902. The terrace is worthy of a Loire château. A marquess's coronet dates the pediment to after 1682*
BOTTOM ROW *An 18th-century plan shows the open loggia. The grandiose door on the south side (top) was pivotal to the Castle of the first three Dukes, as it led to the original entrance hall. For several decades the door served as an imposing entrance to the house from the chapel built in the Courtyard by the 5th Duke in 1849*

BELOW CIRCLE OF CHARLES D'AGAR
Portrait of a young man
One of the 1st Duke's sons, perhaps William (later Earl of March), whose Grand Tour drawings may have inspired his father

a great church builder, erected a chapel against the south wall of the quadrangle in 1849 – its pews are visible in an early photograph in *Country Life* magazine.

In 1902 the magazine referred to the lingering influence of Inigo Jones, dead some 30 years by the time the 1st Duke was building his palace. But a Loire château comes more readily to mind.

So what was the real inspiration behind the 1st Duke's palace? No one knows the answer to that, but it may lie with one of his sons. All three of them were profoundly influenced by the education of a Grand Tour. James, the future 2nd Duke, and William (later 1st Earl of March) went in 1680–84, George in 1686–93.

The boy in the portrait on the right is said to be William (Old Q's grandfather). 'William fences very well, better than his brother,' noted his tutor, Dr James Fall. But Fall encouraged his obvious interest in architecture, 'anxious to find a talent he could focus on… The book will never succeed with him but he is otherwise an excellent youth'.

In Paris in April 1681, William and James were 'designing by pencil', and by the time they reached Lyon, William knew he had found his métier. 'I have sent your lordship… a book of Mr William's handiwork,' Fall wrote to his father. The Loire châteaux of Menars, Blois, Chambord and Beauregard made a particularly strong impression. Sadly the sketches are lost, but it could well be that the Castle owes its idiosyncrasy as much to William's youthful love of Continental architecture as it does to its architect, James Smith, for whom Drumlanrig was his first commission.

The Inner Hall

This small hall is hung with family portraits and Fencible and Militia memorabilia

Right *Three generations of Dukes. Walter, 8th Duke of Buccleuch and 10th Duke of Queensberry, hangs in an alcove leading to the Duke's Study, below Felix Kelly's view of the Castle. John Ward RA painted Richard, the present Duke (centre), the week he became engaged to Elizabeth Kerr. Derek Hill painted Richard's father in a wheelchair soon after his riding accident in 1971*

Below *Duchess Elizabeth (Bizza), the present Duke's wife, seen here with a guitar, was painted by John Ward in 1993 at Dabton, the house near Thornhill where they brought up their children*

When you enter the Castle, it is a relief to find lots of pleasingly small rooms. The Inner Hall, which leads off the Front Hall, is in the Northeast Tower, where early plans show a chapel.

The three most recent generations of the family hang here together. Richard, the present Duke, is opposite his wife, Lady Elizabeth Kerr, both by John Ward and painted in 1979 and 1993 respectively. To the right is his father, Johnnie, 9th Duke, and, in the alcove to the left, his grandfather, Walter, 8th Duke, in the uniform of Captain General of the Royal Company of Archers, The Queen's Body Guard for Scotland, both by Derek Hill.

In 2021 this room, along with the adjoining corridor, was redecorated. Formerly an antiseptic white, its walls were lined with green brushed silk, which provides a rich background to

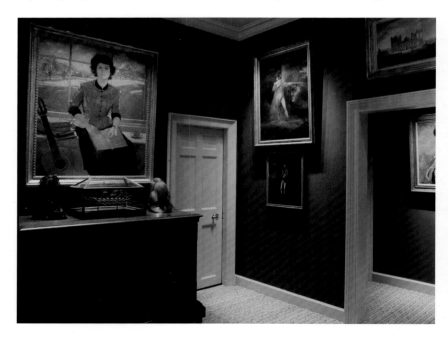

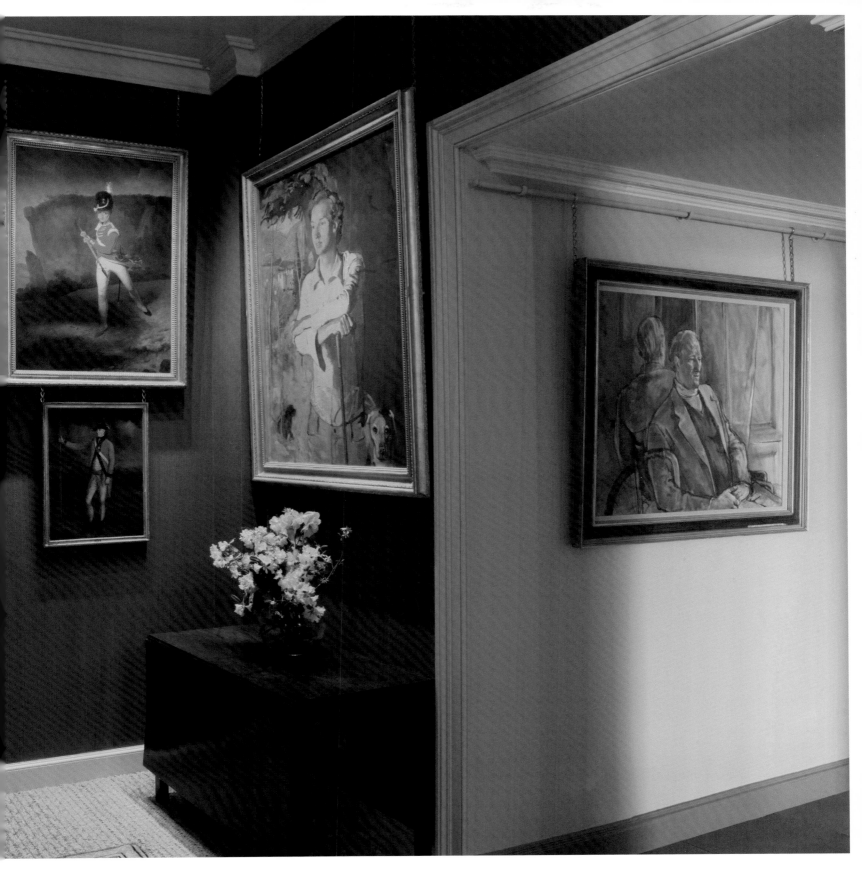

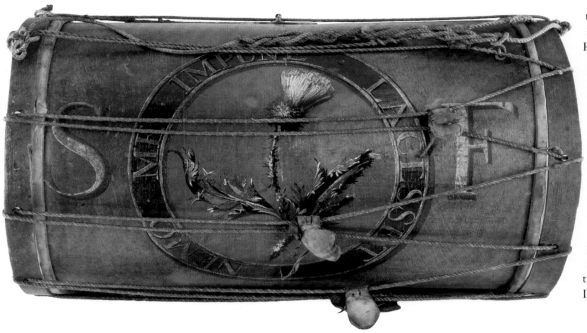

the scarlet uniforms and memorabilia associated with the Fencible and Militia Regiments raised in the 1780s and 1790s by Henry, 3rd Duke of Buccleuch, in response to fears of invasion from revolutionary France and its newly independent American allies.

Facing each other in the window are two fine 20th-century paintings that show Drumlanrig's spectacular setting with a backdrop of the encircling Lowther Hills. Edward Seago's conversation piece (page 25) shows the 8th Duke and his wife, Mollie, and their three children, while the tryptich panel by Jonathan Warrender (below left) is a bird's-eye view of the Castle with the present Duke's son, Walter, Earl of Dalkeith, as a young boy on the back.

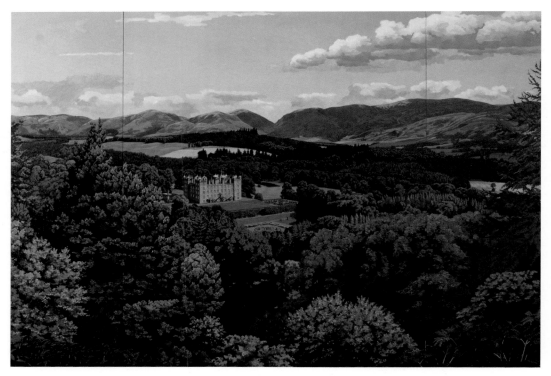

ABOVE LEFT *The regimental drum of the South Fencibles, on loan from Drumlanrig to the National Museum of Scotland*

LEFT JONATHAN WARRENDER (1954–)
Drumlanrig from the Southwest, 1993
Painted in the Flemish tradition of the bird's-eye view, this tryptich captures the Castle from Mount Malloch. The Warrenders descend from the Lord Provost of Edinburgh who proclaimed George I king in 1714. The 3rd Duke would no doubt have known him well

OPPOSITE MARTIN FERDINAND QUADAL (1736–1808)
Henry, 3rd Duke of Buccleuch, 1780
The Duke takes the salute at an Edinburgh parade of the South Fencibles, raised in 1778 to defend the country against invasion by America and its French and Spanish allies in the War of Independence. They were disbanded in 1783 after Britain recognised the United States in the Treaty of Paris

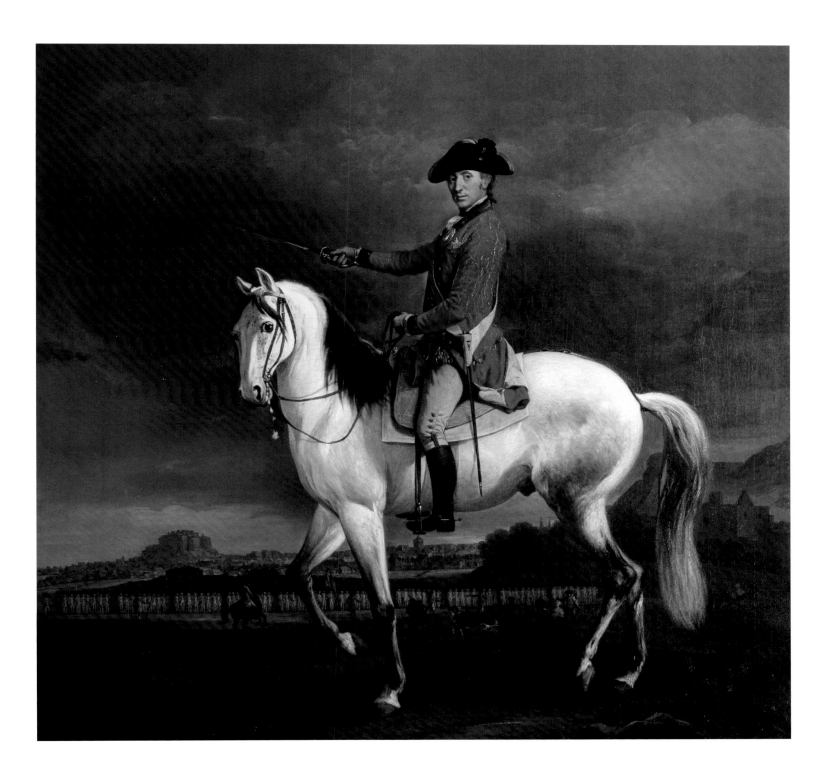

The Fencible and Militia regiments

Duke Henry raised the Southern Regiment of Fencible Men in North Britain at Dalkeith in 1778. It came to be known as the South Fencibles and consisted of a grenadier, a light infantry and eight battalion companies. In all, 1,120 men, drawn from Edinburgh, Dumfries and the Borders, volunteered to serve in any part of Britain. In 1779 they were guarding French prisoners of war in Edinburgh Castle and in 1780, the west coast of Scotland. The regiment was disbanded in 1783.

In a portrait by Quadal (page 45), the Duke appears with his regiment on a grey charger at a military review in Edinburgh. Quadal, a Moravian émigré, painted the Duke's eldest son, Charles – wearing the same red uniform, with its distinctive gosling-green facings – in the park at Dalkeith, then the principal family seat.

The Duke also helped to raise the Dumfries Militia (later the 10th North British Militia and 3rd Battalion of the Royal Scots). These two militia sergeants in action, by Danloux, hang in the Inner Hall, above two South Fencible soldiers attributed to Alexander Nasmyth. When conscription led to 'furious mobs' in 1797, the Duke had to leave his Duchess and daughters in 'the hands of my tenants' in Langholm, ready to cross the border.

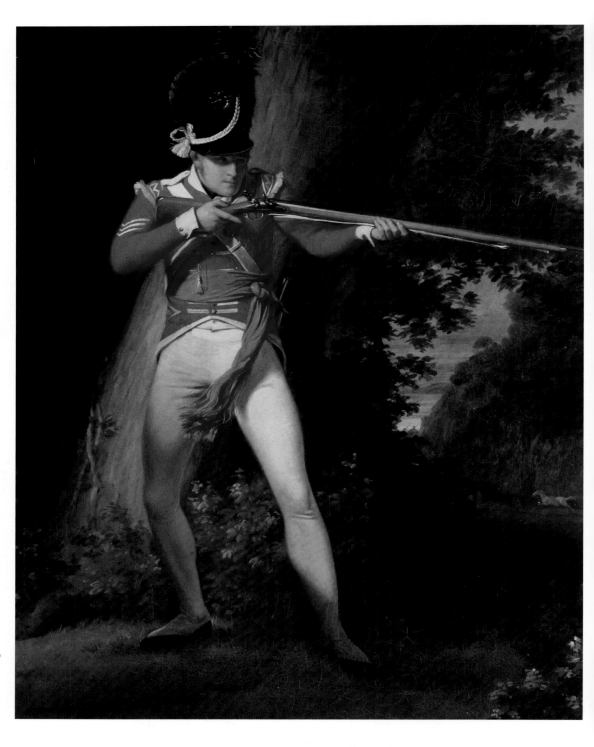

HENRI-PIERRE DANLOUX (1753–1809)
Sergeant Stevenson firing a musket and Sergeant Mather wielding a spontoon, 1799
Dumfries Militiamen painted for Henry, Lord Montagu (Duke Charles's brother, overleaf). Mather is labelled 'The perfect specimen of a British grenadier'

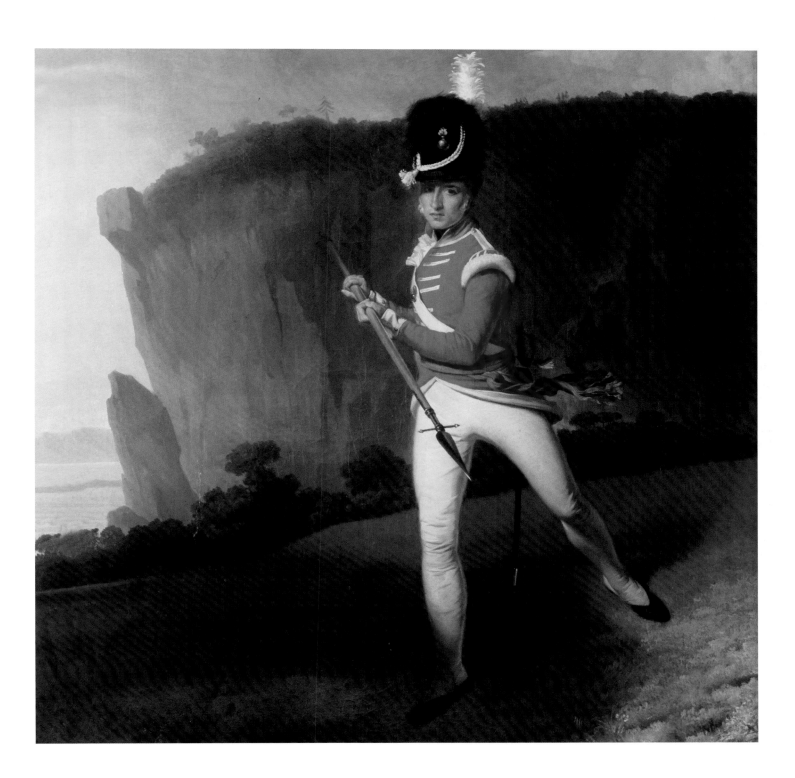

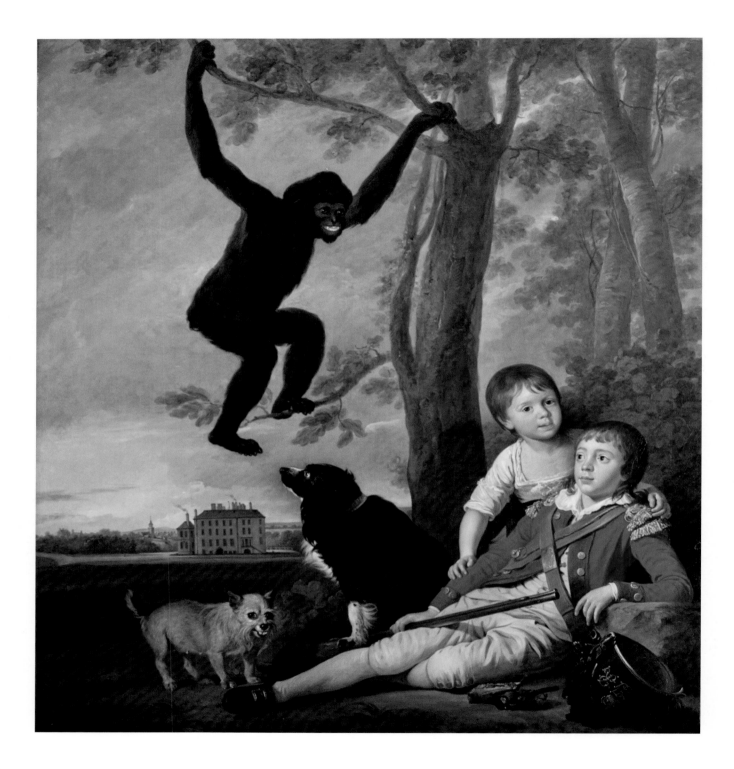

The East Corridor

Over the centuries the Castle, with its striking pale pink stone and spectacular setting, has proved irresistible to artists. The East Corridor is given over to a selection of watercolours, drawings and prints by those who worked at Drumlanrig. Among them was the present Duke's father, whose view from Mount Malloch hangs close to his portrait, but the earliest date from the mid-18th century and include Paul Sandby's engraving of the Castle (page 30). Most prominent by scale and number are the subtle watercolours by William Leighton Leitch, who was Queen Victoria's drawing teacher.

There are views from every angle, both of the Castle and from it. Generally, the sun is shining but a strikingly honest watercolour by the celebrated local painter Archie Sutter Watt shows it on a dark and glowering autumnal day.

This and the other well-lit corridors that run round much of the Castle were a significant innovation that allowed more private, less draughty individual rooms.

OPPOSITE MARTIN FERDINAND QUADAL (1736–1808)
Charles, Earl of Dalkeith, in Fencible uniform, with his brother, Henry, 1779
Quadal's charming portrait of the sons of Henry, 3rd Duke of Buccleuch, in the park at Dalkeith, includes their pet monkey, Jacko (in fact an ape), and their mother's dogs Toby and Jim. Dalkeith had a noted menagerie, including two live 'emusses'

received by Sir Walter Scott from a former gardener who had emigrated to Australia to build his own 'Abbotsford'. Charles became 4th and 6th Duke and rescued Drumlanrig after Old Q's years of neglect.

Quadal and Danloux were attracted to Edinburgh by the presence of the exiled French court after George III gave the Comte d'Artois (Charles X) refuge from his debtors in Holyroodhouse. Danloux has

been promoted by some art historians as the painter of one of Scotland's best-loved portraits, 'The Skating Minister', hitherto attributed to Sir Henry Raeburn – Holyrood was in the parish of the painting's subject, the Rev. Robert Walker

ABOVE *The flagged East Corridor, with its views of Drumlanrig and Nithsdale, leads to the Great Oak Staircase Hall*

The watercolours

The Scottish watercolourist W. L. Leitch (1804–83) painted eight atmospheric views of Drumlanrig for the 5th Duke and Duchess in 1843–44 (opposite, top and bottom left). He remained a family favourite: in 1888 Queen Victoria thanked Duchess Louisa (wife of the 6th Duke) for 'beautiful watercolour drawings by my dear old drawing master which do indeed remind me of happy bygone days for ever engraved in my heart and memory'. The sketching party (above) and the angler (far right) were painted c. 1858 by Philip Sheppard (1835–95). An unknown guest painted the view inscribed 'From my window, Drumlanrig, Sep 29, 1855' (right).

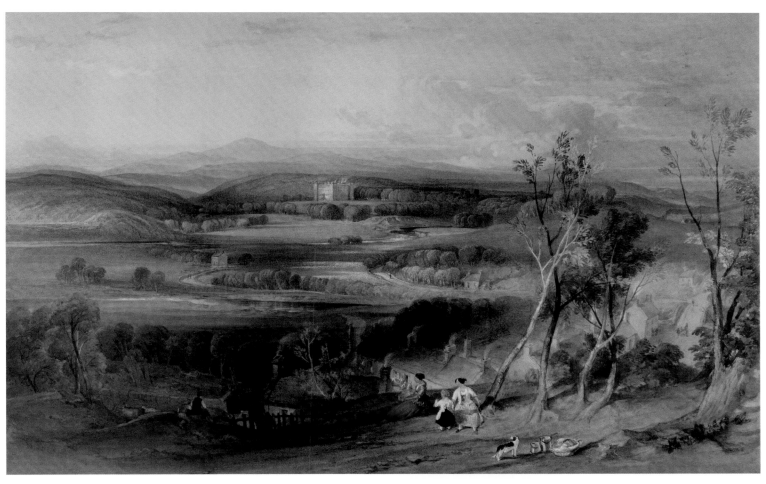

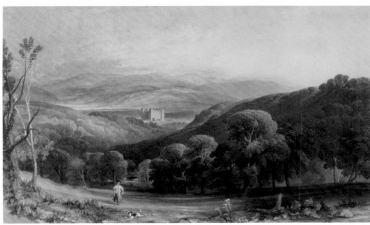

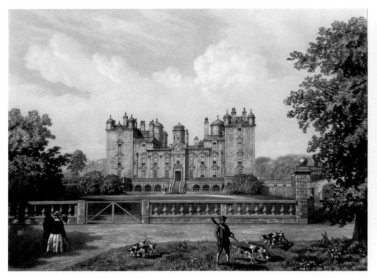

TOP LEFT *The straight staircase that briefly replaced the Horseshoe Staircase after 1813 appears in this watercolour by an unknown artist. Duchess Charlotte Anne had the stairs restored to their original form in 1860 (page 20)*

ABOVE LEFT *A watercolour by Archie Sutter Watt (1915–2005) captures the North Front under a dark, autumnal sky. The artist lived for 55 years in the village of Kirkgunzeon near Dalbeattie*

ABOVE RIGHT *A brilliant drypoint engraver, Archie Sutter Watt deftly drew the view from Mount Malloch. Admired for both his still lifes and his Galloway landscapes, he was an inspiring teacher*

TOP RIGHT *Hanging in a nursery bedroom, 'The Enchanted Tree' has been the stuff of dreams for generations. One of a group of six watercolours, it was painted in 1873 by the illustrator Dickie Doyle, one of Arthur Conan Doyle's artist uncles*

OPPOSITE *'The Scots Greys' (bottom) by Thomas Rowlandson (1756–1827) is one of a small group of incidental country scenes. 'A loaded waggon with a team of eight horses' (top right) is by Samuel Howitt (1757–1822), who married Rowlandson's sister and painted animal portraits. The woman on horseback with the charming cow and dog is by the Amsterdam-born Peter La Cave (1769–c.1811), a watercolourist who settled in England in around 1789*

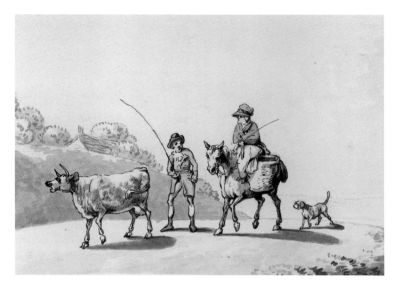

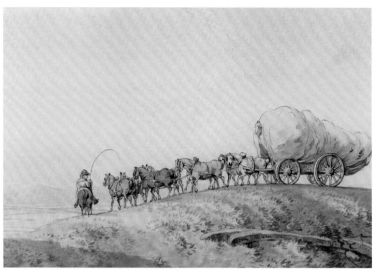

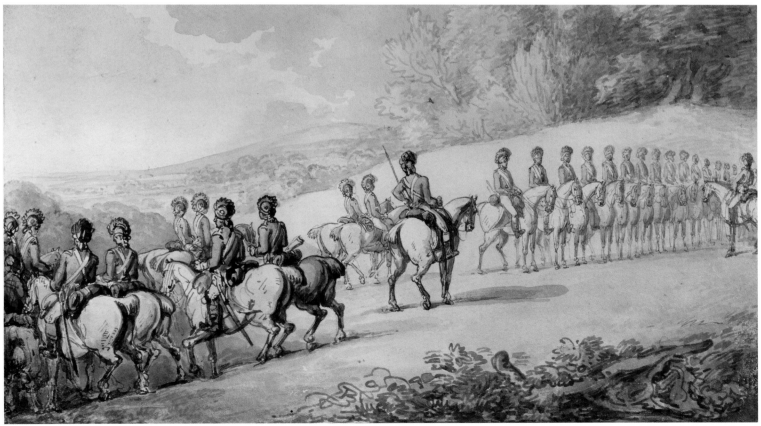

The Great Oak Staircase Hall

Once the free-standing staircase had been added in 1697, the Staircase Hall on the South Front would become one of the Castle's most beautiful – and unexpected – spaces, filled with Renaissance and post-Restoration paintings

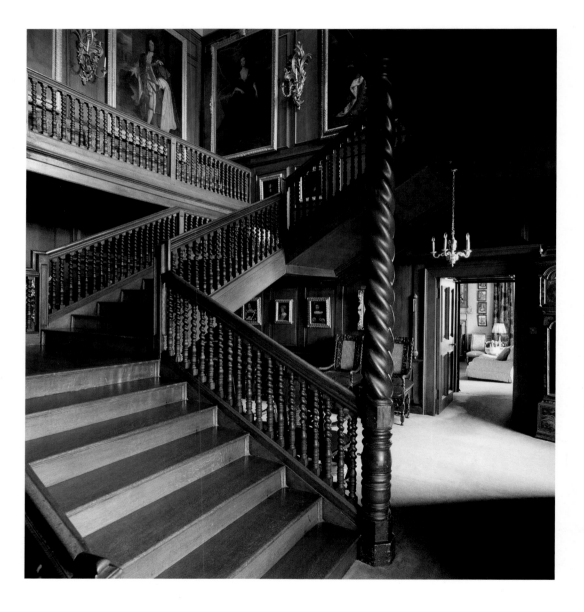

Access to the formal rooms of the South Front is by the Great Oak Staircase. The dark panelling and inviting views into the Dining Room and Morning Room on the ground floor, and upstairs all the way through the Drawing Room to Bonnie Prince Charlie's Bedroom, make this hall one of the most atmospheric spaces in the Castle. Light pours in from the south through three storeys of windows. One disguised door gives as if by magic onto a balcony, a favourite place to catch both the morning and evening sun, with steps down to the garden.

When James, the well-travelled 2nd Duke, ordered this free-standing staircase – still a novelty in Scotland in 1697 – it appears to have extended into what was then the front hall, now the Dining Room. Duchess Charlotte Anne remodelled it in 1842, turning the bottom flight at a right angle and giving the staircase its own hall.

The lower walls lend themselves perfectly to a set of gem-like Renaissance paintings including an impressive portrait, by a contemporary of Hans Holbein's, of Henry VIII's Master of the Horse, Sir Nicholas Carew (page 59). A boyhood friend of the King's, Carew was executed in 1539 on charges of conspiracy.

The upper walls, with their swirling, gilded candelabra, provide an august setting for the Royals closely associated with the 2nd Duke and Duchess of

LEFT *Looking through to the Morning Room*
RIGHT *Originally, the lower flight of steps was flanked by two barley-sugar columns and ended in the Dining Room (the Castle's old entrance hall). The 2nd Duke, who built the staircase, would have seen similar columns in Rome. Murillo's Madonna on the wall at the foot of the stairs was bought by the 3rd Duke and Duchess of Montagu*

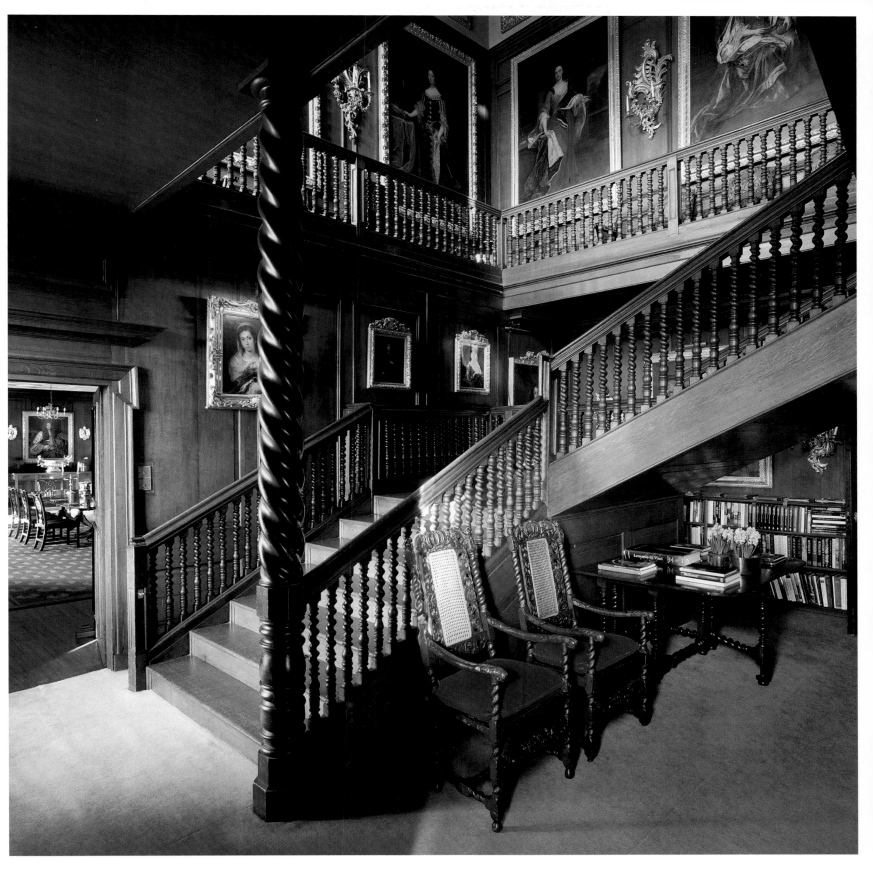

Queensberry. By the Drawing Room
door are portraits of William and Mary
(obscured by the chandelier), which
Mary's sister, Queen Anne, presented to
the Duke and Duchess. An enthroned
Queen Anne is on the right between the
Queensberrys. It is a mark of the esteem
in which they were held that Kneller
portrays them on the same scale.

The gallery running round the walls
below these portraits appears to be there
for viewing purposes only, but in fact
the 2nd Duke's portrait conceals a secret
door to the Southeast Tower stairs.

The equestrian painting of William III
that so irked Bonnie Prince Charlie's
Highlanders (page 89) is on the ground
floor, hidden in part by the stairs.
Notably absent is Queen Mary's father,
James II, whom the 2nd Duke had
helped to depose. But James's consort,
Mary of Modena, though not seen here
(see page 86), gains a place at the top of
the stairs thanks to Anna, Duchess of
Buccleuch, who had been her lady-in-
waiting. The portrait hung in pride of
place in the Queen's Room at Dalkeith.

Mary of Modena would have been
amazed to see the 16-arm chandelier
here with its sea serpents and mermaids
– 54kg of solid silver. It has been
identified as the one sold by the Dutch
silversmith John Cooqus to Charles II's
Queen, Catherine of Braganza, for her
Whitehall Palace drawing room in 1669.
Mary knew it well, as she enlarged it
in 1686. Sold from the Royal Collection
in 1832, it was bought by the 5th Duke
of Buccleuch from Garrard.

*Kneller's portraits dominate the oak-panelled
walls. William and Mary hang to the left of the
2nd Duchess of Queensberry and Queen Anne.
When the 5th Duke bought the chandelier in
1835, Robert Garrard added a ducal coronet*

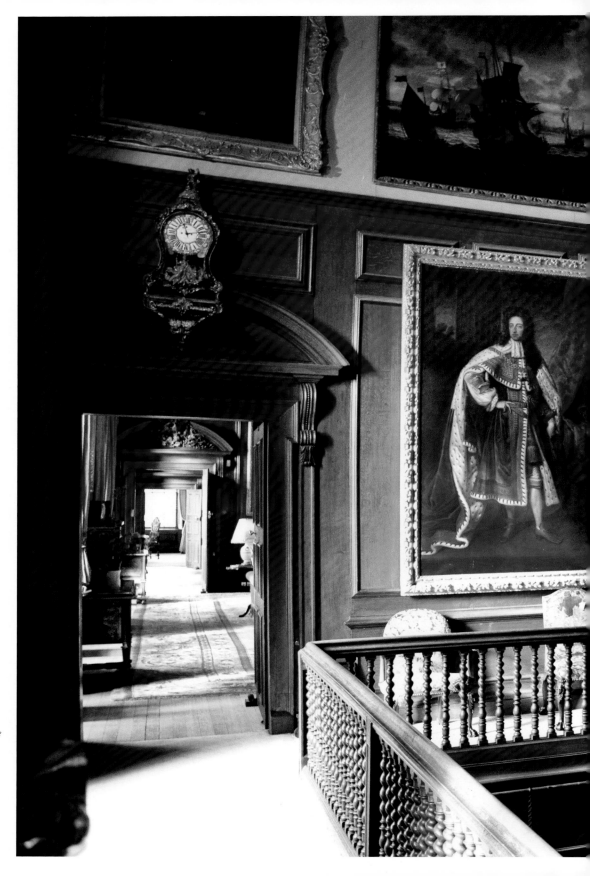

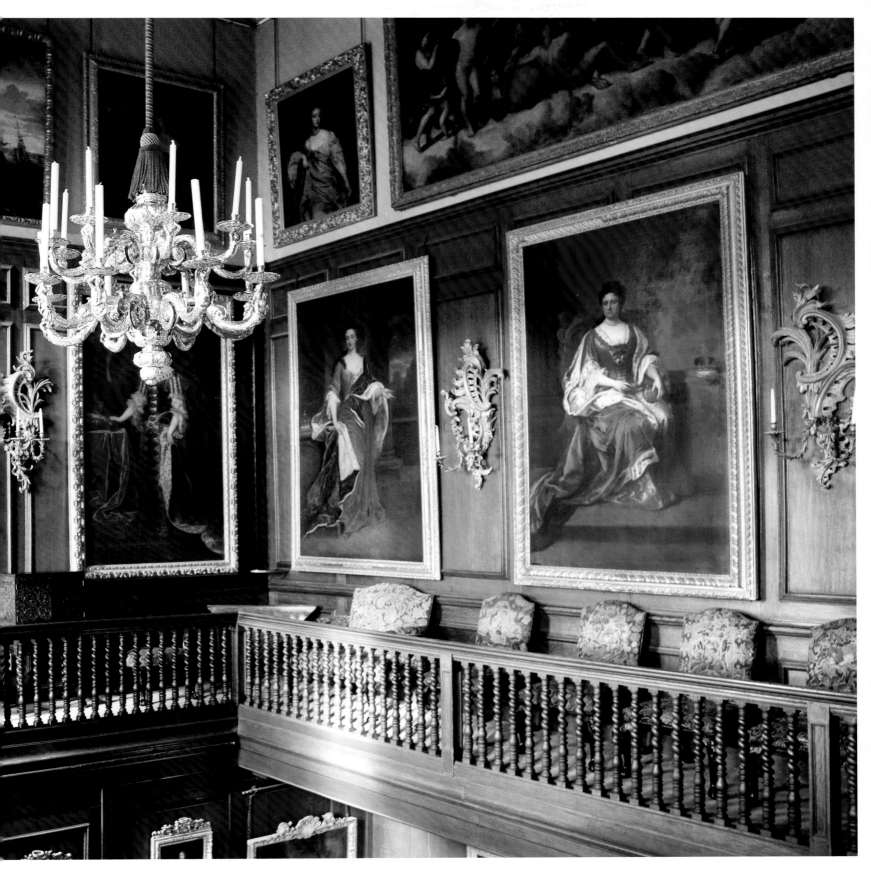

Renaissance portraits

*The upper gallery of the Great Oak Staircase is
hung with Restoration grandees. Downstairs
is the courtly art of the Northern Renaissance*

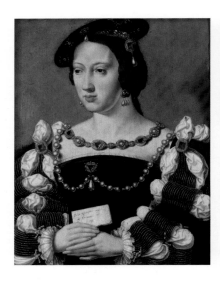

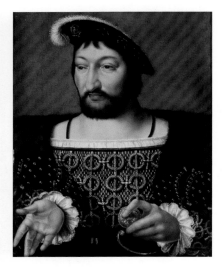

OPPOSITE ASSOCIATE OF
HANS HOLBEIN THE YOUNGER
Sir Nicholas Carew (d. 1539)
*Resplendent in shining armour with a
black cap trimmed with a white plume
over a cloth-of-gold turban and brown
slashed breeches, Carew was Henry VIII's
Master of the Horse. Elizabeth Montagu,
wife of the 3rd Duke of Buccleuch, bought
the painting for 10 guineas from a sale at
Lumley Castle in County Durham in 1785,
apparently by mistake. Passing through
on her way to Scotland, she had spotted
two paintings she wanted to buy – in this
instance, the agent purchased the wrong one*

BERNAERT VAN ORLEY (C. 1488–1541)
Eleanor of Austria (1498–1558)
*One of a pair of portraits said to have been
given to the Duke of Monmouth by Charles II.
The Holy Roman Emperor Charles V's
sister was betrothed to the future Henry VIII.
But when he became king, Henry married
her aunt Catherine of Aragon instead.
Eleanor married Manuel I of Portugal, who
died of the plague, then Francis I of France*

CIRCLE OF JOOS VAN CLEVE (C. 1485–1540)
**Francis I, King of France
(reigned 1515–47), c. 1530**
*Francis I, arch-rival of Henry VIII and
ally of the Ottoman sultan Süleyman the
Magnificent, is in his 30s here. Francis
convinced Leonardo to move to France,
bringing the 'Mona Lisa' with him. His
father-in-law, Louis XII, owned the
'Madonna of the Yarnwinder' (page 224)*

RIGHT MASTER OF THE MAGDALEN
LEGEND (ACTIVE C. 1483–C. 1527)
**Jacques de Vendôme, Prince de
Chabanais, Vidame de Chartres (d. 1507)**
*Vendôme was Louis XII's 'grand-maître
des eaux-et-forêts', one of France's most
prestigious offices. Here he is seen in a cap
bearing the badge of the Virgin Mary*
FAR RIGHT AFTER JAN GOSSAERT,
CALLED MABUSE (C. 1478–1532)
**Anna van Bergen, Marquise de Veere, and
her son Hendrick as the Virgin and Child**
*Mabuse acquired a Leonardo-esque polish
when he accompanied Philip of Burgundy
to Italy in 1508. He established the custom
for Flemish artists to study in Italy, which
lasted into the age of Rubens and Van Dyck*

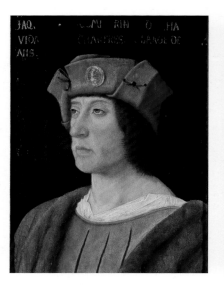

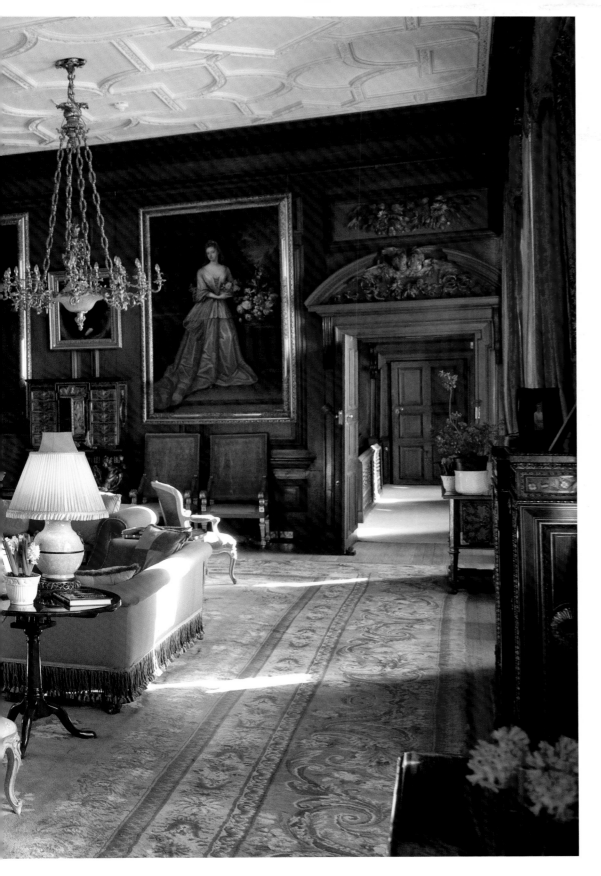

The Drawing Room

Originally the Great Dining Room, Drumlanrig's Drawing Room is the grandest room in the Castle

State rooms befitting a ducal palace, Dumlanrig's formal rooms are laid out in an enfilade along the first floor of the South Front. The grandest, once the Great Dining Room, is now the Drawing Room, gracious but far from stiff. This splendid room is dominated by a colour scheme of rich reds set off by dark oak panelling and elaborate woodcarvings, complemented by Louis XV giltwood fauteuils covered in Aubusson tapestry. Card tables, with jigsaw and backgammon board in place, await for the amusement of house parties retiring after dinner. Above the marble fireplace, probably

THE DRAWING ROOM, LOOKING EAST
The set of giltwood fauteuils covered in Aubusson tapestry are by Jean-Baptiste Lebas (1729–1800). The bureau-plat on the left is by a follower of Boulle and probably belonged to Duchess Anna

THE PORTRAITS *To the right of the fireplace are the Duke of Monmouth and Buccleuch in Garter robes, after Sir Peter Lely; John, 2nd Duke of Argyll, in armour, and Sarah, Duchess of Marlborough (mother of the 2nd Duchess of Montagu), both by Sir Godfrey Kneller. The portrait of Lady Anne Scott, by the door, is attributed to Charles d'Agar*

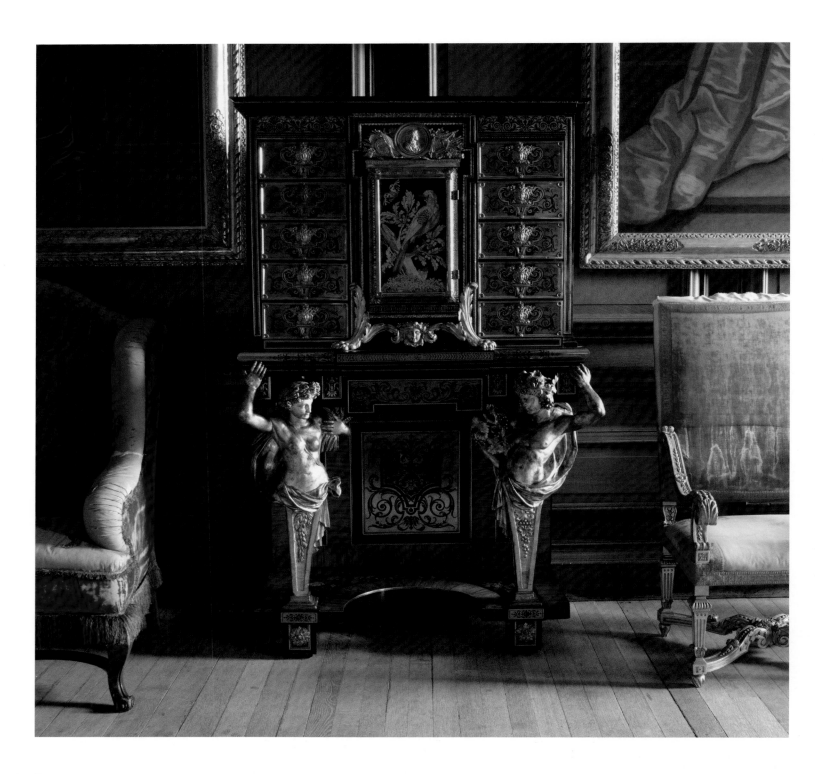

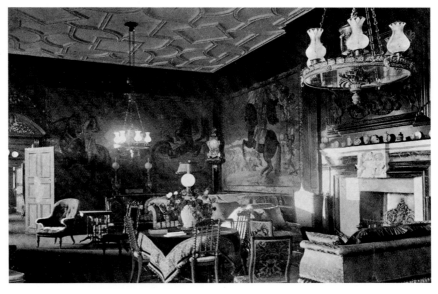

THE DRAWING ROOM IN 1905
ABOVE *This photograph from 'The Car
Illustrated' (published by a Buccleuch
cousin, John, Lord Montagu of Beaulieu)
shows the tapestries bought for the room by
the 1st Duke from Roger Jones, a Flemish
weavers' agent, in 1685, now in storage. On
a towering scale, they depict horses being
trained at Bolsover Castle's famous Riding
House, built by the royalist general William
Cavendish, Duke of Newcastle, who had
introduced the art of dressage to England
after the Restoration. The 1st Duke, having
attended the Academy of Saumur on the
Loire, famed for its riding school, was keen
to claim the kudos attached to dressage*

OPPOSITE *One of the two Louis XIV Boulle
cabinets in the Drawing Room: this one
opens to reveal drawers, supported by figures
representing Summer and Autumn*
LEFT *The cabinet is inlaid with brass,
pewter, tortoiseshell and various woods in
extravagant contre-partie marquetry*

by John van Nost, are woodcarvings
rescued from the Gallery that once ran
the length of the North Front, when it
was turned into bedrooms. They were
wrongly thought to be by Grinling
Gibbons and replaced a painting of
The History of Scipio similar to the one
of *Hercules at Rest* in Bonnie Prince
Charlie's Bedroom (page 79). In fact the
1st Duke had employed some obscure
woodcarvers named Bonis and Hunter.

It is easy to miss the ornately carved
pediments over the doors, which are
original to the room, vestiges of a
grand processional way leading to the
Withdrawing Room, now Ante-Room,
and the State Bedchamber beyond.

The 1st Duke's Great Dining Room
was originally hung with equestrian
tapestries depicting William Cavendish,
Duke of Newcastle's manège at
Bolsover Castle. Since 1930, when
paintings at Dalkeith Palace and
Montagu House were dispersed to
the other family houses, these giant
depictions of horses have ▷*p.67*

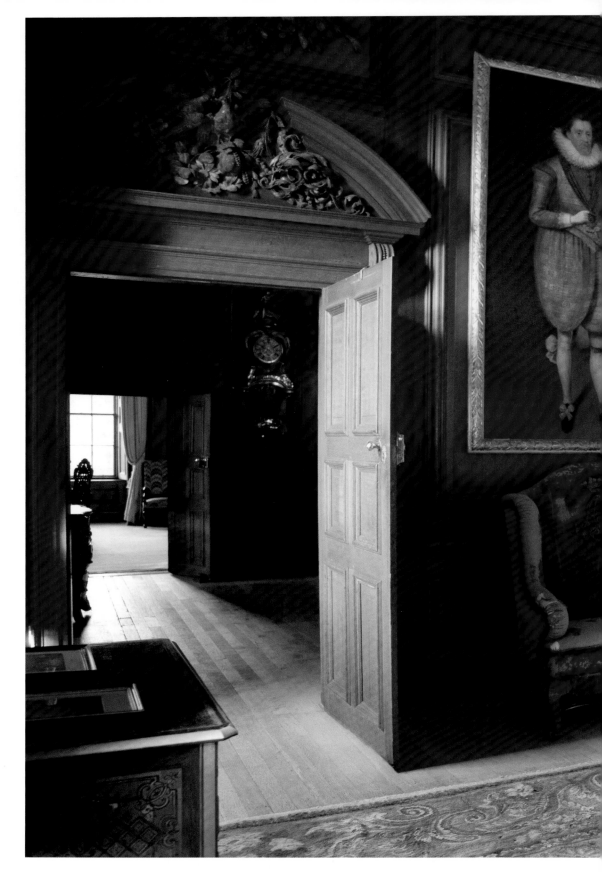

THE DRAWING ROOM, LOOKING WEST
This magnificent Boulle cabinet from Versailles, the larger of the two in the Drawing Room, is flanked by fine velvet settees bearing the 'AB' monogram of Monmouth's wife, Anna, Duchess of Buccleuch. The ornately carved pediments above the doors at either end of the room are part of the 1st Duke's original decoration

THE PORTRAITS *Above the cabinet is a portrait of Charles II, Monmouth's father, by the studio of Sir Peter Lely. Either side of him are James VI of Scotland and I of England, who visited Drumlanrig in 1617, and his Queen, Anne of Denmark, by the studio of Paul van Somer. To the right is Francis, 2nd Duke of Buccleuch, in blue coat and red waistcoat, with the star and sash of the Thistle, by Allan Ramsay (1713–84). Out of sight is John, 2nd Duke of Montagu, in scarlet uniform, by John Shackleton (died 1767). Below them are photographs of the present Duke and his father as royal pages in similar uniform – some fashions are timeless*

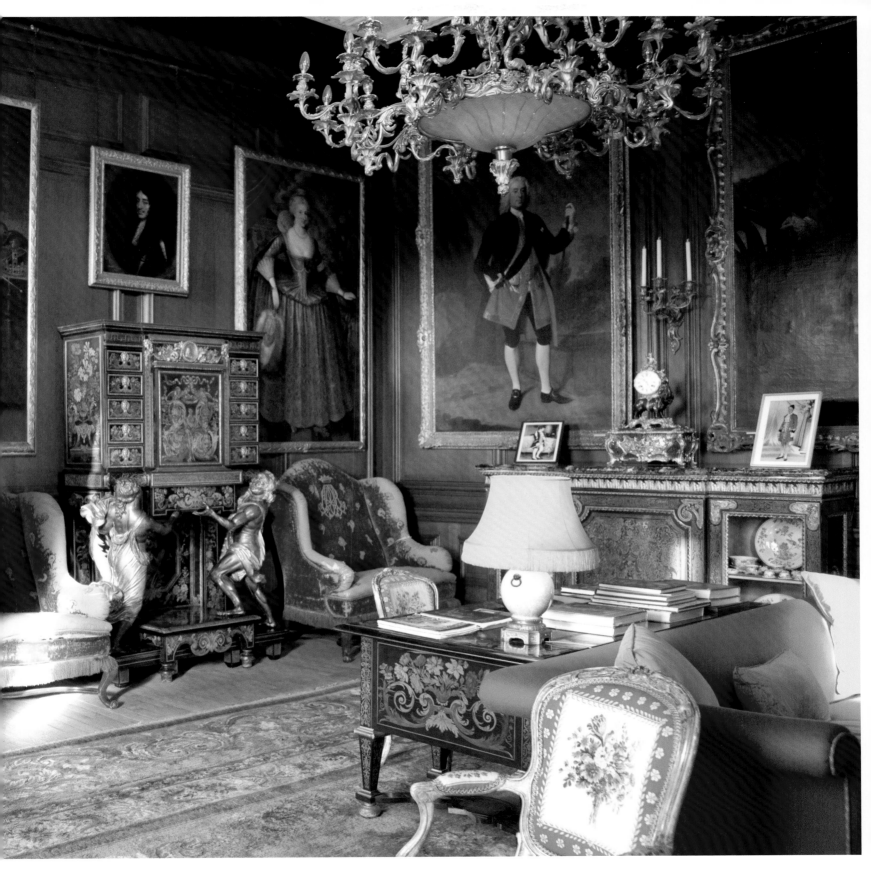

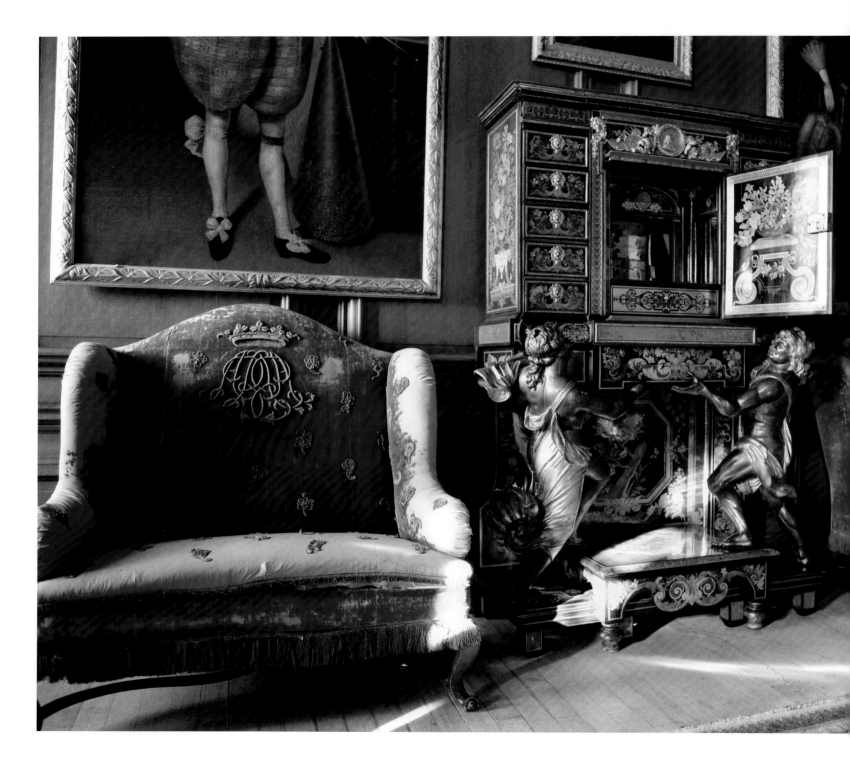

been replaced by full-length portraits of figures in rich attire, including King James VI of Scotland and I of England with his pearly Danish bride; and the dashing Duke of Monmouth in full Garter regalia.

But stealing the show are two great cabinets at either end of the room by the renowned André-Charles Boulle. Once thought to be a gift of Charles II to his son Monmouth, they had been at Dalkeith since the 18th century. Probably made for Louis XIV, the larger one, supported by Hercules and his mistress Omphale, stands below a portrait of Charles. Its woodwork marquetry contrasts with the dazzling metalwork of the one opposite, beneath a portrait of Monmouth.

THE SUN KING'S CABINET
LEFT *Omphale, Queen of Lydia, and Hercules support the larger of the two Versailles cabinets by André-Charles Boulle* RIGHT *The door opens to reveal a painted garden framed by columns. Family tradition held that it was a gift from Louis XIV to Charles II, who in turn gave it to the Duke of Monmouth. While that is implausible, it is certainly a royal piece, decorated with a medallion of Louis at the top, aged 21, after a 1663 coin by Jean Varin, and another of the sun with the inscription 'Le Roi Soleil' inside*

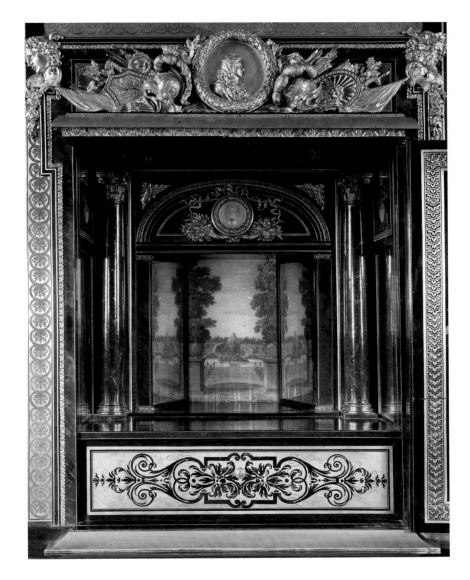

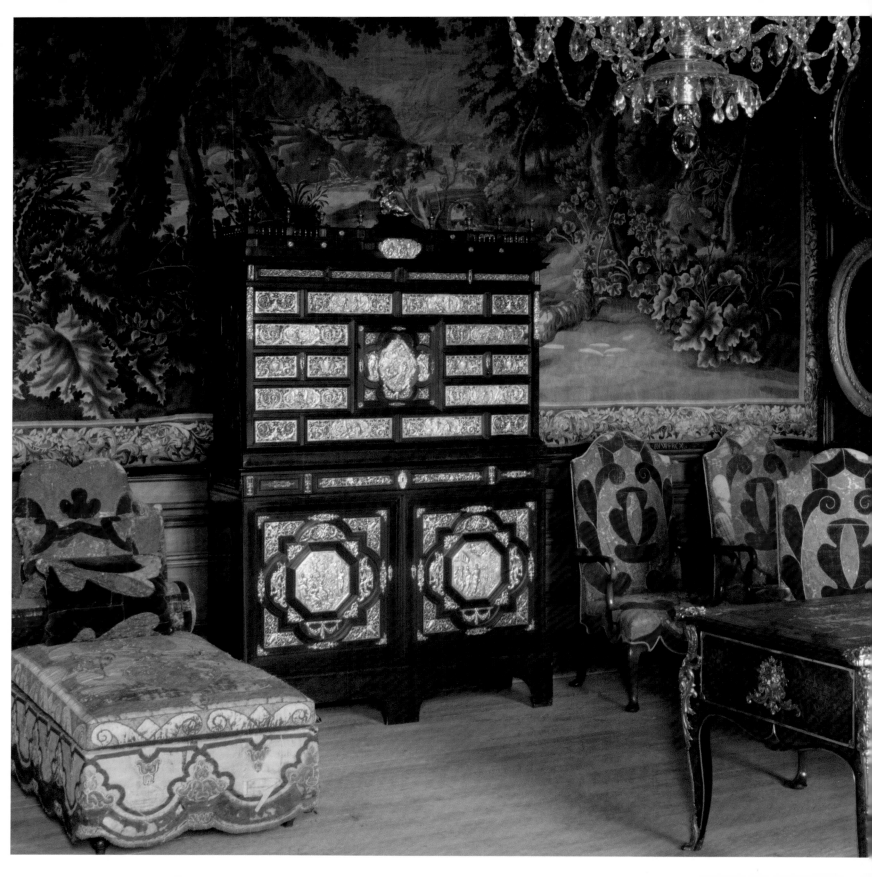

The Ante-Room

*The 1st Duke's former Drawing
Room is one of Drumlanrig's
most atmospheric rooms*

Following the Victorian changes to the layout of the Castle, the 1st Duke's Drawing Room took a step back in favour of its neighbour to become the Ante-Room. The title belies what remains the most satisfying of rooms, particularly since its reorganisation in 2019.

Beautifully proportioned, with a fine fireplace, the room's tone is set by the exceptional late-17th-century walnut chairs and daybed in their original crimson velvet coverings. Their silver-thread embroidery may have tarnished but they comfortably hold their own with the gleaming gilt plaques on the contemporary ebony cabinet, the metalwork marquetry of Charles Cressent's clock, and the huge 19th-century Boulle writing desk in the centre of the room. Soaring between the windows, the breathtaking *verre églomisé* ▷*p.72*

COURT APPEARANCE
*Velvet-covered chairs for courtiers and
a Charles II daybed in the original state
Drawing Room. The Brussels tapestry
by Albert Auwercx (c.1629–1709) was
recorded here in 1694. Mythological gilt
plaques decorate a large ebony Louis XIII
cabinet. A Chinese-export chess set on the
Boulle 'bureau plat' awaits the first move.
The two right-hand portraits are of the
2nd Duke and Duchess of Queensberry*

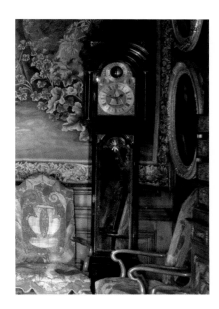

ABOVE *The phases of the moon are shown in the early-18th-century longcase clock, signed by a London clockmaker who styled himself 'John Topping Memory Master'*

RIGHT *The gilt plaques on the ebony cabinet are based on Antonio Tempesta engravings*

OPPOSITE *The 18th-century velvet covers of the high-backed walnut chairs glow in sunlight reflected off the wooden floor. Above are portraits of Margaret, Countess of Buccleuch, Anna's mother, by the studio of Lely (top left); the 1st Duke of Queensberry, attributed to John Riley (top right); and a man in armour thought to be one of his three brothers (bottom left) – all were killed in action and painted posthumously by the Scottish artist David Scougall (c.1610–80). The fourth portrait (bottom right) appears to be of Henry Boyle, Lord Carleton, brother of the 2nd Duke's wife*

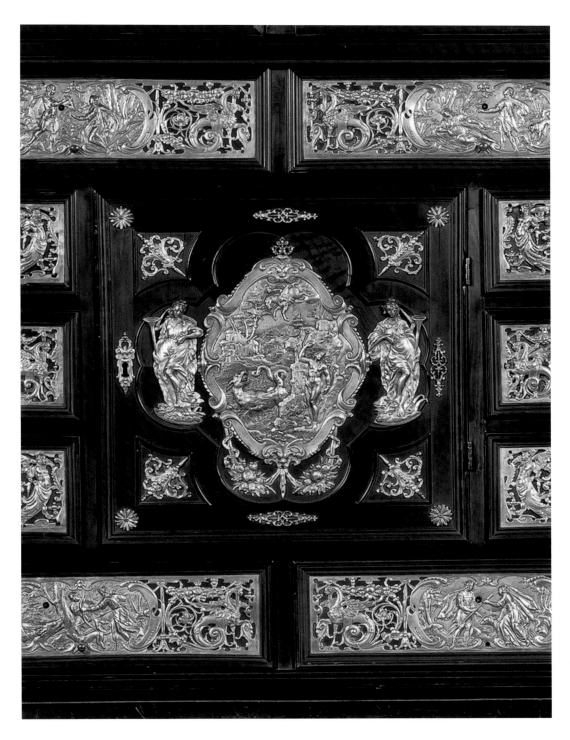

mirror, one of the Castle's greatest treasures, bears, like its two companions next door, the Argyll arms, inherited through the 3rd Duke of Buccleuch's mother, Lady Caroline Campbell.

Above the fireplace her cousin Lord Frederick Campbell adds a touch of dash and colour to the room's otherwise rather predictable family portraits. A 17th-century Brussels tapestry, one of 'four pieces of landscape of beasts and birds' purchased by the 1st Duke, takes us back to how the room might have looked when it was created.

RIGHT *The dark oak panelling is a fine foil for glittering highlights: the white marble fireplace with brass andirons, the George III chandelier, and the tortoiseshell and brass bracket clock by Charles Cressent (1685–1768), whose Régence style broke with the pomposity of Louis XIV's court*

BELOW CIRCLE OF SIR GODFREY KNELLER
Lord Frederick Campbell (1729–1816)
A son of the 4th Duke of Argyll, and the 3rd Duke of Buccleuch's maternal great-uncle. Originally, a Classical scene painted on leather was set into the oak panelling

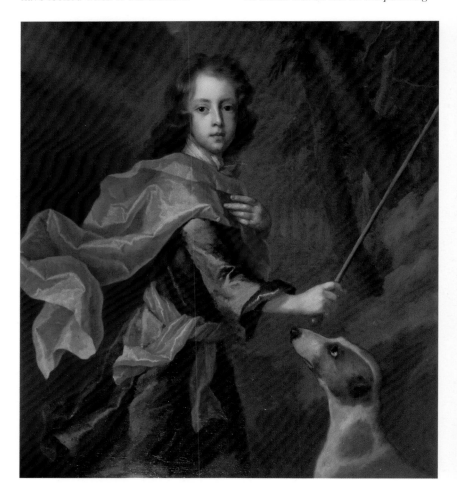

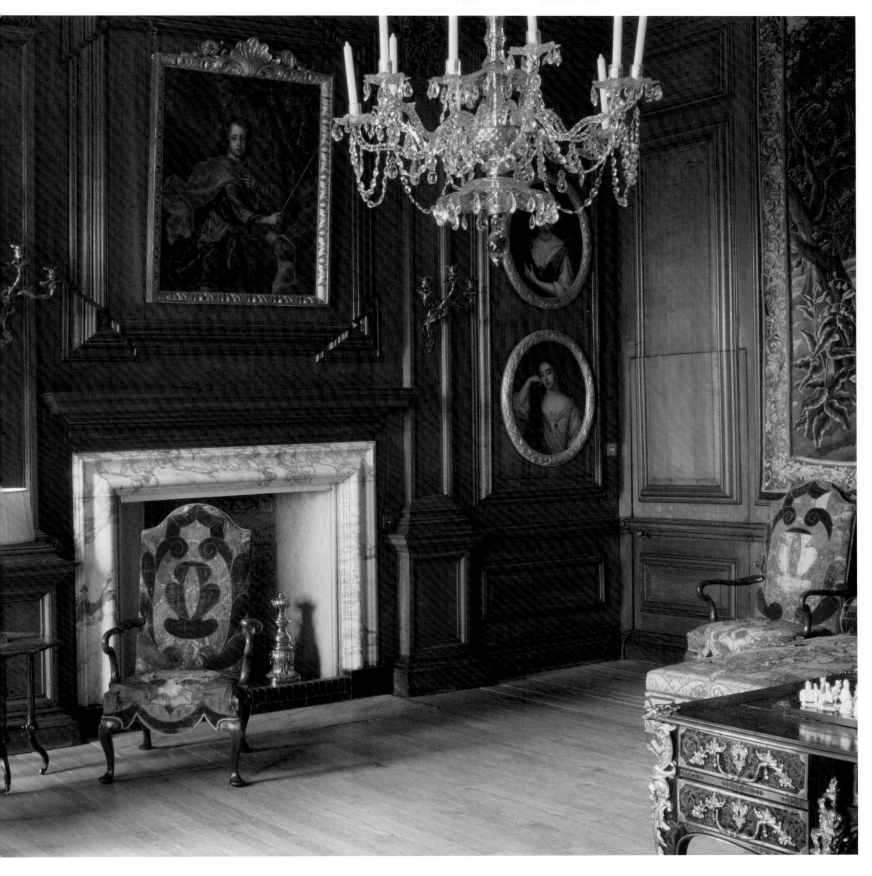

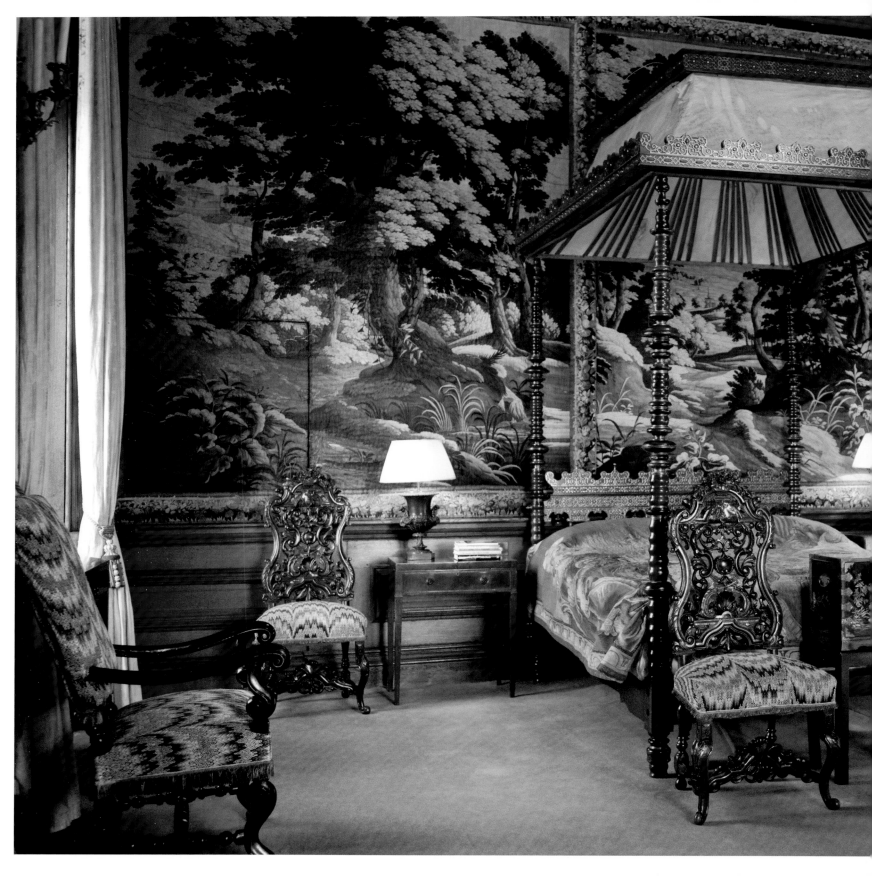

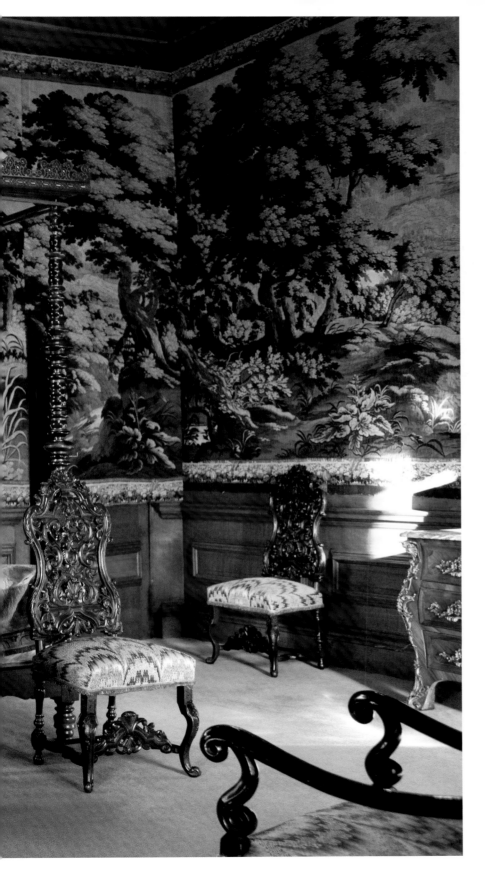

Bonnie Prince Charlie's Bedroom

With its 17th-century tapestries and furniture, the State Bedchamber is very much of its time

The State Bedchamber, the last room in the enfilade of 17th-century rooms on the first floor, takes its name from an uninvited guest, the grandson of James II, Prince Charles Edward Stuart, the Young Pretender. His portrait by Liotard with his brother Henry (overleaf) is one of the masterpieces in the Buccleuch collection of miniatures. Bonnie Prince Charlie stayed on December 22, 1745, during his retreat north – to the horror of James Fergusson of Craigdarroch, the 3rd Duke of Queensberry's chamberlain.

The Prince's 2,000 Highlanders bedded down on straw in the Castle, consumed sheep from the park, which they slaughtered at the foot of the stairs, bayoneted Kneller's equestrian portrait of William of Orange on the Great Oak Staircase (page 89) and broke down doors. 'May God grant there may never again be any such guests here,' Fergusson wrote to the Duke.

A strong late-17th-century feel pervades the room, from the Brussels tapestries of river landscapes (purchased specially by the 1st Duke in 1685) to the Japanese black lacquer cabinet at

LEFT *The tapestry-lined State Bedchamber with its 17th-century rosewood bed*

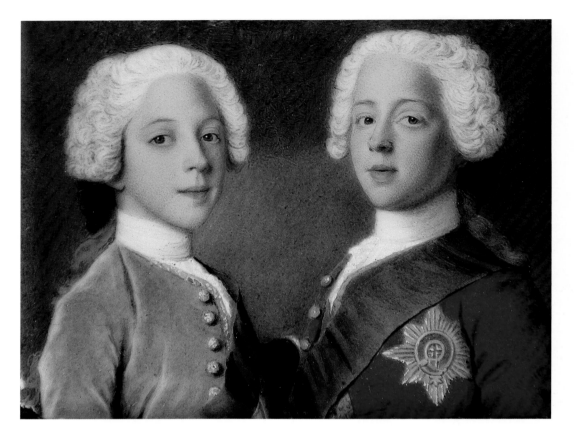

the foot of the bed, and the Dutch or
Portuguese colonial rosewood bed
itself, with its elegant coved canopy
and spiral columns. The high-backed
chairs are in the manner of Daniel
Marot, the Huguenot arbiter of taste
at William and Mary's court.

In 1692 a little-known London-
based Huguenot, Nicolas Heude,
was invited to Drumlanrig to paint
Classical scenes on leather to be set
into the oak panelling above the
fireplaces of all the state rooms. The
painting in the Bedchamber shows
Hercules at rest after his feats.

The original state bed was
destroyed at the start of the 19th
century when much of the original

furniture was consigned to a bonfire.
It had blue velvet drapes, with gold
satin lining, and was supplied in 1685
with matching furniture by the
London upholsterer John Hibbert,
who worked for the royal household.
James Simpson remembered it as
'a perfect marvel of the beautiful in
art, and worth a pilgrimage itself
to look upon'. Some of the silver
braid was made into a plate and set
into a curling stone.

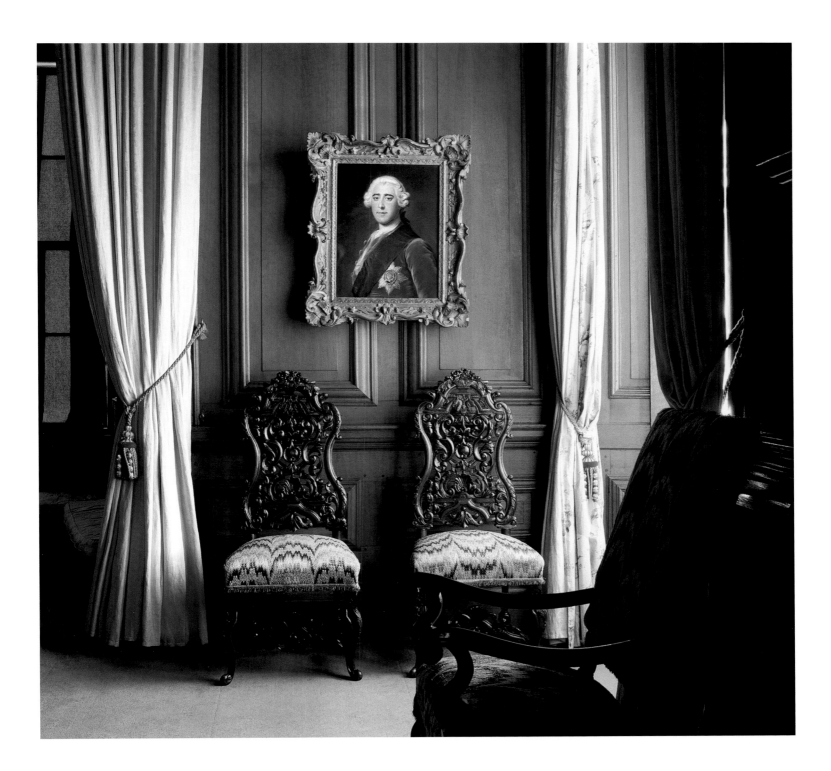

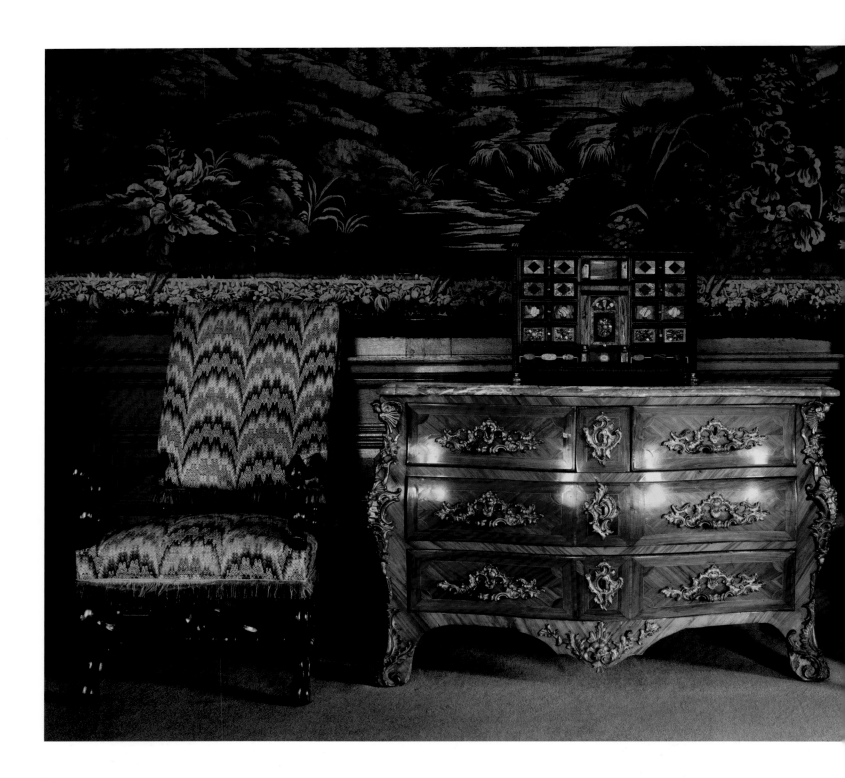

LEFT *The jewel-like pietra dura table cabinet is Florentine and was probably purchased in 1692, during the ambitious Grand Tour undertaken by the 1st Duke's youngest son, Lord George Douglas (page 150). He died tragically young, not long after his return, leaving a promising diplomatic career unfulfilled. His great collection of books was left to the Advocates' Library in Glasgow. The cabinet rests on a tulipwood and kingwood Régence commode with portasanta marble top by Pierre Roussel of Paris (1723–82), stamped 'P. Roussel JME'*

BELOW NICOLAS HEUDE (D. 1703)
Hercules at rest, 1692
The bedroom has kept the original painting set into the panelling over the chimneypiece. It was painted on leather by the Huguenot Nicholas Heude, who was paid £15 a month to paint pictures for all the state rooms

FOLLOWING PAGES THE WEST FRONT *Bonnie Prince Charlie's Bedroom looks out from the Southwest Tower on the right. On the left, stone stairs lead up to the terrace of the North Front*

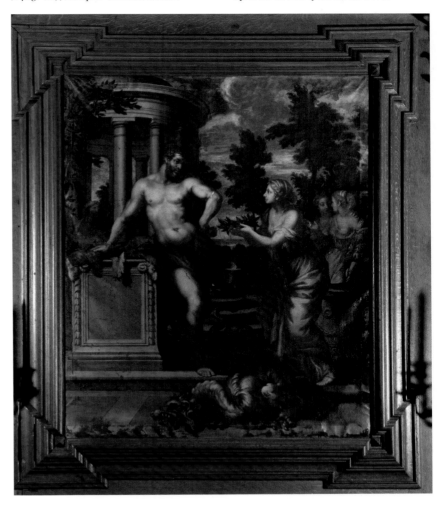

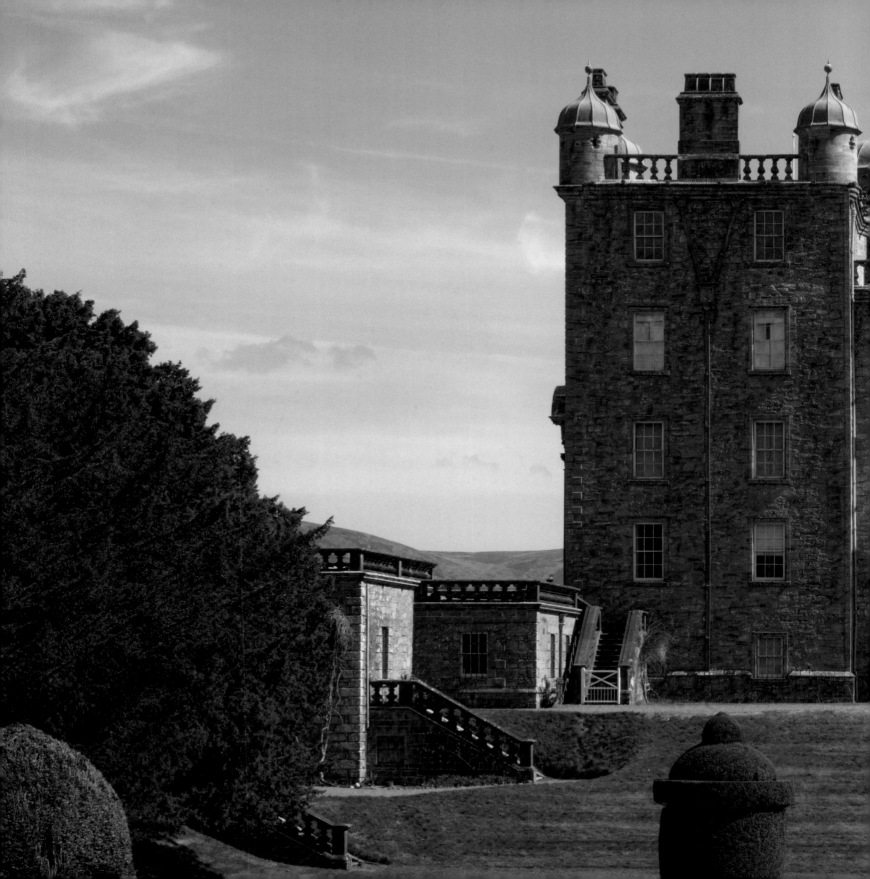

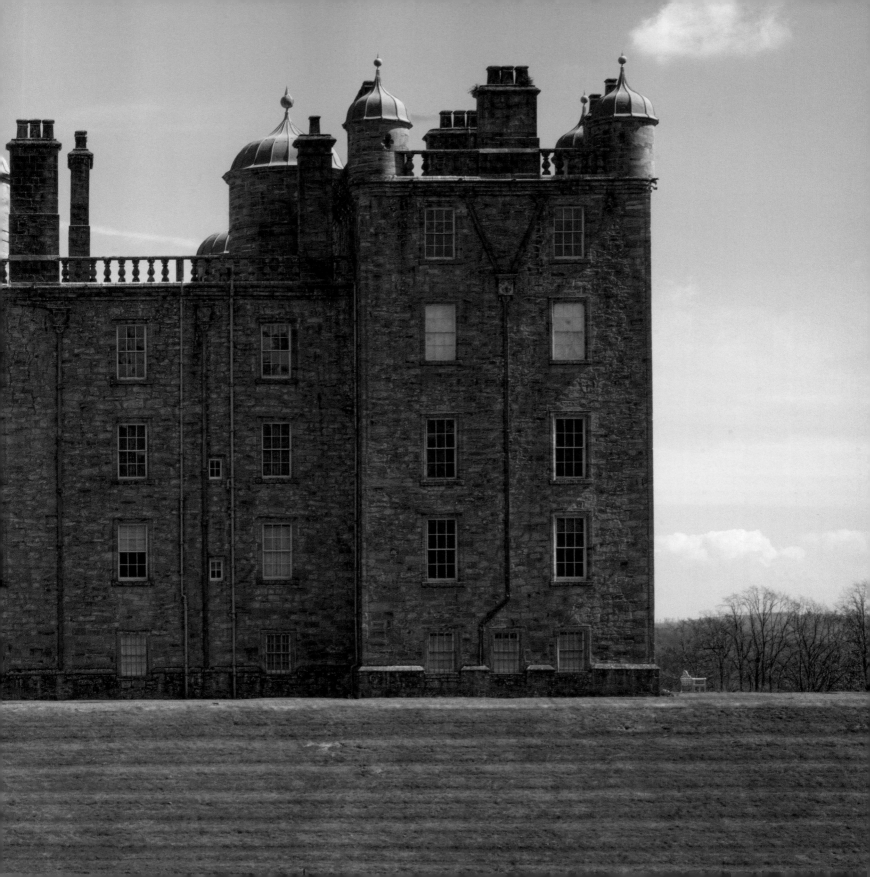

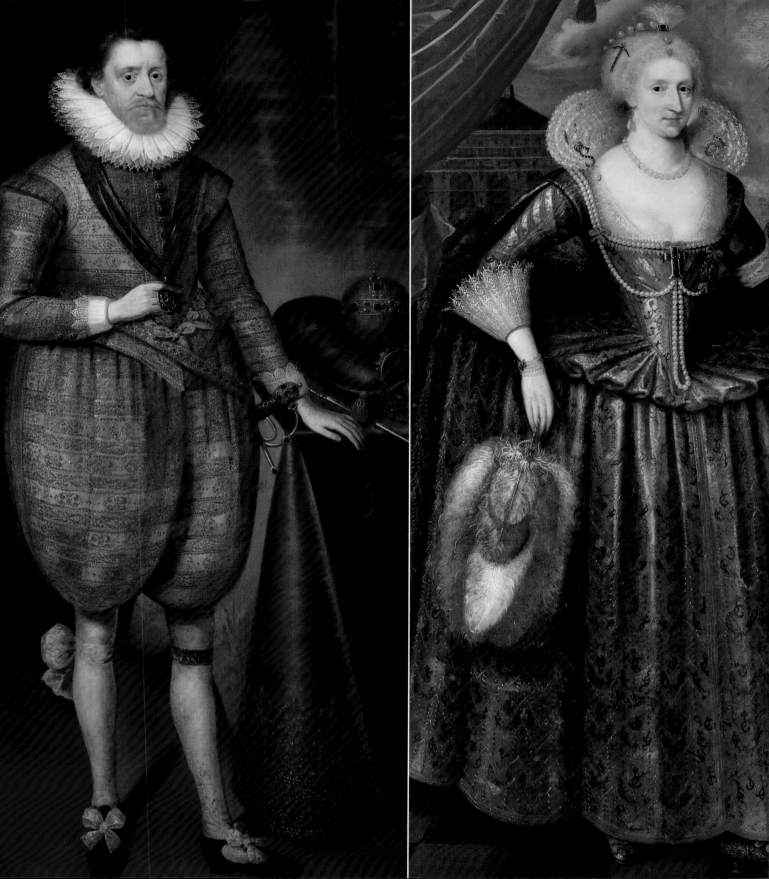

The Royals in the story

The history of Drumlanrig is entwined with the story of Restoration Scotland, and the Castle is full of royal portraits

STUDIO OF PAUL VAN SOMER
(c. 1577 – 1621)
FAR LEFT **James VI of Scotland and I of England (1566–1625)**
In this portrait in the Drawing Room, King James, in embroidered pink coat, breeches and lace ruff, holds the badge of the Order of the Garter. On the table are his crown, orb and sceptre. James is remembered for uniting the crowns of Scotland and England, and for authorising the version of the Bible that bears his name, still considered the finest flowering of the English language. The Flemish artist Paul van Somer arrived in London from Antwerp in 1616 and became his favourite court painter. Van Dyck would follow in his footsteps

STUDIO OF PAUL VAN SOMER
LEFT **Anne of Denmark, Queen of Scotland and England (1574–1619)**
James's Queen wears an embroidered silk dress with matching shoes and lustrous pearls and holds a plumed fan. Although her husband considered her frivolous for her love of masques, Anne was an influential patron of the arts, supporting both the playwright Ben Jonson and the architect Inigo Jones

Mary, Queen of Scots denounced 'Drumlanrig young and old' as the 'hellhounds, bloody tyrants, without souls or fear of God' who helped to depose her in 1567. Had it been true, as tradition once suggested, that she and her ladies-in-waiting embroidered the needlework panel in the Front Hall (page 36), it would have been irony indeed. By 1617, however, when her son, King James, and his Queen visited Drumlanrig, relations between the Stuarts and the Douglases had healed.

In the Civil War, the Douglases were firmly Royalist, and the 1st Duke of Queensberry's father was imprisoned and ruinously fined by Parliament. The 1st Duke revived the family fortunes after the Restoration in 1660. The 2nd Duke consolidated them by backing William and Mary even before the Glorious Revolution of 1688, then by supervising the Act of Union in 1707 for Queen Anne, which forestalled a Jacobite Restoration in Scotland upon her death. By 1745, when Bonnie Prince Charlie marched in, the Stuarts were simply an embarrassment.

Charles II never visited Scotland after the Restoration, but James, Duke of Monmouth and 1st Duke of Buccleuch, his firstborn natural son, campaigned there on his behalf. In 1810 Drumlanrig and its estates passed to his direct descendant, Henry, 3rd Duke of Buccleuch. The initial ire of Monmouth's great-great-grandmother Mary, Queen of Scots would surely then have been assuaged.

The visit to Drumlanrig in 1617 of King James and his Queen does not explain the presence of their full-length portraits in the Drawing Room. These early Stuart paintings originally belonged to Monmouth and his wife, Anna, Duchess of Buccleuch, and were hung prominently at her palace at Dalkeith after the failed Monmouth Rebellion in 1685. In Anna's eyes, Stuarts were family. To this day, the Scotts of Buccleuch wear the Royal Stuart tartan.

Anna had been lady-in-waiting to Mary of Modena, James II's consort, and her portrait, now in the Oak Staircase Hall, was given pride of place in the Queen's Room at Dalkeith – despite James II having executed Anna's unfortunate husband. In an odd political twist, Anna hung a prophetic painting by Jacob Huysmans (c. 1633–96) of a young Monmouth as John the Baptist in pride of place in her Dining Room. It is now at Bowhill in a room of mementos, with his saddle and sword, his teething ring, and the beautiful lace shirt he wore at his execution.

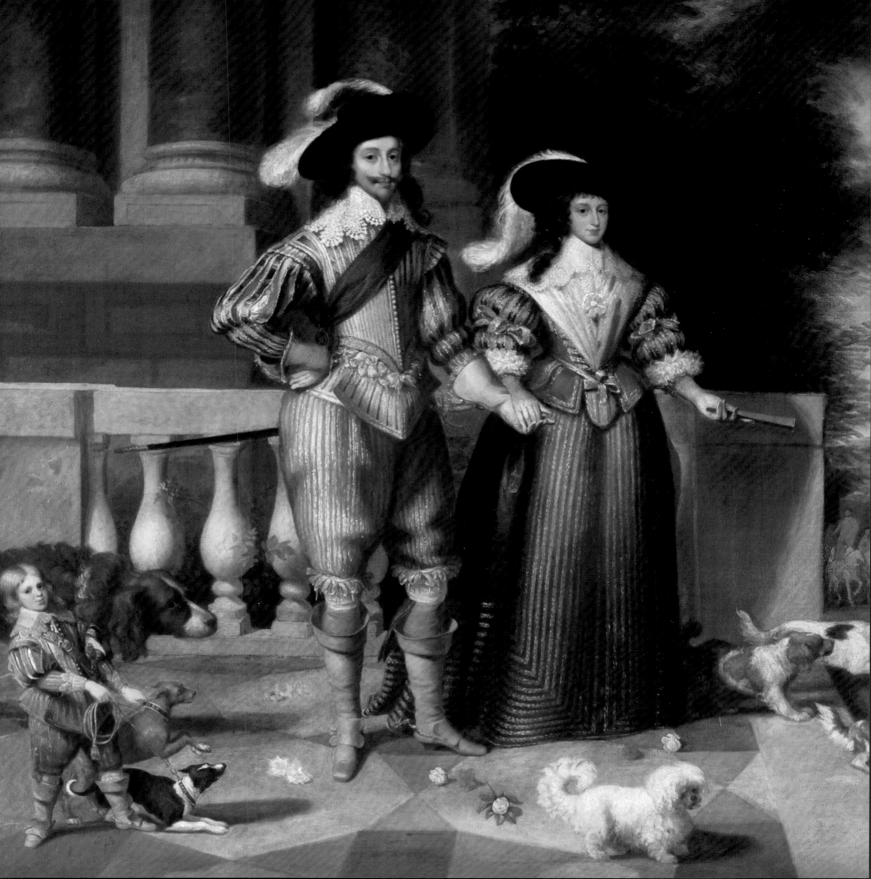

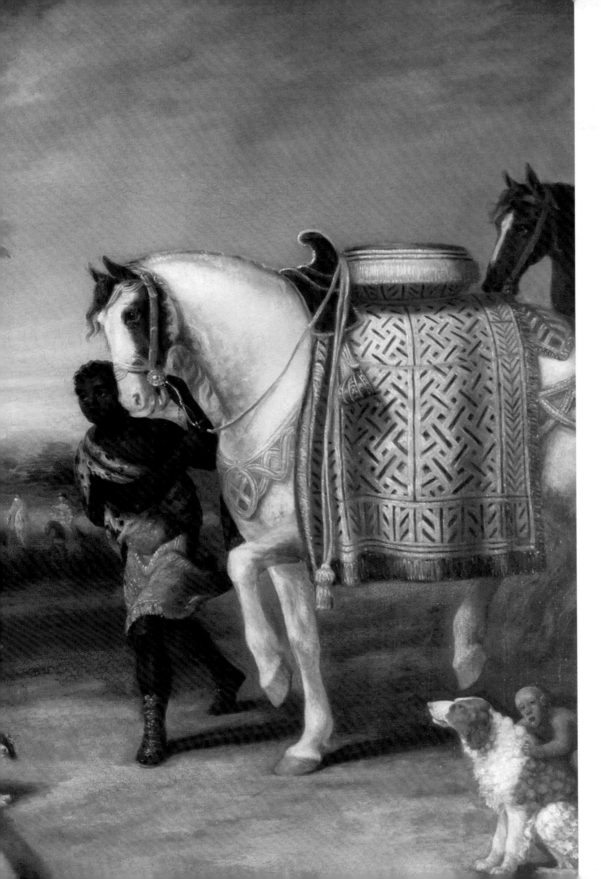

AFTER DANIEL MYTENS
(C.1590–1647/48)
King Charles I and Queen Henrietta Maria departing for the chase
In this delightful portrait (a small-scale version of a work in the Royal Collection), horses are led by an African servant up to the King and Queen, who, lovingly hand in hand, wear fashionable dress rather than court regalia. They are surrounded by lively dogs as they prepare for a hunting expedition. A water spaniel waits in the right-hand corner. In the original painting a cherub is seen showering them with the flowers that lie on the terrace. The Queen's dwarf, Jeffrey Hudson (far left), was known affectionately as 'Lord Minimus'

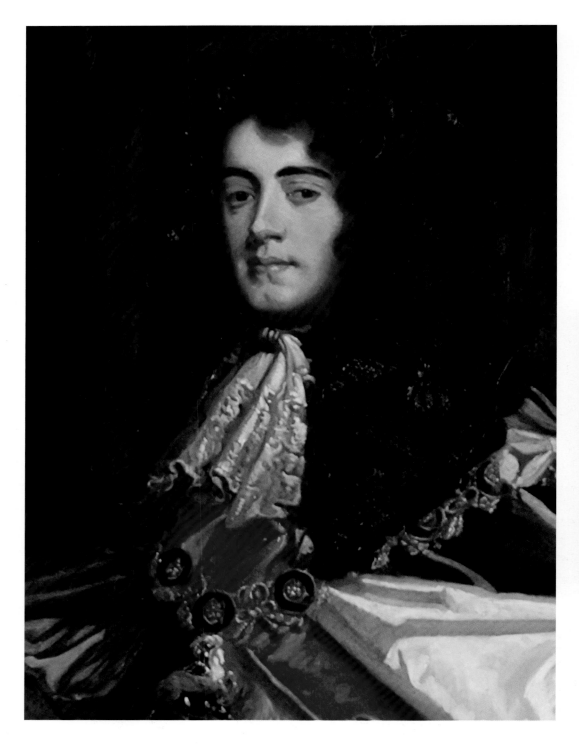

LEFT SIR PETER LELY AND STUDIO
James, Duke of Monmouth and 1st Duke of Buccleuch (1649–1685)
A detail of Monmouth's full-length portrait in Garter robes in the Drawing Room. After his father, Charles II's death, he boldly attempted to seize the throne from his uncle, James II, but was defeated in battle. His rashness cost him his head

OPPOSITE SIR PETER LELY AND STUDIO
King Charles II (1630–85)
Dressed in armour with a lace cravat, Charles II hangs above one of the two cabinets he supposedly gave to his son the Duke of Monmouth, now at either end of the Drawing Room

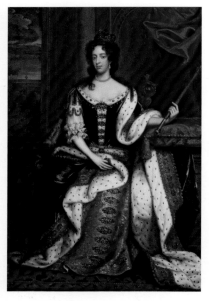

ABOVE WILLEM WISSING (1656–87)
Mary of Modena (1658–1718)
This portrait of the Queen Consort of James II, whose reign ended with the Glorious Revolution, was displayed prominently by Duchess Anna in the Queen's Room at Dalkeith, despite the King having executed her husband

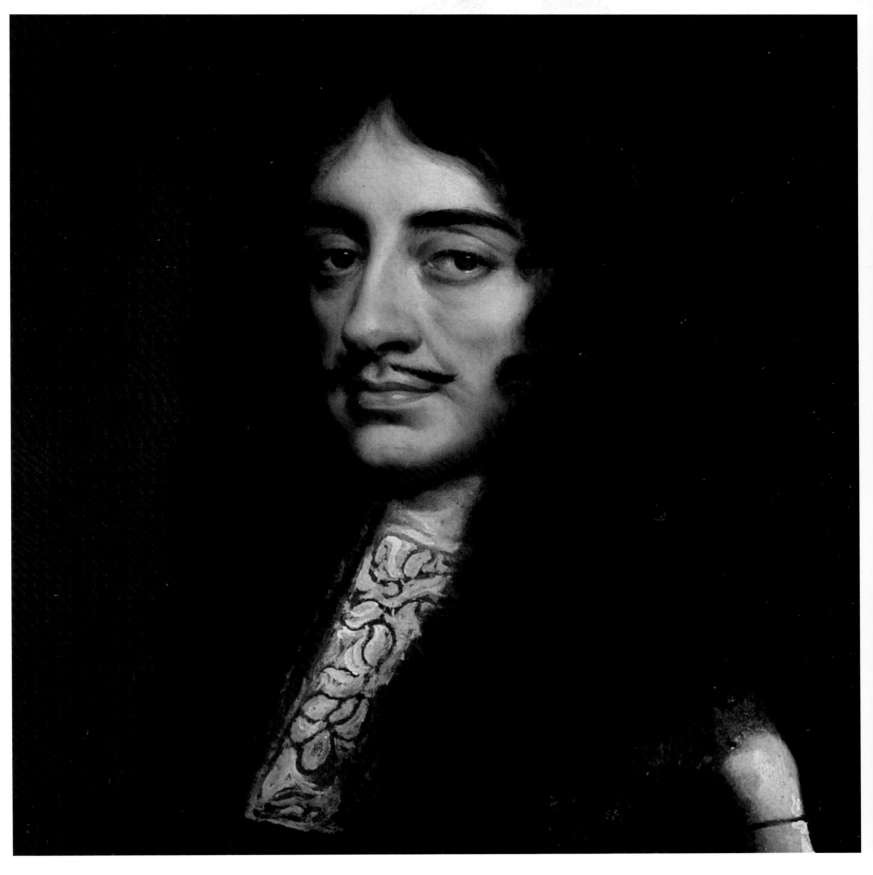

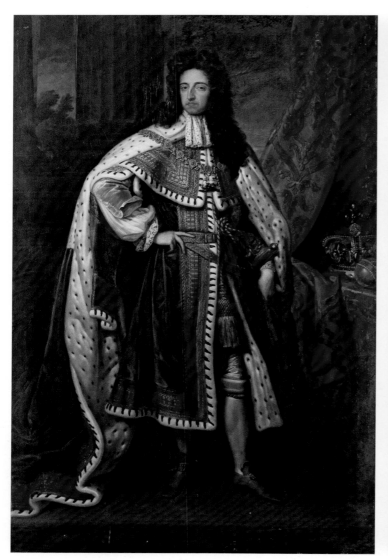

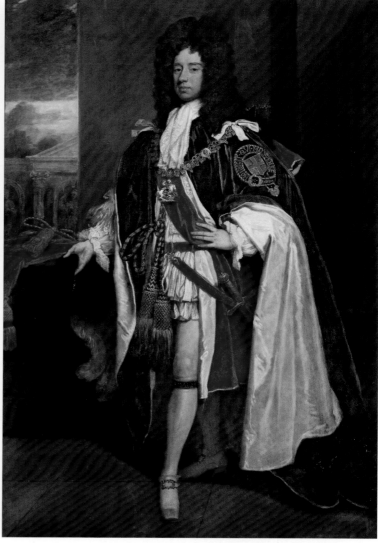

SIR GODFREY KNELLER (1646–1723)
ABOVE **William III (1650–1702)**
William of Orange and his wife, Mary,
came to the throne in the Glorious
Revolution of 1688–89; the 2nd Duke
was an early supporter. Here the King
is seen in coronation robes, wearing the
collar of the Order of the Garter

ABOVE RIGHT
James, 2nd Duke of Queensberry and
1st Duke of Dover (1662–1711)
Kneller's no less majestic portrait, in
Garter robes, of 'The Union Duke',
who oversaw the Act of Union between
Scotland and England in 1707

OPPOSITE AFTER SIR GODFREY KNELLER
William III greeted by Ceres and Flora
In this equestrian portrait, famously
bayonetted by Bonnie Prince Charlie's
Highlanders in 1745, the King is
welcomed on the seashore by Ceres and
Flora personifying Peace and Plenty

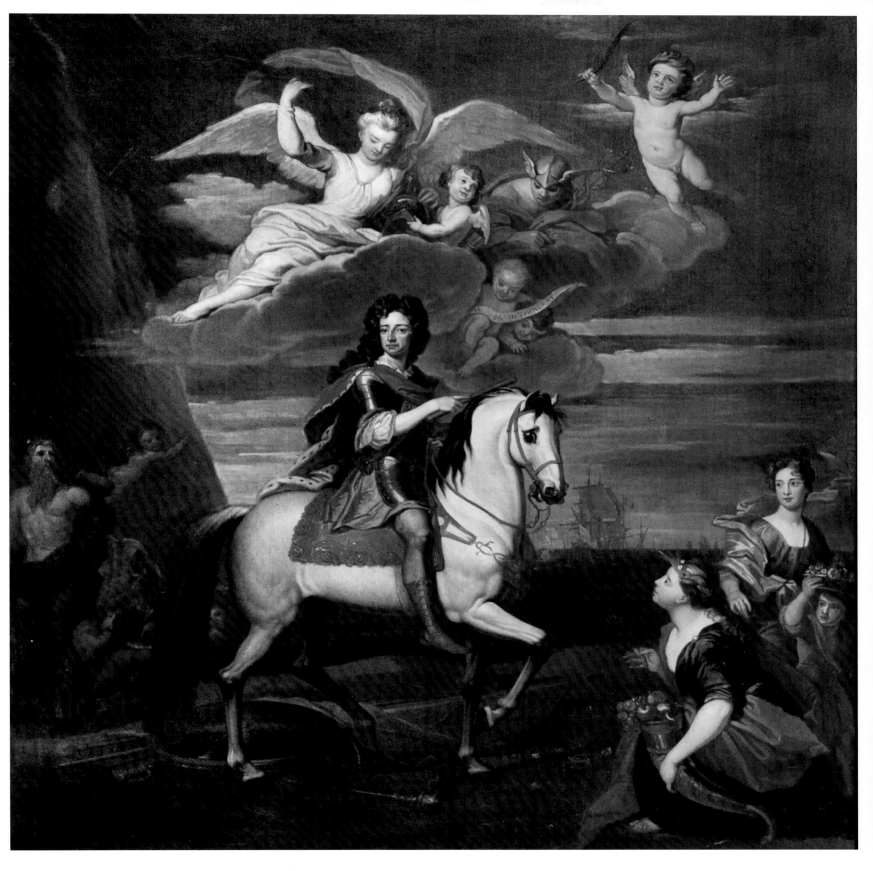

The Duchess's domain

Through a tangled web of inheritance, women have played a decisive role in Drumlanrig's history, which was enriched by the convergence of three noble families, the Douglases, Scotts and Montagus. Duchesseses' portraits are everywhere. Through their wealth, power, force of character and taste, they have shaped the heart of the Castle where the family gather, from the welcoming Dining Room to the Boudoir with its glorious Rembrandt

RIGHT *The Castle's austerity is softened by the profusion of delicate domes. In this view of the unadorned but sunny South Front, the only flourishes are staircases that draw the eye to the Dining Room's magnificent portal and Sundial Terrace* LEFT AND ABOVE *The fine iron balustrade with its Douglas heart dates from the 1680s*

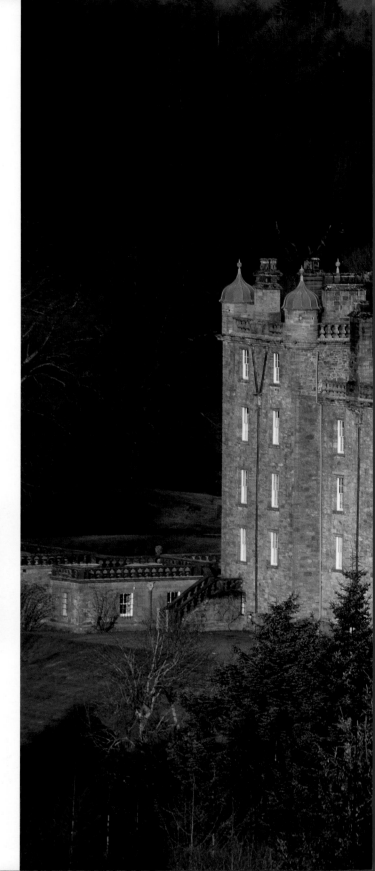

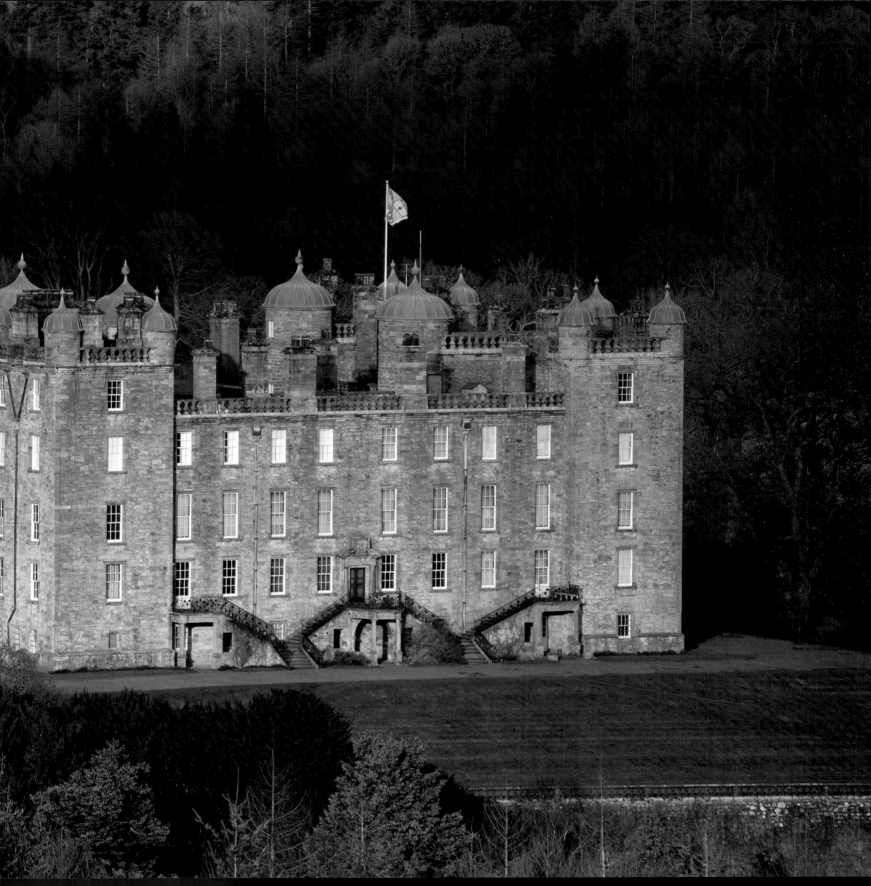

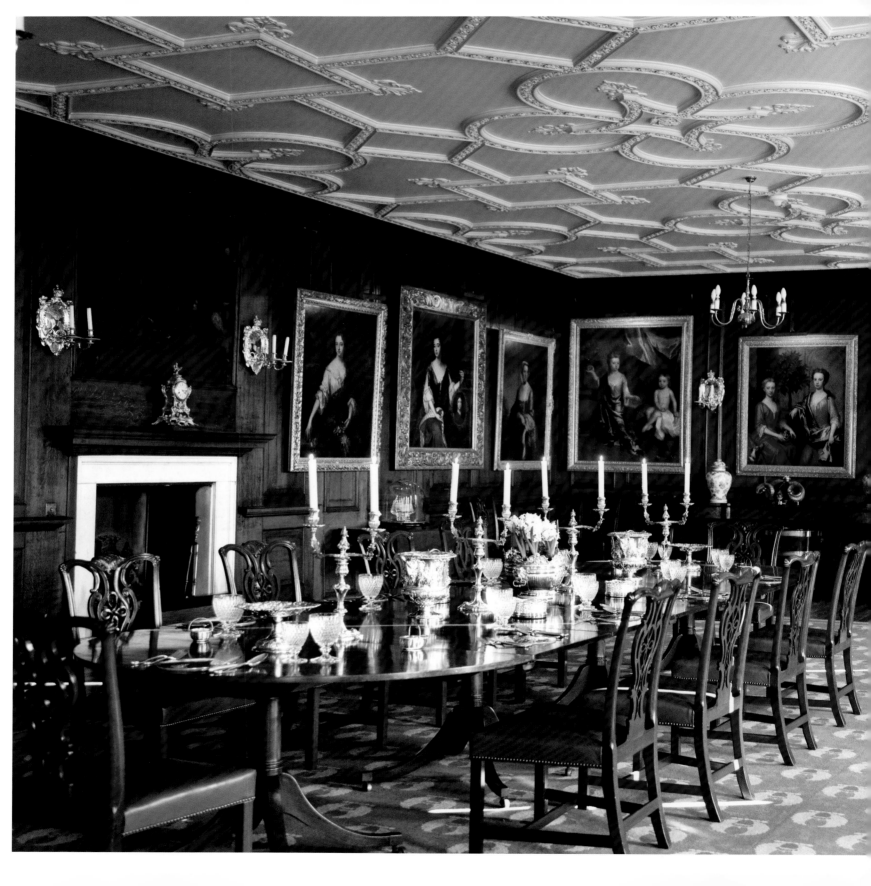

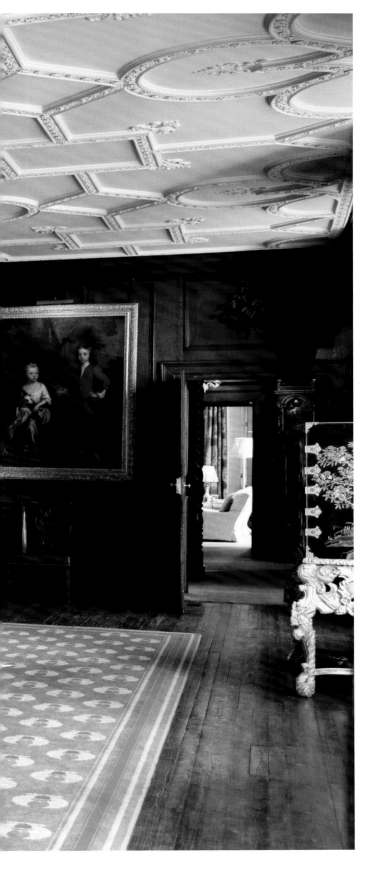

The Dining Room

The sweep of portraits in this room includes four of the first five Dukes of Queensberry, and the women who united three powerful families: the Douglases, the Scotts of Buccleuch and the Montagus

When this room was the grand staircase hall leading to the state rooms above, stepping from the Courtyard into the light-filled space must have created a tremendous sense of arrival. More astonishing still would have been the views of gardens vanishing into the woods.

At one end of the room sits William, 1st Duke of Queensberry, one of the most powerful men in Restoration Scotland and the builder of Drumlanrig. Next to him is the 4th Duke, the profligate Old Q, who almost lost it all.

At the other end is the 2nd Duke's daughter Lady Jane Douglas, who united the Douglas and Scott families by marrying Francis Scott, 2nd Duke of Buccleuch – rather to the annoyance of his grandmother Duchess Anna. Henry, 3rd Duke of Buccleuch, would thereby become 5th Duke of Queensberry. Between the windows is Henry's future wife, Lady Elizabeth Montagu (page 95), a reminder that his marriage also united the Scotts with the Montagus.

It wasn't only the tangled lineage and glittering silver that impressed Victorians. One visitor marvelled at the 'piles and pyramids of fruit that crowded the dining room table at every meal'. With its acres of greenhouses Drumlanrig produced its own exotic fruits: figs, passion fruit, grapes, and so many pineapples that second-rate fruit was 'sold at the Coventry markets in London for ten shillings each'.

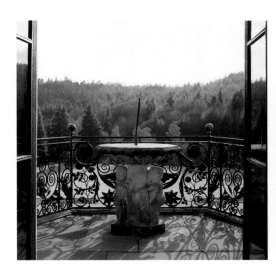

ABOVE *The Sundial Terrace. The 1st Duke's architect, James Smith, carved the cherub pedestal for the sundial himself in 1693*

LEFT WIVES OF INFLUENCE
The portraits here include the women whose marriages enriched three already powerful families. On the fireplace wall, Charles II's mistress Lucy Walter holds up a portrait of their son, James, who married the Buccleuch heiress, Anna Scott, becoming Duke both of Monmouth and Buccleuch. By the fireplace is Mary, 2nd Duchess of Queensberry. In red at the end of the room is her daughter Lady Jane Douglas, who married Duchess Anna's grandson Francis, 2nd Duke of Buccleuch. This would later lead the Scotts of Buccleuch to inherit the Queensberry dukedom

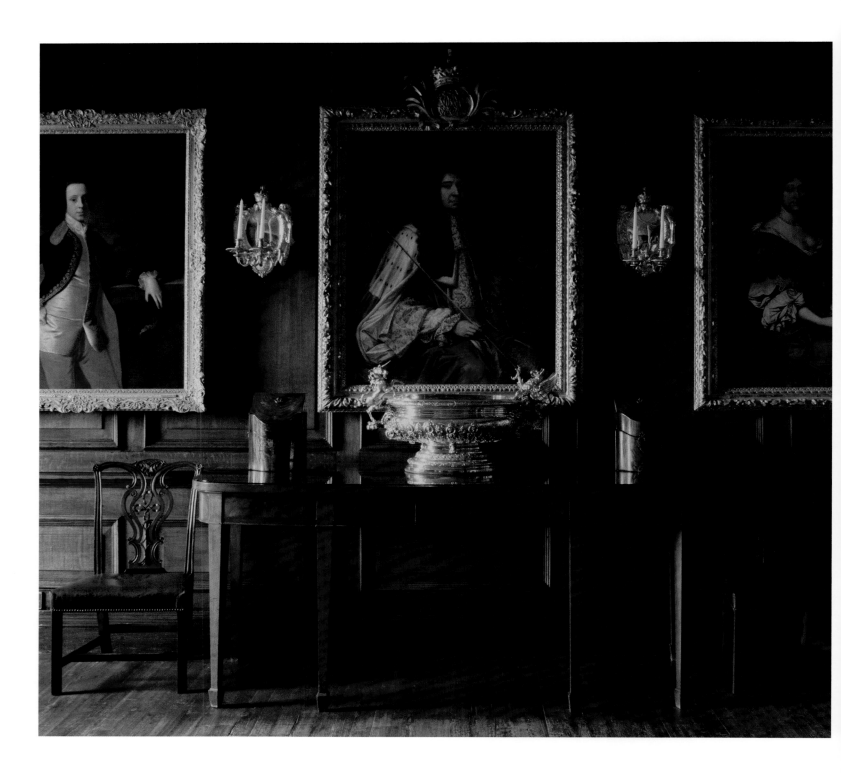

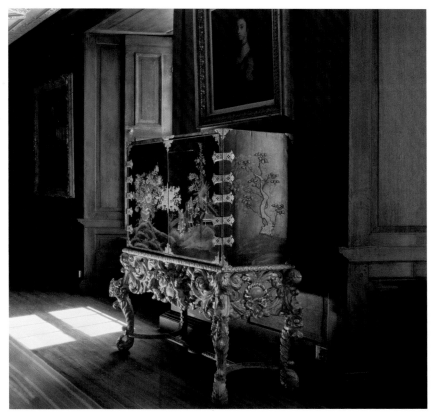

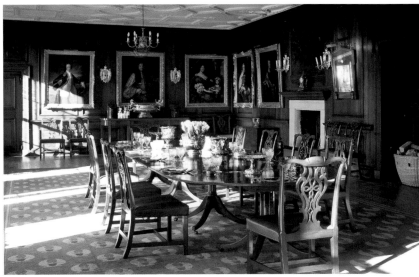

ABOVE *A young Elizabeth Montagu, future wife of the 3rd Duke of Buccleuch, painted by Sir Joshua Reynolds, hangs above a German japanned cabinet on an Anglo-Dutch stand*
ABOVE LEFT *A George III mahogany signal barometer by Watkins & Smith, London, creates 'a perpetual regulation of time'*
OPPOSITE *The 1st Duke of Queensberry by Kneller surveys the room from above a heraldic silver wine urn by Francis Nelme. Next to him is his Duchess, Isabel, by John Scougall. To their left is the 4th Duke, Old Q, by Allan Ramsay*
LEFT *In the corner is Charles, 3rd Duke of Queensberry, and by the fire Henry, 3rd Duke of Buccleuch and 5th of Queensberry, the first to inherit both dukedoms. The chairs were made by Robert Leemin in 1740 for Mary, Duchess of Montagu's house at Richmond*

The Serving Room

The smell of silver polish pervades the light-filled Serving Room, next to the Dining Room. It now houses portraits of the all-important men who ran the family's palace at Dalkeith

The huge oak table in the Serving Room is the perfect place for leaving trays ready to be carried to the Dining Room. The door to the right leads to the Southwest Tower and the kitchen and pantry downstairs. The Serving Room shows members of the household at Dalkeith Palace in the early 1800s, a testament to the 4th Duke of Buccleuch's keenness to portray favourite retainers.

Above the chimneypiece is John Ainslie's 1817 portrait of 'the Duke of Buccleuch's celebrated cook' Joseph Florance, who came to the family as a refugee from the French Revolution, and turned down offers to serve the royal family to stay with the Buccleuchs. He was chef to three successive dukes and was much admired by Sir Walter Scott.

He is seen here pointing to a menu which lists '*potage a la reine*', '*boudins a la Koln*', '*gradin a la Drumlanrig*' and '*croquette a la Montagu*'. Scott's biographer John Lockhart notes that Florance created 'magnificent representations in pastry of citadels taken by the Emperor' (Napoleon) for Sir Walter, 'to gratify the Poet's military propensities'.

Also bringing a colourful history to the Pantry is Signor Giuseppe Giustinelli. A soprano castrato who made his debut as an opera singer in Rome in 1751, he came to London to perform in 1763, but his voice was to fail him. The Dalkeith dinner books record that he was 'the friend of Lord Home who has lived in his family many years'. The Hon. James Archibald Home described the Italian coming 'almost penniless to The Hirsel to give Lord Home violin lessons'. He spent the rest of his life 'between that place, Dalkeith and Bothwell' and almost forgot his Italian, never advancing in English 'beyond "perfectly not" and similar expressions'. But 'his genius and skill in mechanical science were remarkable'.

At Dalkeith, where Giustinelli was the children's dancing master, he was affectionately known as 'Rusty Naily'. Said to be aged 113 when he died in 1820, the year Ainslie painted him, he was buried in Lennel churchyard near Coldstream. Lord Home's gravestone commemorating him can still be seen.

In another portrait Ainslie captures the dapper Major Walter Scott, one of the widower 2nd Duke of Buccleuch's children by his two mistresses. He became very close to his half-nephew's family and kept the dinner books at Dalkeith, a revealing diary record of the house, which he wrote out every day in his beautiful hand.

RIGHT *Over the chimneypiece hangs the chef Joseph Florance. The silver includes a vase-shaped wine cooler, engraved by Paul Storr in 1812, and an 1828 oval dish cover by Robert Garrard, one of a pair*

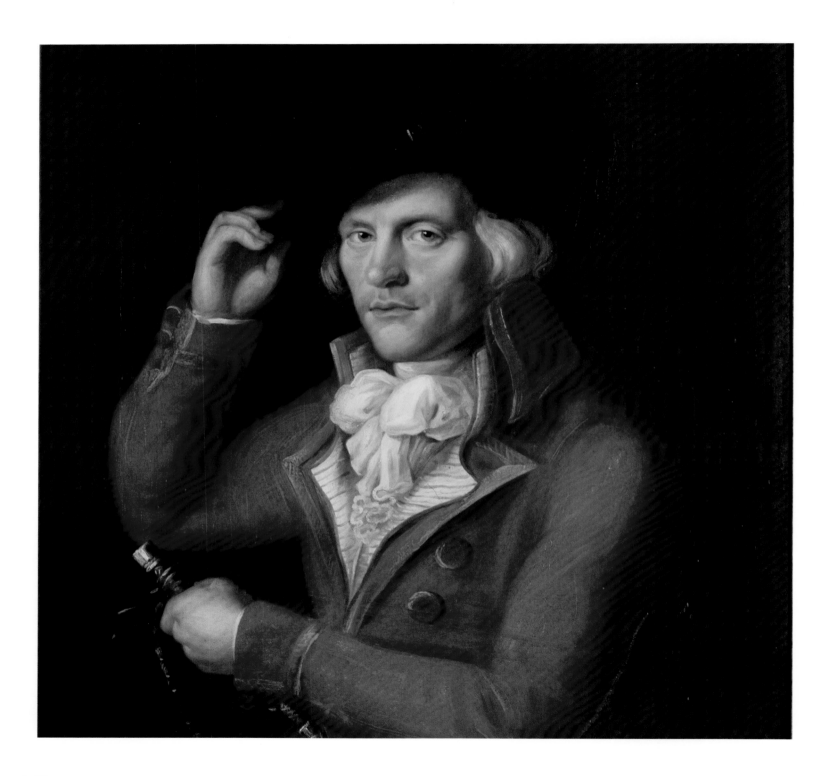

Gentlemen in the Serving Room

Household characters from Dalkeith Palace

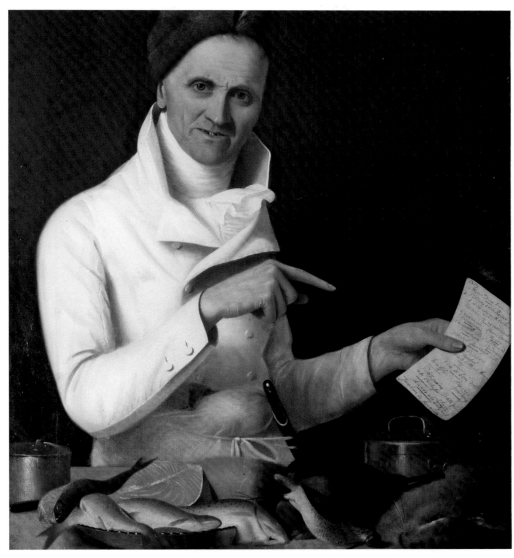

OPPOSITE **The Courier**
The courier to Henry, 3rd Duke of Buccleuch, in red riding coat, white stock and black hat. The name of the dashing courier is not recorded, nor is the artist's, but the style recalls that of Martin Ferdinand Quadal, painter of the equestrian portrait of the Duke in the Inner Hall

THIS PAGE *Five portraits of retainers at Dalkeith by the little-known John Ainslie, who was active in Edinburgh from 1815 to 1835. Only 14 of his works are recorded. In 1817 he was paid five guineas each for portraits of Dr Graham and Major Scott, and 12 guineas for that of Joseph Florance*

TOP **Joseph Florance, 1817**
Celebrated cook to three Dukes of Buccleuch – Henry, Charles and Walter Francis
BOTTOM ROW, FROM LEFT
Signor Giustinelli, 1820
The dancing master was reportedly aged 113 when Ainslie painted him
Baillie William Tait of Pirn
Tait, with his glass eye, was the Duke's chamberlain for over 30 years from 1803
Dr Andrew Graham
The devoted family physician
Major Walter Scott
Natural son of the widower 2nd Duke of Buccleuch, the Major kept the Dalkeith dinner books, a diary record of the house

 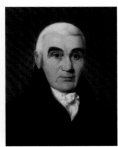 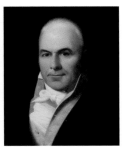

The Southwest Tower and Basement

Symmetry reigns in the graceful circular staircases of the four corner towers

Many a house guest with a less-than-perfect sense of direction has been found wandering up and down the wrong stairs at Drumlanrig. Understandably, for all four towers appear identical, except that in the case of the Southwest Tower, the walls are unplastered and display smoothly pointed stonework. Given the quality of the masonry, it is easy to see how the 1st Duke's bills mounted up. The stepped ceiling gives the stairs an even more sculptural feel. Dates above windows outside each of the four towers show how the Castle progressed between 1679 and 1689. The Southwest Tower, completed in 1685, appears in an early plan of 1618; the lower part, which does not have a date stone, may have belonged to the earlier castle.

These handsome oak armchairs, with their high spindle backs and rush seats, are mid-Victorian. They stand in a stone-flagged, whitewashed Basement passage outside the Old Servants' Hall in the East Service Wing, added in the early 1840s.

LEFT *The Southwest Tower staircase, its pink sandstone still visible*
OPPOSITE *A pair of elegant Victorian chairs in the stone-flagged Basement*

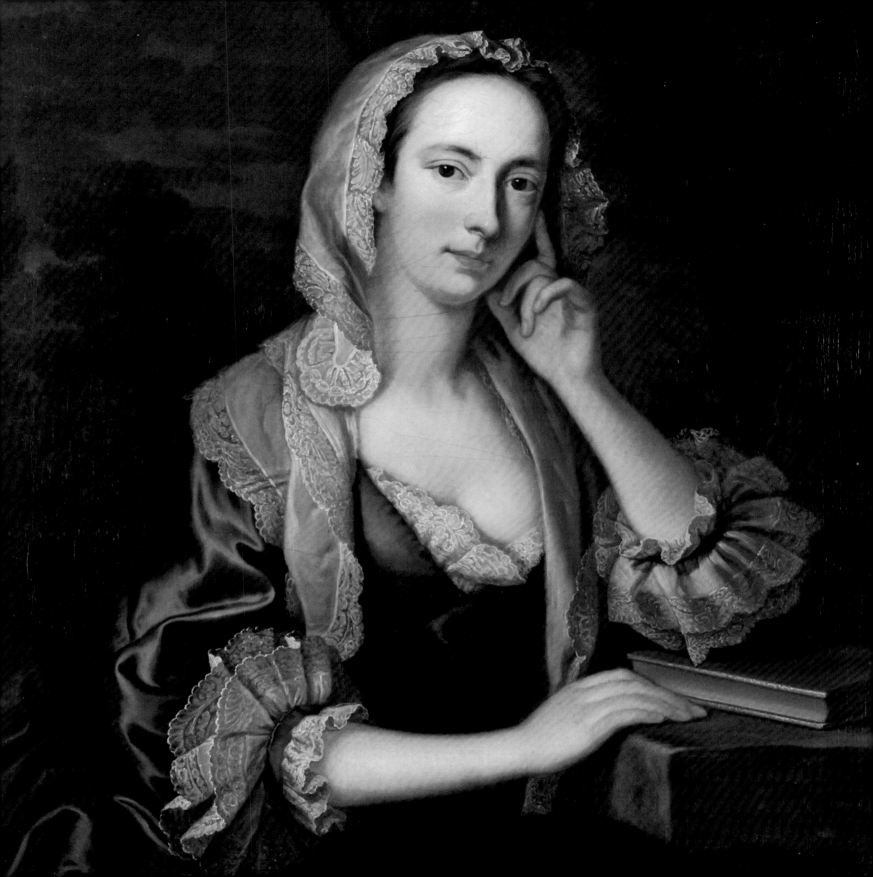

Portraits of the Duchesses

Remarkable and beautiful women have shaped Drumlanrig's story, from the Restoration to the new Elizabethan age. Their presence brings life to every room in the Castle

Patrick Lichfield captured four generations in this classic 1980s conversation piece. Jane, Duchess of Buccleuch, the present Duke's mother, looks up at her daughter, Charlotte Anne. In the centre, Elizabeth, the present Duchess, then Countess of Dalkeith, looks down at her daughter Louisa Jane. Smiling out at society's favourite photographer is Louisa Jane's great-grandmother Mollie, Dowager Duchess, widow of the 8th and 10th Duke.

Catherine Hyde (opposite), known as Kitty, was mistress of Drumlanrig seven generations earlier. She married the kindly 3rd Duke of Queensberry and helped to transform the garden, creating a two-mile-long aqueduct to feed a magnificent cascade. She is celebrated by the poet Matthew Prior as 'Kitty, beautiful and young, and wild as a colt untamed'. She spent much of her time in the south. Dumfriesshire women annoyed her, as did the Scottish Sabbath, and she was famous for her frankness. As Prior's poem concluded,

> *Fondness prevail'd – Mamma gave way;*
> *Kitty, at heart's desire,*
> *Obtain'd the chariot for a day,*
> *And set the world on fire.*

LEFT JEAN-BAPTISTE VAN LOO (1685–1745)
Lady Catherine Hyde, Duchess of Queensberry (1701–77), c.1730
The charismatic Kitty, wife of the 3rd Duke of Queensberry, hangs in the White Bedroom
RIGHT PATRICK LICHFIELD (1939–2005)
From right: the late Dowager Duchess Mollie; Lady Charlotte Anne (Comtesse de Castellane); Elizabeth, the present Duchess; the late Duchess Jane; young Louisa Jane

This marble bust has only recently been identified as Mary, Countess of Drumlanrig. 'A daughter of the house of Burlington', as Daniel Defoe wrote, Mary Boyle married Lord Drumlanrig, the future 2nd Duke of Queensberry, at the age of 15 in 1685. A 'marble bust of her late Grace' is in the inventory made on Duke James's death in 1712. This tallies with a voucher in the Archives referring to the 1st Duke's payment of £5 to Thomas Bennier in 1688 'for a bustoe', when Mary was 19.

Bennier (Benière) is possibly related to a sculptor employed by Charles I, Isaac Bennier. Thomas was 'curious and ingenious,' wrote the engraver and antiquary George Vertue, who said that Bennier would create a marble bust from life for two guineas. But he died in his 30s, in 1693, and almost no known work survives, which makes this sculpture particularly intriguing.

Mary's family supported William of Orange, as did her husband, and they secretly helped to pave the way for the Glorious Revolution. The Boyles also shared his interest in the arts. Besides 'looking very well', Mary 'sang to admiration', according to a relative, Lady Rochester. Mary's nephew, Richard Boyle, 3rd Earl of Burlington, was known as 'the Architect Earl'. His passion for Palladio was born in the Veneto in 1719, during the last of his three Grand Tours. His London homes, Burlington House and Chiswick House, became the first major statements of Palladianism in Britain.

Mary Boyle, 2nd Duchess of Queensberry (1670–1709)
LEFT SIR GODFREY KNELLER (1646–1723)
BELOW SIR JOHN MEDINA (1659–1710)
Two leading portraitists painted the 2nd Duchess: Kneller, court painter to five successive Kings and Queens of England and Scotland, and Sir John Medina. The Brussels-born son of a Spanish army captain, Medina was popular with the Scottish nobility and was eventually buried with pomp in Edinburgh

OPPOSITE THOMAS BENNIER (D.1693)
Mary, Countess of Drumlanrig, 1688
Mary was also the subject of two fine sculptures: the bust carved by Thomas Bennier when she was still Lady Drumlanrig, and the Durisdeer memorial (page 203), where she lies next to the touchingly attentive Duke. Hers was a classic beauty of the period – a 'natural' look with a centre parting and small curls swept away from the face, consciously avoiding the extreme artifice of men's wigs

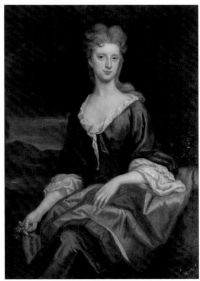

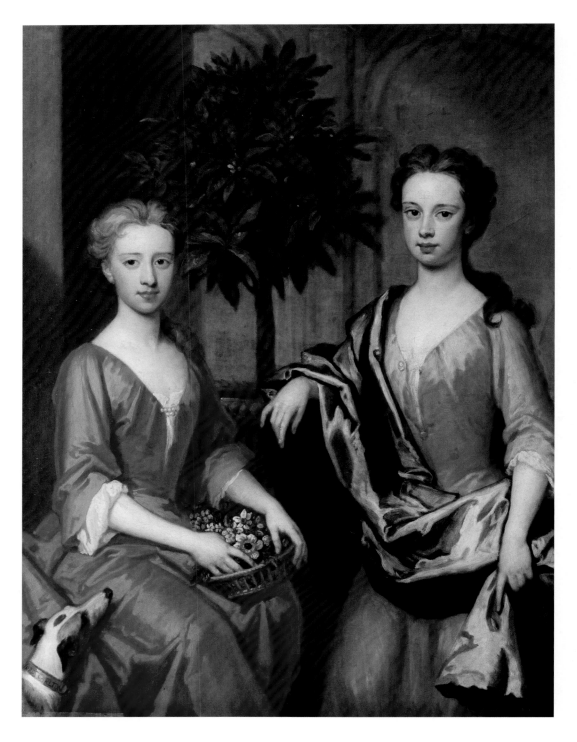

More by happenstance than design, the fortunes of three powerful families, the Douglases, Scotts and Montagus, are entwined at Drumlanrig.

Francis Scott, 2nd Duke of Buccleuch, was a man not easily swayed. When he brought together the Douglases and the Scotts in 1720 by marrying the 2nd Duke of Queensberry's daughter Lady Jane Douglas (left, in red), it was in defiance of his grandmother. Anna, Duchess of Buccleuch (Monmouth's wife and the builder of Dalkeith Palace), had expected him to marry the daughter of the then more promising Duke of Douglas, confusingly also called Lady Jane Douglas.

It was another 90 years before the two dukedoms and fortunes were united, when their grandson Henry, 3rd Duke of Buccleuch, inherited the Queensberry dukedom as a result of Old Q, the 4th Duke of Queensberry's death without legitimate children.

By then, Henry's wife, the swan-like Elizabeth Montagu (far right), had already added the Montagu fortune to the pot. Her brother, Lord Monthermer, son and heir of George Brudenell, Duke of Montagu, died in 1770 at the age of 35, three years after her marriage, leaving her heiress to the Montagus of Boughton, but not to the dukedom, which could only pass through the male line and so became extinct.

Adam Smith, the young Duke of Buccleuch's tutor, wrote to the philosopher David Hume telling him of Elizabeth's arrival at Dalkeith as a bride, saying, 'I am sorry you are not here because I am sure you'd fall perfectly in love with her.'

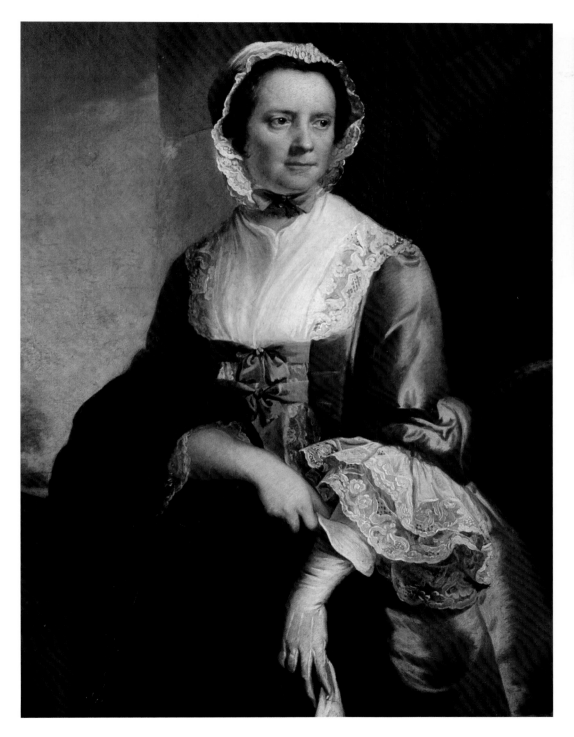

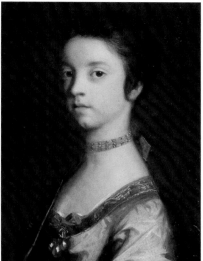

ABOVE SIR JOSHUA REYNOLDS (1723–92)
Lady Elizabeth Montagu
(1743–1827), 1755
The 3rd Duke of Montagu's daughter married
Henry, 3rd Duke of Buccleuch, in 1767,
and was admired for her brains as well as
her beauty by his tutor, Adam Smith. On
her brother's death in 1770, she became the
Montagu heiress, and, when Henry inherited
Drumlanrig in 1810, Duchess of Queensberry
OPPOSITE SIR GODFREY KNELLER
Lady Jane Douglas (1701–29) and
Lady Anne Douglas (d. 1741)
Kitty's sisters-in-law, daughters of the 2nd
Duke of Queensberry. Lady Jane (in red)
married Francis, 2nd Duke of Buccleuch,
who was succeeded by their grandson, Henry
LEFT THOMAS HUDSON (1701–79)
Alice Powell, Duchess of Buccleuch (d. 1765)
Long after Lady Jane Douglas died aged 29,
Duke Francis would again follow his heart
by marrying Alice – a slightly scandalous act,
as she was a Windsor washerwoman. They
married in 1744 at the Mayfair Chapel,
a notorious venue for rushed marriages
without licences or banns. The Duke settled
a generous annuity for her widowhood

Philip de László's masterful painting shows the present Duke's grandmother in 1932. Mary Lascelles, or Mollie as she was known, a granddaughter of the Duke of St Albans, married Walter, the future 8th Duke of Buccleuch and 10th of Queensberry, and quickly learned to keep up with him out hunting, riding side-saddle with great elegance. In 1921 Glyn Philpot had portrayed her as a fragile beauty, but in de László's hands she gains a striking Thirties glamour. She could hold her own in any company, and such was her charisma that Winston Churchill said that when Mollie entered a room it was as if a light had been turned on.

In 1958 the portrait of Jane, Countess of Dalkeith, wife of the future 9th and 11th Duke and mother of the present Duke, caused a sensation at the Royal Academy: all 14 judges gave it a coveted A, and the painter, John Merton, leapt to fame, although its unfashionable hyperrealism caused a furore in certain circles. Merton depicts the Countess framed in a Classical archway, holding a book with the Scott crest. Above her head is a winged Douglas heart (page 14). Beyond are the River Tweed and the Eildon Hills. In one *oeil-de-boeuf* above the columns of the Classical portico, she holds a white fantail dove from Eildon Hall; in the other, her Siamese cat.

LEFT PHILIP DE LÁSZLÓ
(1869–1937)
Mary, Countess of Dalkeith, 1932
Mollie Lascelles was the spirited wife of Walter, who became 8th and 10th Duke in 1935. De László, who succeeded John Singer Sargent as London's leading society painter, captures her penetrating gaze

ABOVE JOHN MERTON (1913–2011)
Jane, Countess of Dalkeith, 1957
John Merton said it took 1,500 hours to paint this celebrated portrait of the wife of the future 9th and 11th Duke. Jane, Countess of Dalkeith, then 26, came from a distinguished Highland family, the McNeills of Colonsay. The portrait provoked heated debate in the art world when it was unveiled. Merton's detailed notes survive in the Archives. The shine of the necklace was created, he wrote, by 'small pieces of diffraction grating made by my father of pure aluminium in corrugated form, 20,000 lines to the inch, embedded in cellulose acetate'

The Morning Room

Among Drumlanrig's great charms are its small, informal rooms, especially this one, bathed in morning light

Drumlanrig may be imposing outside, but inside it is surprisingly intimate. Two of the loveliest, most feminine rooms are the Morning Room, in the southeast corner, and the adjoining Parlour. It is around these two rooms that life in a more relaxed age revolves. Piles of inviting books and a roaring fire tempt you to spend the day curled up in a deep sofa or armchair. Window recesses offer the chance to complete a jigsaw, play cards or simply admire the splendid views.

After the dark oak panelling of the staircase hall, the aquamarine walls make a refreshing backdrop for eight luminous Paul Sandby watercolours of Windsor Castle, an elaborate giltwood Queen Anne mirror over the writing table, and porcelain figurines on gilded corner brackets. The colour also sets off to perfection the pearly pink taffeta worn by Jane, Countess of Dalkeith, seen over the fireplace, and the white satin and coral bow of Queen Henrietta Maria's dress on the wall opposite.

John Merton's 1957 portrait of Jane, Countess of Dalkeith, hangs above the fireplace. Chintz curtains frame deep window recesses. The Jacobean-style plasterwork ceiling, with its repeating heart motif, was added in 1863 by James Annan & Son of Edinburgh and Perth, who also transformed the ceilings in the Dining Room and Drawing Room

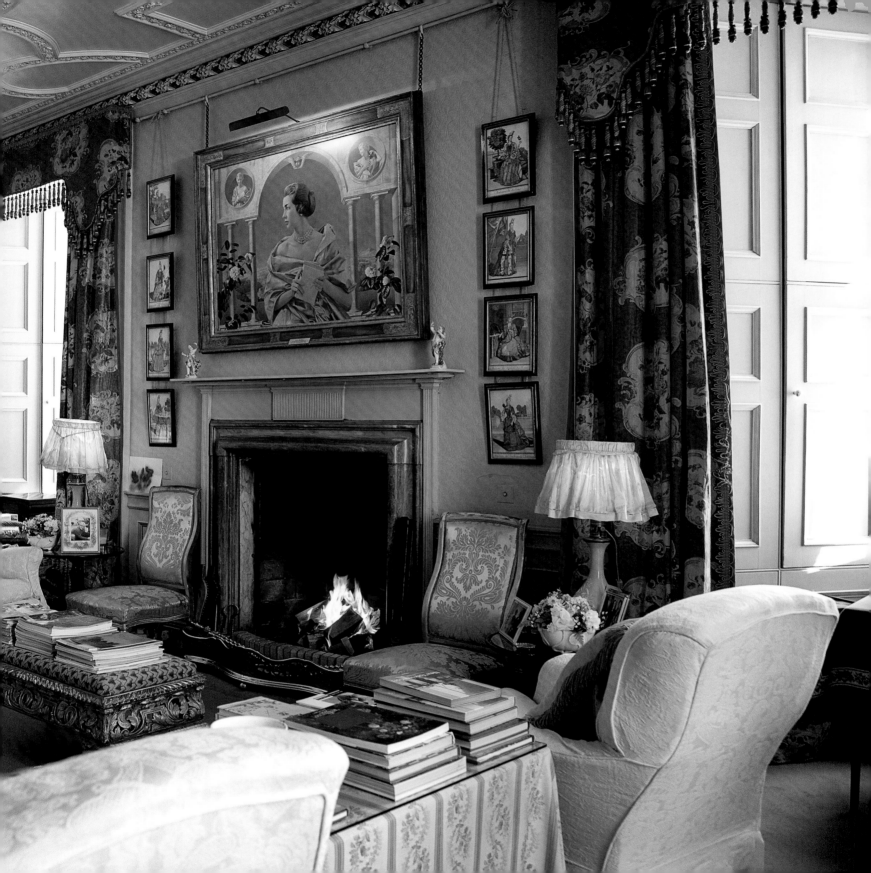

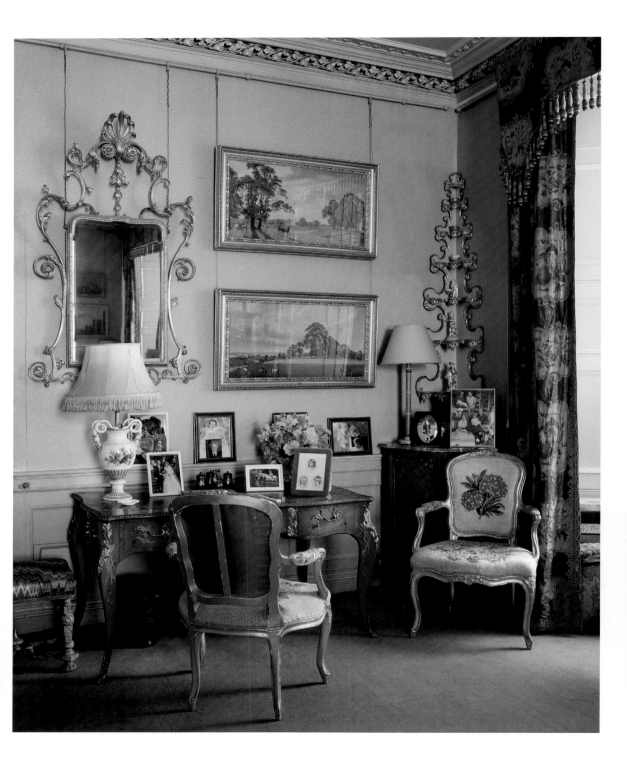

LEFT *Light reflects off the Queen Anne giltwood mirror above a Louis XV 'bureau plat'. Next to Paul Sandby's views of Windsor Great Park is a display of Meissen and Chelsea porcelain. The china bracket is one of four in the room from Duchess Anna's closet at Dalkeith, where all the furniture was said to have been a royal gift from Whitehall Palace*

BELOW *In 1814 the room became a dining room for the Duke's agent, with a sideboard occupying the pilastered recess. The 18th-century prints either side of Henrietta Maria are of 17th-century court costumes and are embroidered with actual fabrics. They belonged to Mary, 2nd Duchess of Queensberry, and used to hang in a room known as 'the Court of France' – a letter of 1846 recalls that the 4th Duke, Old Q, would walk about in it 'singing French chansons out of tune'*

OPPOSITE CIRCLE OF
SIR ANTHONY VAN DYCK (1599–1641)
Queen Henrietta Maria (1609–69)
Seen here in a silvery silk dress, Henrietta Maria was Charles I's beautiful French Queen. This is a version of Van Dyck's portrait in the Royal Collection

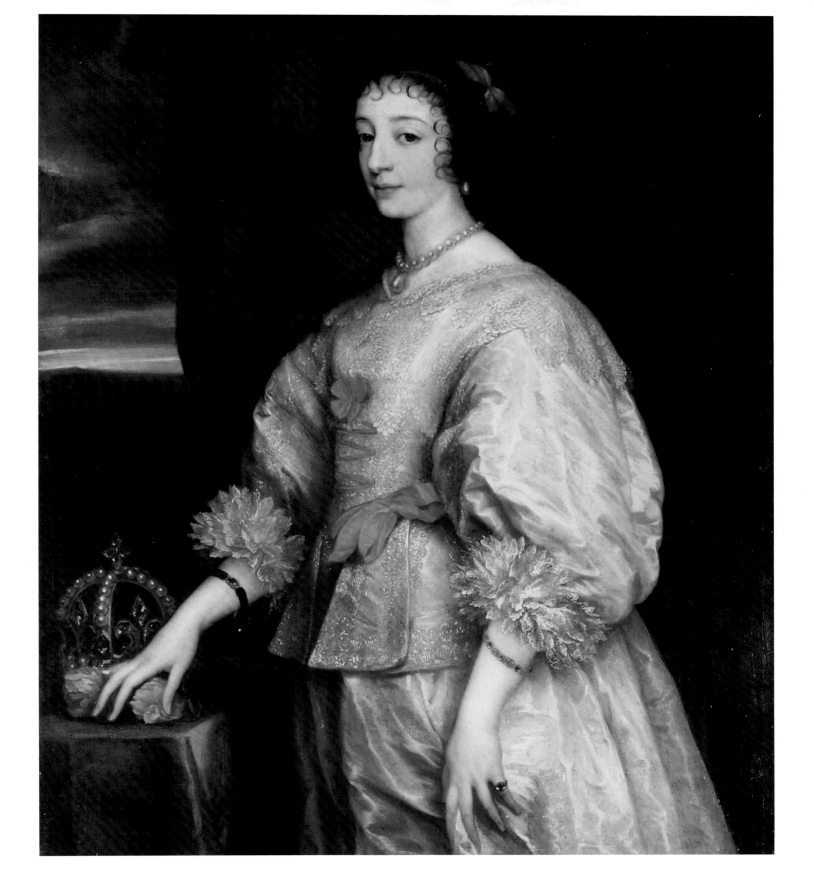

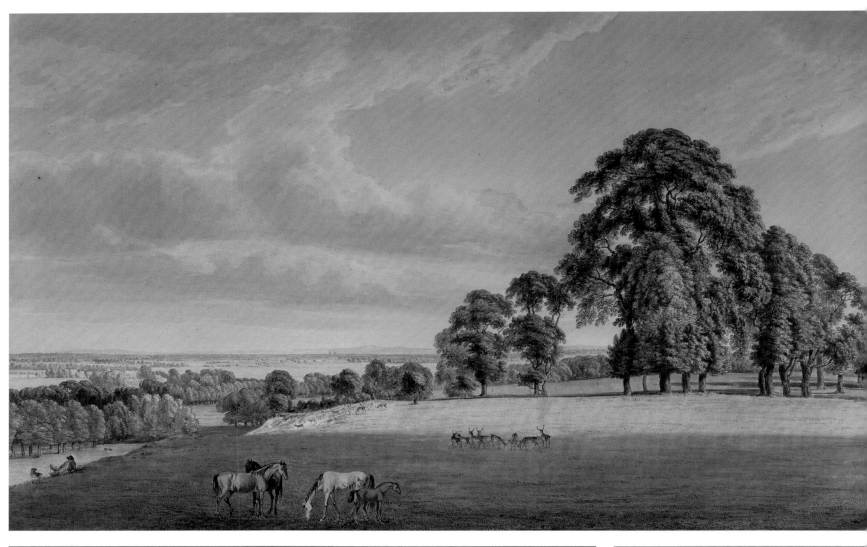

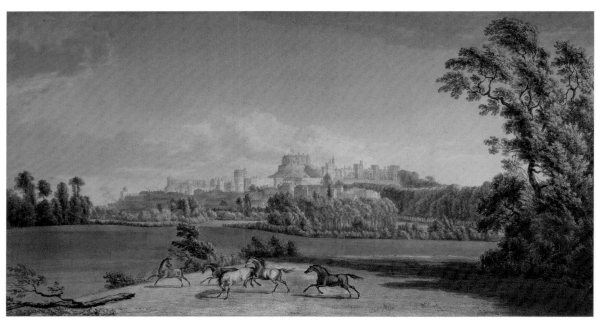

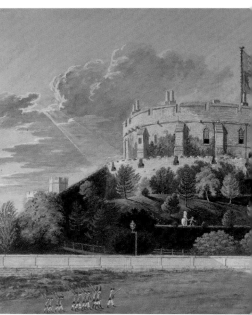

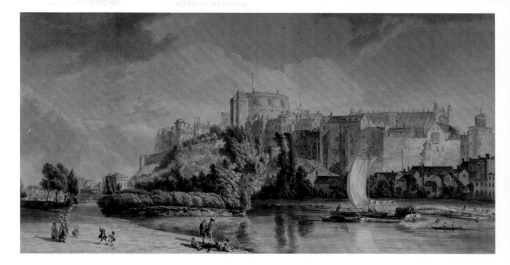

Views of Windsor

The park at Drumlanrig still shares the ordered beauty of Paul Sandby's studies of Windsor Castle and its royal park. Originally a map-maker, Sandby is considered to be the father of English watercolour painting. As a young man, he worked with his brother, Thomas, for the Ordnance under the Buccleuch family's map-loving forebear, John, 2nd Duke of Montagu. Paul honed his skill as a draughtsman while surveying the Highlands after the '45 Uprising.

The family's support continued with George, 3rd Duke of Montagu, whose influence as governor of Windsor Castle would also be of great help. And late in life, Thomas is recorded in the accounts of 1793 as receiving £28.16 for teaching 'the ladies' of the family. He died in 1798. So it's a long story of support and patronage. It would be nice to think that Caroline Scott, seen sketching in Danloux's portrait (page 19), was a pupil.

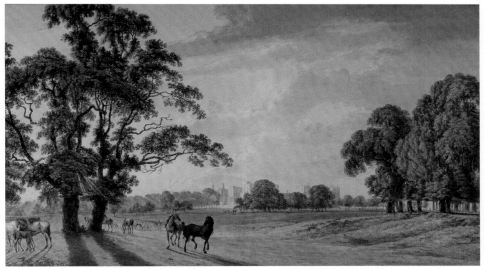

PAUL SANDBY (1731–1809)
**Views of Windsor Castle
and Windsor Great Park**
ABOVE LEFT *Windsor Great Park*
FAR LEFT *Windsor Castle from the
southeast on Spital Hill, with the avenue
of the Long Walk on the right*
TOP RIGHT *The Castle and Windsor town,
with a barge sailing down the Thames*
ABOVE RIGHT *The Castle seen in the
distance against the light*
RIGHT *In 1763 the North Terrace was
called 'the noblest walk in Europe'*

CHARLES MARTIN POWELL (1775–1824)
LEFT **The Round Tower, Windsor**
*Powell employs his skill as a marine artist to
convey the movement of a splendid Royal
Standard in the evening breeze*

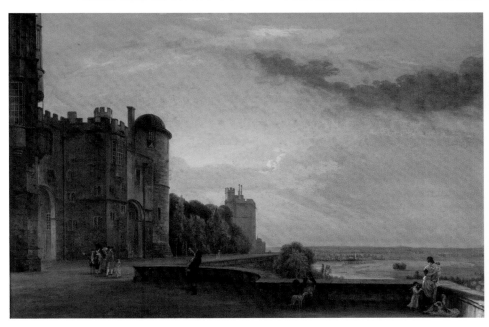

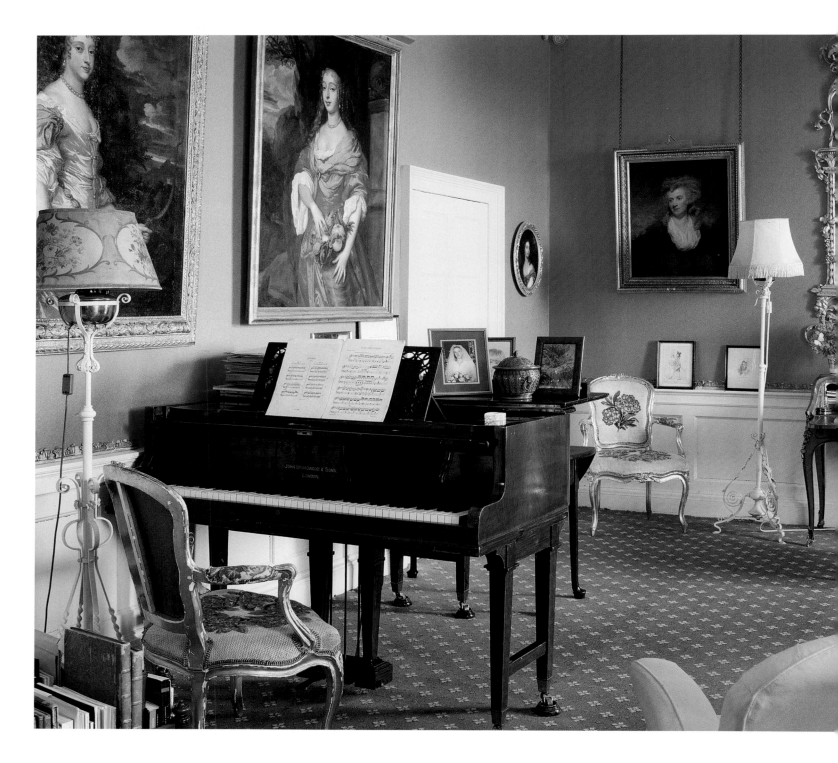

The Parlour

House parties in the Fifties and Sixties involved people gathering for tea in the Parlour. The room now has a group of the Castle's loveliest portraits

The Parlour is similar in atmosphere to the Morning Room next to it, and indeed a secret door connects the two. From time to time it is now used for practice by the Royal Scottish Conservatoire. The paintings on the warm coral walls include two 17th-century portraits by Sir Peter Lely which hang above the baby grand piano. These have been chosen for the sumptuousness of the garments rather than for the sitters' identities. One shows Jane Myddleton, a society beauty rumoured to be the mistress of Ralph, Duke of Montagu, as the goddess Ceres; the other is thought to be of Frances Stuart, Duchess of Richmond, posing as the goddess Diana. By the door is a theatrical portrait of Sophia Campbell, Baroness de Clifford, after Sir Joshua Reynolds.

There is also a self-portrait of David Wilkie, painted in 1811, which shows the great Scottish painter as a shy and intense young man newly arrived in London from Fife. (An old photograph shows the portrait on a stand in front of Rembrandt's *Old Woman Reading*.) The other self-portrait is by Enoch Seeman the Younger, painted when he was 19, an enigmatic likeness as a young man.

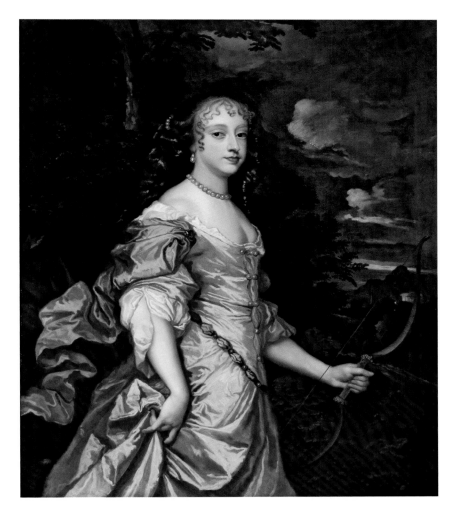

OPPOSITE *Over the piano are Sir Peter Lely's sumptuous portraits of women at Charles II's court known as the Windsor Beauties. Above Duchess Charlotte Anne's monogrammed writing desk, supplied by E.H. Baldock for Dalkeith, is an exuberant George III mirror attributed to John Thomson – at its base a winged Douglas heart is surmounted by a ducal coronet. Sophia Campbell, Baroness de Clifford, governess of Princess Charlotte, hangs above a caricature of her rakish contemporary, Old Q*

ABOVE SIR PETER LELY (1618–80)
Frances Stuart, Duchess of Richmond and Lennox, dressed as Diana
The Duchess, dressed in shimmering gold silk, holds Diana's bow against a stormy landscape. Francis Stuart was the daughter of a physician at Queen Henrietta Maria's court. She was born in exile in 1647 and sent back to England as a maid of honour. There 'La Belle Stuart', as she was known, famously refused to become Charles II's mistress

LEFT ENOCH SEEMAN (C.1694–1744)
Self-portrait, c.1713
*This portrait of a young man looking
quizzically over his shoulder – a nod to
Kneller's 1685 self-portrait – was recorded
as hanging in Montagu House in 1746, so
it may have been bought from the artist
by John, 2nd Duke of Montagu. Born into
a family of painters in Danzig, Seeman
had come to London with his father in 1704
and was soon in demand for portraits*

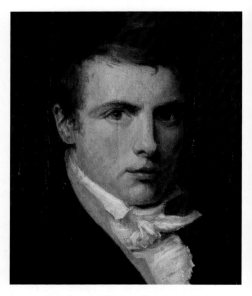

ABOVE SIR DAVID WILKIE (1785–1843)
Self-portrait, 1811
*A minister's son from Fife, Wilkie was 20
when his genre scenes brought him overnight
fame in London. An early drawing of his
mother and a pencil self-portrait from 1803,
now at Bowhill, reveal a precocious talent.
Nothing prepares us for the intensity of this oil*
RIGHT CIRCLE OF DAVID MARTIN (1737–97)
Portrait of a lady and a gentleman
*When the 5th Duke bought this painting in
1868 it was identified as a portrait by George
Romney of the playwright Sheridan and
the actress Mrs Robinson as Perdita. Mary
Robinson was also a poet and freethinker*

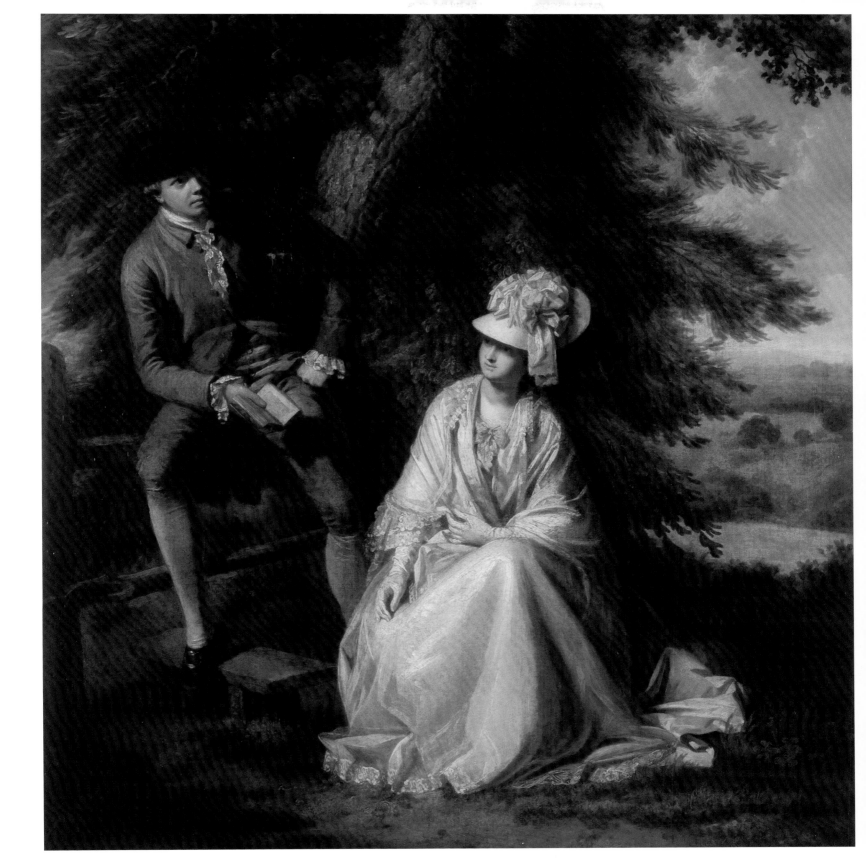

ABOVE SIR EDWIN LANDSEER (1802–37)
Comet, saddled for a lady, 1858

SIR DAVID WILKIE (1785–1843)
ABOVE LEFT **'The Gentle Shepherd', 1802**
*Painted when he was 17, this dramatised genre
study anticipates Wilkie's 'Village Politicians',
which took the Royal Academy by storm in
1806. The scene is from Allan Ramsay's
1725 comedy of the same name, in which the
character Patie disbelieves the prophecy of Sir
William, now disguised as a seer. Ramsay was
born in Leadhills, not far from Drumlanrig.
His son Allan became Painter to the King*
LEFT **A man shearing sheep in a barn**
*Wilkie visited the 4th Duke of Buccleuch at
Bowhill in 1815 when staying with Walter
Scott at Abbotsford. He was fêted there at
'a great cattle show', eating at 'the Table of
Talents' with Scott and the poet James Hogg
(The Ettrick Shepherd). He later made an
informal portrait of the 4th Duke at Thames
Ditton, just before the Duke's death*

LEFT *Portraits of Walter Francis, 5th and 7th Duke, by Henry William Pickersgill RA (1782–1875), and a lady by Cornelius Johnson (1593–1661) hang beside a slim walnut longcase clock, one of the few pieces of furniture in the Castle to survive from the 1st Duke's day. The 30-hour clock was supplied in 1687 by Joseph Knibb of London (1640–1711), who had made the clock on the North Front, along with its bell, in 1685–86. One of the most inventive clockmakers of the Restoration, Knibb created the first anchor clock for Wadham College in 1670*

ABOVE SIR EDWIN LANDSEER **Georgiana, Duchess of Bedford, 1837** *Georgiana was a daughter of the Duke of Gordon. Her mother, famed for her 'routs' (parties), took her to Paris to marry Napoleon's stepson – politics intervened*

The Northeast Tower

The 1st Duke's 'Gusto Grande' is distilled here into a pleasing geometry of bare essentials

A contemporary admirer of the 1st Duke of Queensberry's grand style, described as 'Gusto Grande', wrote that the Palace at Drumlanrig 'is a square Building of fine free Stone, with a spacious Court in the middle, and a Turret, and great Stone Stairs in each Corner'.

The Great Oak Staircase built by the 2nd Duke in 1697 was for formal occasions. The tower stairs, on the other hand, were, and remain, the real arteries, providing access to every part of the house without cluttering up any rooms or views. The pale stone steps fanning out from a central stone newel have an almost geometric modernity. The only ornament on the white walls is an elegant black 'iron cord' banister.

Never mind that this was all rather old-fashioned in the 1690s. Drumlanrig was 'an ancient paternal seat'. Like French châteaux, castles in Scotland were still expected to evoke the aura of *noblesse d'épée* (nobility of the sword).

THE TOWER'S SPIRAL STAIRCASE
Built between 1679 and 1686, this was the first of the four costly tower staircases to be started and the last to be completed. The door opens into the Courtyard

Rembrandt in the Boudoir

A world apart from the rest of the house, the Duchess's Boudoir has been recast as a contemplative space for the Castle's luminous masterpiece

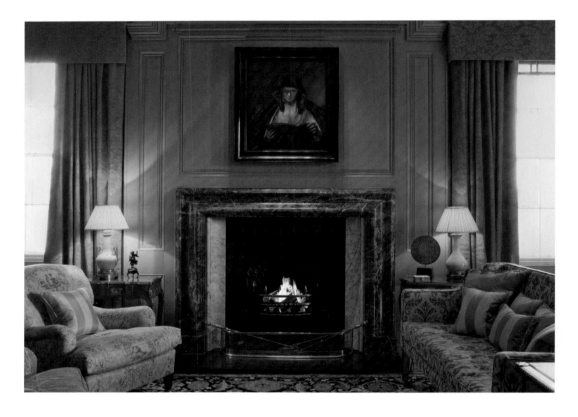

REMBRANDT VAN RIJN (1606–69)
An Old Woman Reading, 1655
Hanging above the fireplace in the Boudoir is one of Rembrandt's most sublime studies of old age, his portrait of 'An Old Woman Reading'. It was one of two Rembrandts acquired in 1756 by the 3rd Duke and Duchess of Montagu, Buccleuch forebears, from the son of the late Edward Scarlett (1688–1743), 'optician to His Majesty'. The other was
a self-portrait. They paid £40 for them. George Vertue records Scarlett, who invented spectacles with earhooks, gathering a 'neat curious collection' of mostly Dutch paintings. Rembrandt's poignant evocation of the power of sight must have appealed to an optician

The transformation of this previously characterless and unloved sitting room into a fitting home for Rembrandt's *An Old Woman Reading* has been perhaps the most rewarding project undertaken in a generation. Only now nearing completion after four years, almost every aspect of the room is new. The oak panelling and bookcases were created by the talented team of Estate joiners. Spanish Marrón Emperador marble was carefully selected for the fireplace to harmonise with the mellow browns of the Rembrandt. A perfect Heriz rug was found by Scott Macdonald, the Collections director. The muralist Alasdair Peebles skilfully teased out the final colour for the walls. Curtains and chair coverings were made with the help of local colleagues Alison Graham and Mags Wilson. It is a home-team production, which is perhaps why taking a seat in it with a fire lit and book in hand is a particularly happy experience.

At its heart is the 'Old Lady', as she is always known in the family, calm and thoughtful. But she needs company, and around the room are a selection from the 17th-century Dutch and Flemish paintings that became so popular with British collectors: landscapes by Van der Neer and Ruysdael, genre scenes by Van Ostade and Teniers, and a scarlet lobster by Jan Fyt that stands out in somewhat shocking contrast. Beautiful portraits

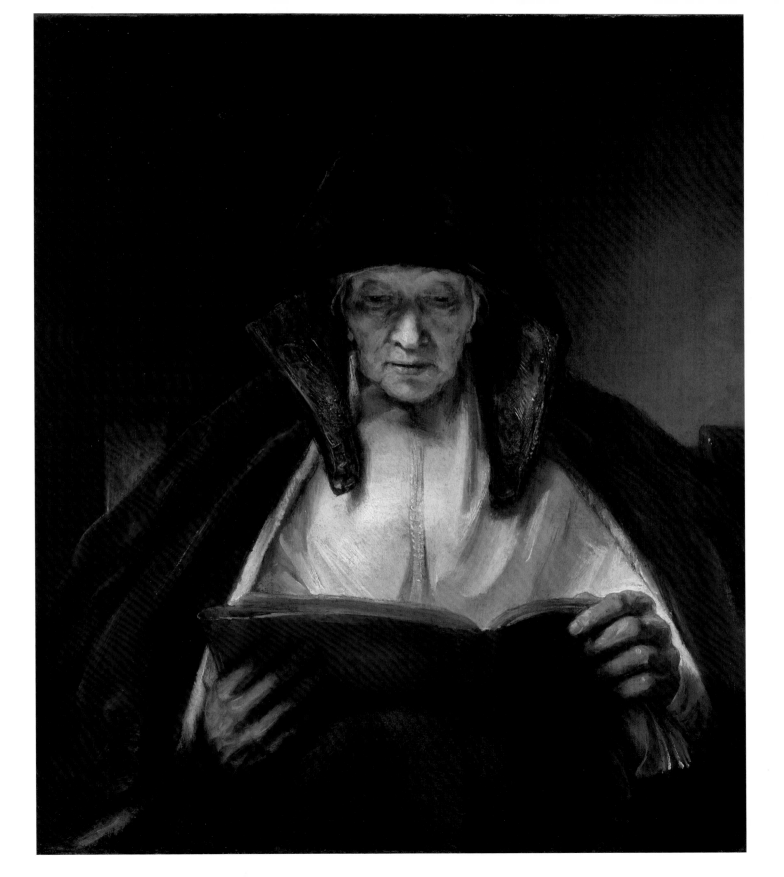

of a surgeon and his wife by Pieter Pourbus (following pages) were brought from Boughton, the family's house in Northamptonshire, to provide further companionship. The surgeon holds his scalpel over a skull as his wife fingers her beads. The year 1565 is just legible next to his head. They were acquired by Ralph, 1st Duke of Montagu, in the belief that they were by the Flemish court painter Antonis Mor, and hung in the 'Painted Stone Hall' of Montagu House in London, later home to the British Museum.

An Old Woman Reading by Rembrandt was bought by Duke Ralph's granddaughter Mary Montagu (page 135) and her husband, George, 3rd Duke of Montagu, in 1756 from the son of George II's optician. It was acquired with a Rembrandt self-portrait that was sold from the Buccleuch collection in 1928 and is now in the National Gallery of Art in Washington.

Thanks to an 18th-century engraving, it was long thought to be Rembrandt's mother, but modern scholarship now suggests that it shows a Biblical figure, possibly the prophet Hannah, who, the Gospel of Luke tells us, worshipped night and day in prayer and reading. On close inspection her robes and hood are richly embroidered with traces of gold and red thread, fitting for someone of importance. The play of light is complex and seems to reflect onto her face from the book almost as if, as someone has suggested, it is concealing an iPad. She is reading with such intense concentration that

her lips seem almost to move as she follows the words. Yet for all that focused mental energy, she exudes a calm that spreads across all who share her company.

When brought into the collection in the mid 18th century, the Old Lady was given an elaborate contemporary gold frame. However, seen beside other Rembrandt masterpieces in recent major exhibitions, it became apparent that the frame distracted from the painting itself. With the invaluable help of the Rijksmuseum's director, Taco Dibbits, a search for a replacement concluded with the acquisition of a fine, simple 17th-century ebony frame from Rollo Whately of St James's, London.

THE BOUDOIR COMES BACK TO LIFE
During the Second World War, when a girls' school moved into Drumlanrig, the Boudoir became the family sitting room – all books, dogs, newspapers and gossip. After the war, daily life gravitated to the Morning Room directly below, and the Boudoir somehow lost its soul. With Rembrandt's Old Lady in need of a more intimate space, it was time to breathe new life into the room, as a place to gather, read and enjoy a feast of paintings. Seen here are a man-of-war saluting the fleet, by a follower of the English marine painter Peter Monamy (1681–1749), and flower paintings by the Huguenot Jean-Baptiste Monnoyer (1636–99)

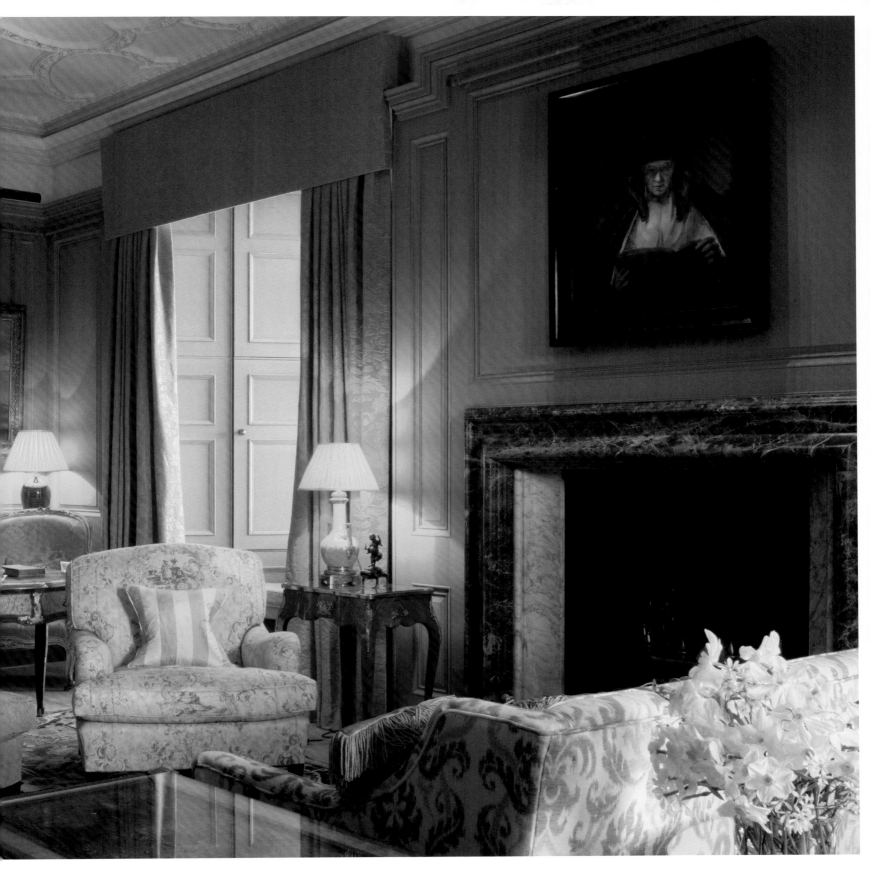

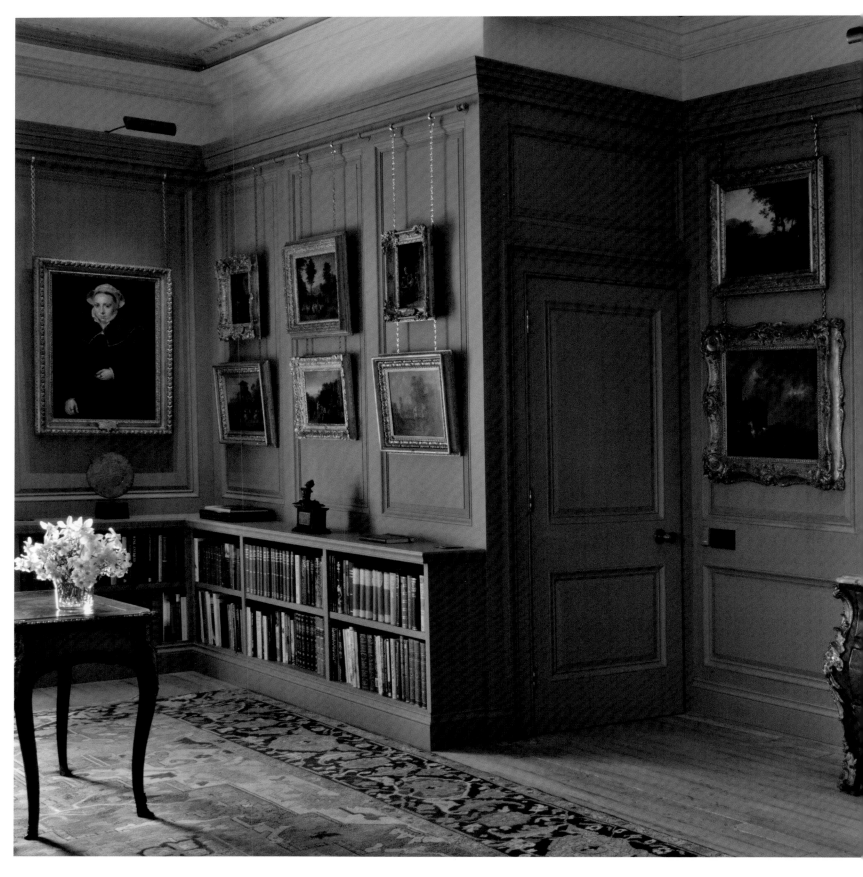

TOP PIETER POURBUS (1523–84)
Portraits of a surgeon and his wife
ABOVE JAN BRUEGHEL THE YOUNGER
(1601–78) **Kermesse with Travellers**
LEFT *'Still Life with a Lobster' by Jan Fyt
(1611–61) was bought by the 5th Duchess of
Buccleuch for Bowhill's Dining Room. Next*

*to it are landscapes by Philips Wouwerman
(1619–68) and Adam Pynacker (1622–73).
Above the books are a moonlit river by
Aert van der Neer, card players by David
Teniers the Younger and a tavern scene by
Van Ostade. Dancing peasants by Francesco
Zuccarelli (1702–88) seem equally at home*

THE BOUDOIR'S CABINET PAINTINGS
LEFT ATTRIBUTED TO
PIETER JANSSENS ELINGA (1623–82)
**An interior with a woman preparing
a meal and four children saying grace**
TOP AERT VAN DER NEER (1603–77)
A town by a river at sunset
ABOVE JAN GRIFFIER (1652–1718)
**View of an old town on the River
Scheldt with Antwerp in the distance**
*Many of the Dutch and Flemish cabinet
paintings in the Boudoir, including the
Rembrandt, were collected by George,
3rd Duke of Montagu, and his wife, Mary,
who toured the Low Countries in 1754,
admiring 'the excellent Flemish masters' and
the prettiness and cleanliness of the cities*

TOP ABRAHAM STORCK (1644–1708)
A Dutch man-of-war with other vessels
*Storck's marine scenes are particularly good
at capturing passengers and bystanders
and the ceremonial side of shipping life*
ABOVE
ABRAHAM GOVAERTS (1589–1626) AND
HENDRICK DE CLERCK (C. 1560-1630)
**The Angel appearing to Hagar and
Ishmael in the Wilderness**
*Abraham Govaerts specialised in forests
and often cooperated with fellow artists. In
this detail of an oil painting on copper, the
figures are by Hendrick de Clerck, known
for his biblical and allegorical scenes*
RIGHT DOMENICUS VAN TOL (C. 1635–76)
A shepherd playing a flute
*Music was a leitmotif of Dutch art. A
version of this work in the Leiden Collection
is attributed to Dirk van Santvoort*

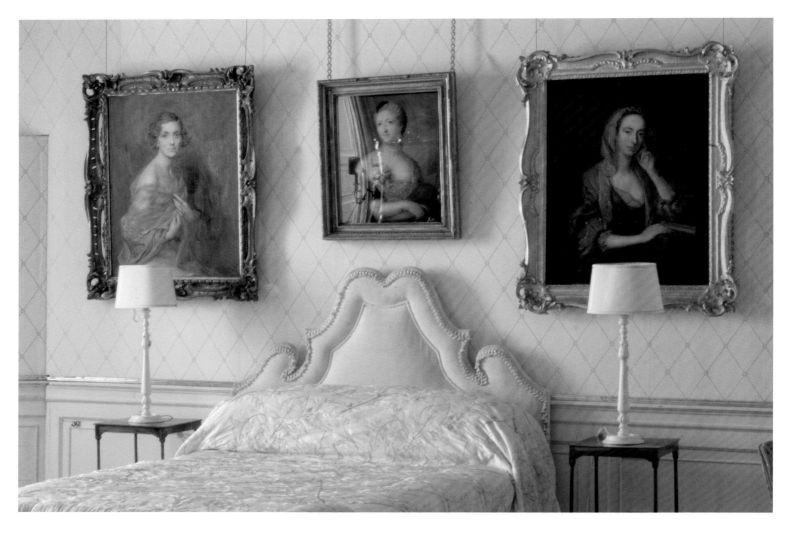

The White Bedroom

A haven of tranquillity for four duchesses

This bedroom, with its many shades of white, has a glorious view over the River Nith. It last belonged to Mollie, Duchess of Buccleuch, grandmother of the present Duke, who loved to walk her succession of black spaniels in the hills around Drumlanrig. Her glamorous portrait by de László, painted in 1932, hangs on one side of the bed. On the other is the impetuous young Kitty, Duchess

of Queensberry. On the opposite wall, an older, wiser Kitty, arms folded, hangs next to the fireplace in a pastel by Katherine Read, painted a year before Kitty died.

Two further duchesses share this coolly elegant room, with its rope-trellis wallpaper by Cole & Son and pale-grey damask sofas. To the left of the fireplace is Kneller's profile in oil of Lady Mary Churchill, daughter of the great Duke of Marlborough, who

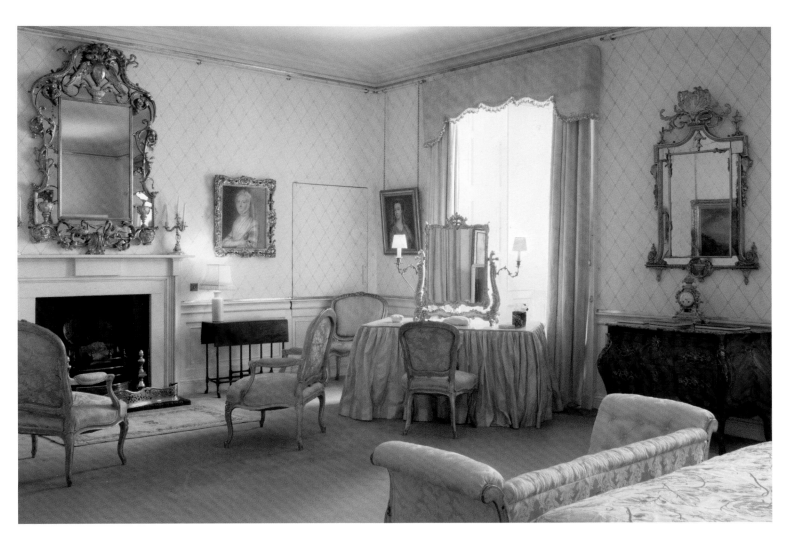

married John, 2nd Duke of Montagu.

Over a marquetry bureau is Gainsborough's portrait of her daughter Mary, 3rd Duchess of Montagu, as a *grande dame*. An intimidating sitter, it was Mary who, with her husband, the Earl of Cardigan, bought the family's Rembrandt and Leonardo. A youthful pastel in vivid blue by Francis Cotes (1726–70) hangs next to a disguised door to the Duke's dressing room.

OPPOSITE To the left of the bed is the great beauty Mollie, Countess of Dalkeith, wife of the future 8th and 10th Duke, by Philip de László, and, to the right, Kitty, Duchess of Queensberry, by Van Loo. Between them is Lady Mary Coke (née Campbell), daughter of John, 2nd Duke of Argyll, and sister of an earlier Lady Dalkeith. The writer, wit and connoisseur Horace Walpole saw this portrait at Adderbury, her father's house in Oxfordshire, and attributed it to Grace Boyle, Countess of Middlesex,

Mistress of the Robes, who was a pastellist and a founder of the Royal Academy
ABOVE To the right of the door is Lady Mary Montagu, later 3rd Duchess of Montagu. The pastel of Kitty at 75 beside the fire is by Katherine Read, who also painted Queen Charlotte and Madame Élisabeth de France. In London it was 'as much the fashion to sit to Miss Read, as to take air in the park'. Born in Dundee into a Jacobite family, her career had taken off in Paris and Rome, where she fled after Culloden

A new addition to the White Bedroom is this capriccio of a seaport by Madame Élisabeth de France, sister of Louis XVI. Its poignant provenance goes back to the exiled French court in Edinburgh. The 5th Duke of Buccleuch bought it from Augustus Lindley, whose grandmother Lady Elizabeth Murray received it from the Comte d'Artois (Charles X) at Holyrood, where both had apartments. Élisabeth, who refused to flee the Terror, was executed in 1794.

The portrait of Mary, 3rd Duchess of Montagu, is one of several Gainsborough painted. She inherited her taste from her parents, the 2nd Duke and Duchess of Montagu (below), but not the dukedom, which her husband had to earn again.

It is tempting to wonder if the painting below right is the 'loosely attired' Nell Gwyn seen at Smeaton, the 2nd Duke of Buccleuch's hideaway at Dalkeith.

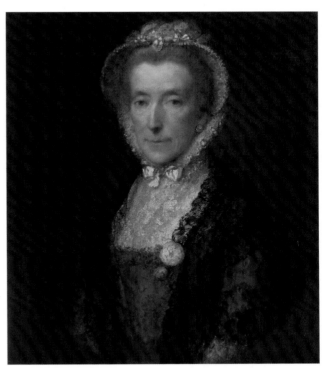

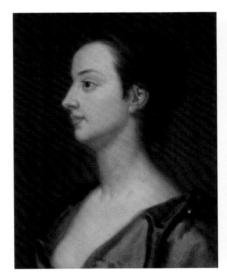

ABOVE ATTRIBUTED TO GODFREY KNELLER
Mary Churchill, 2nd Duchess of Montagu
LEFT MADAME ÉLISABETH DE FRANCE
(1764–94) **A capriccio of a seaport**

ABOVE CIRCLE OF GARRET MORPHY (C. 1655–C. 1716)
Portrait of a lady, perhaps Nell Gwyn
TOP THOMAS GAINSBOROUGH RA (1727–88)
Mary, Duchess of Montagu (1712–75), 1768

The independent Duchess

Catherine, or Kitty, Hyde, who married Charles, 3rd Duke of Queensberry in 1720, was a wonderful woman of independent spirit and imagination – 'Wild as a colt untamed', as an admiring satirist Matthew Prior famously described her in his poem 'The Female Phaeton' (page 103). Her circle included many of the leading musicians and writers of the day, most notably John Gay, whose satirical ballad opera *The Beggar's Opera* caused a sensation, running for a record 62 nights at Lincoln's Inn Fields. The

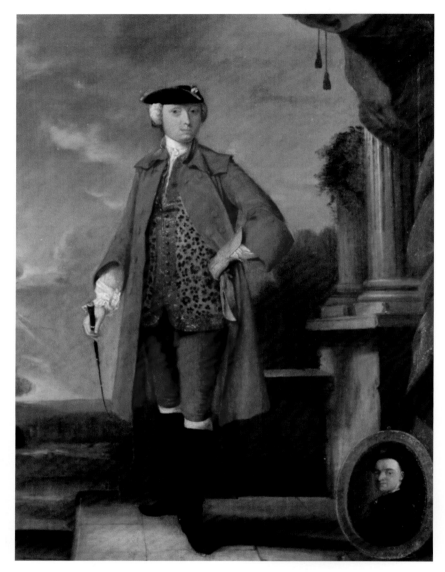

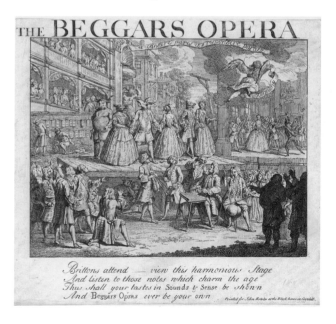

ABOVE CHARLES PHILIPS (C.1703–47)
Charles, 3rd Duke of Queensberry
In this dashing portrait of the 3rd Duke in red coat and leopard skin, John Gay's portrait leans against a pedestal
LEFT *A popular engraving promoting Gay's operatic satire of politics, poverty, injustice and governmental corruption*

OPPOSITE KATHERINE READ (1723–78)
Kitty, Duchess of Queensberry, 1776
An oil version of the pastel portrait of Kitty aged 75. Late in life, Kitty took Archibald Douglas's side against the Duke of Hamilton over the Duke of Douglas's inheritance, a case dubbed the Douglas Cause, which led to riots in Edinburgh. The portrait was a thank you gift for Judge Lord Thurlow's perceived help

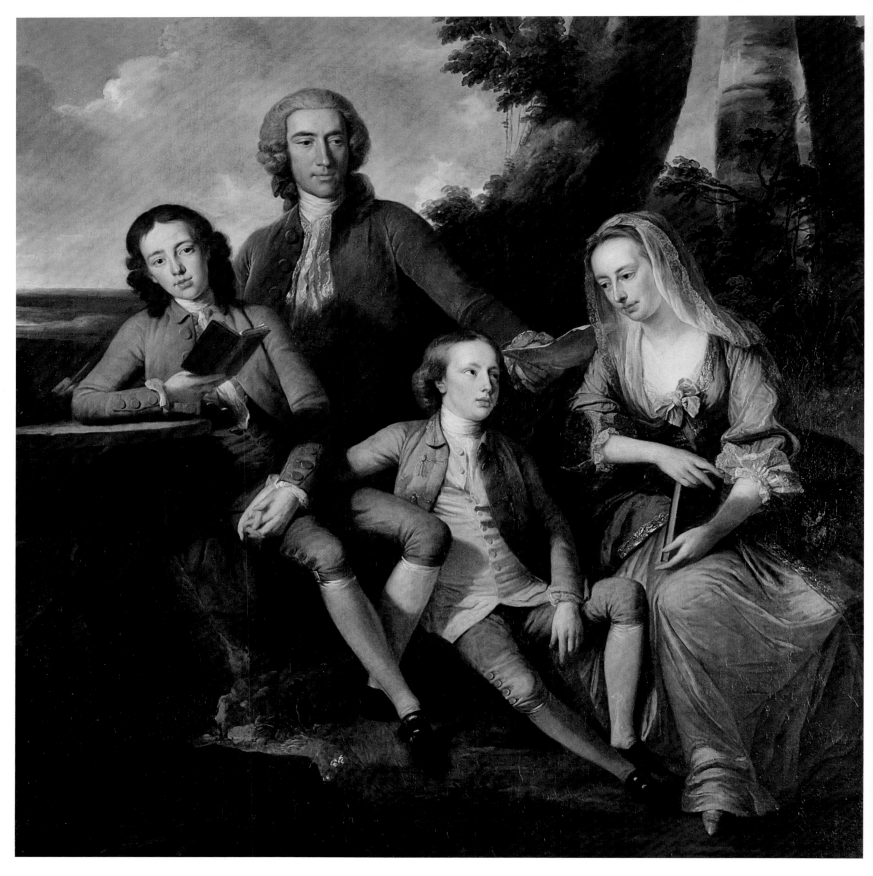

prime minister, Sir Robert Walpole, outraged by his caricature, had its sequel, *Polly*, banned (see page 36). When Kitty's outspoken demands that George II intervene led to her being banned from Court, her response was unabashed: 'The Duchess of Queensberry is surprised and well pleased that the King hath given her so agreeable a command as to stay from Court.'

Charles and Kitty's friendship with Gay was a deep one and he spent much time with them as they retired to their Scottish homes, Drumlanrig and Queensberry House in Edinburgh's Royal Mile, now part of the Scottish Parliament complex. When Gay died in 1732, the couple were responsible for his fine monument in Westminster Abbey, with its elegiac inscription by Alexander Pope (page 142). In 1733, Kitty also built a hermitage in

ABOVE *A theatrical flourish on a mirror attributed to John Thomson that once belonged to Duchess Kitty (page 156)*
RIGHT *A washstand with English jugs, bowls and a foot basin was found in every bedroom before the days of running water*
BELOW RIGHT *A caricature by William Austin of Kitty with her fencing and riding master, Julius Soubise, an Afro-Carribean slave given to her by a cousin in the Royal Navy. She freed him, and he became a popular society figure*

OPPOSITE
GEORGE KNAPTON (1698–1778)
The 3rd Duke and Duchess of Queensberry with their two sons
The intimate family portrait in the Front Hall, of Charles and Kitty with their sons, Henry, Earl of Drumlanrig, and Lord Charles Douglas. Henry, who chose a military life, was 31 when he accidentally shot himself with one of his pistols in 1754. Charles died of consumption in 1756

ABOVE CHARLES PHILIPS (C. 1703–46)
Kitty, Duchess of Queensberry (right)
in a garden with an unknown lady, 1733
Kitty, with a cockatoo, sits with a lady long
said to be her cousin Bridget Hyde, Duchess
of Leeds. But the Duchess died, aged 64, a
year after this picture was painted. Kitty's
companion is more likely to be her younger
sister, Charlotte Hyde, a great beauty who
died unmarried. This picture may show
Gay's Cave, a hermitage Kitty built in 1733
at Amesbury in Wiltshire to honour Gay.
More probably, it is a Bronze Age tumulus.
A fearless gardener, Kitty incorporated
prehistoric features of Salisbury Plain into
her great garden landscape with the help of
Charles Bridgeman, a pioneer of naturalism.
Stonehenge was a 20-minute walk away

OPPOSITE
WILLIAM AND DAVID CRAWFORD
AFTER DAVID LOW
Plan of Drumlanrig Castle and
Gardens as they were in 1739
The original plan of Charles and Kitty's
splendid flower gardens was drawn
by their head gardener, David Low.
This hand-coloured copy, made by the
Edinburgh surveyors William and
David Crawford in 1818, suggests a
new interest in reviving the gardens.
Their colourful rendering, with its
vignettes of the Castle and the cascade,
reflects the Crawfords' artistic skills

Gay's memory in their garden at Amesbury, their Wiltshire estate.

Their banishment left them time to complete the magnificent gardens at Drumlanrig, installing great parterres, avenues, basins and a cascade, which were carefully recorded in the 1730s in detailed illustrated plans by the Huguenot surveyor John Rocque and the Drumlanrig gardener, David Low.

Kitty remained a figure of interest and controversy throughout her life. Once among the most fashionable in society, she later refused to wear anything but the plainest of clothes. Energetic in her support of theatrical life, she put on new plays and corralled her friends into taking part. Her relationship with Julius Soubise, an Afro-Caribbean slave, whose freedom she arranged and who became her riding and fencing master, also caused tongues to wag.

For all that she was often ridiculed and disparaged, nobody could fault her or her husband's charitable generosity – among many good works he was a founding Governor of the Foundling Hospital in 1739. Nor could they doubt her curious and inventive mind, one small legacy of which is the early medicine spoon she devised in 1755 for ensuring accurate dosages, now displayed in the collection of the Royal College of Physicians. A true original.

After her death at the age of 76, George, Duke of Montagu, wrote that she had latterly taken on a new lease of life and 'appeared quite happy and in good spirits on the revival of her favourite opera', but she became ill from 'an immoderate quantity of fruit'. Kitty 'undoubtedly had many oddities', he concluded, but 'also, very many great and good qualities'.

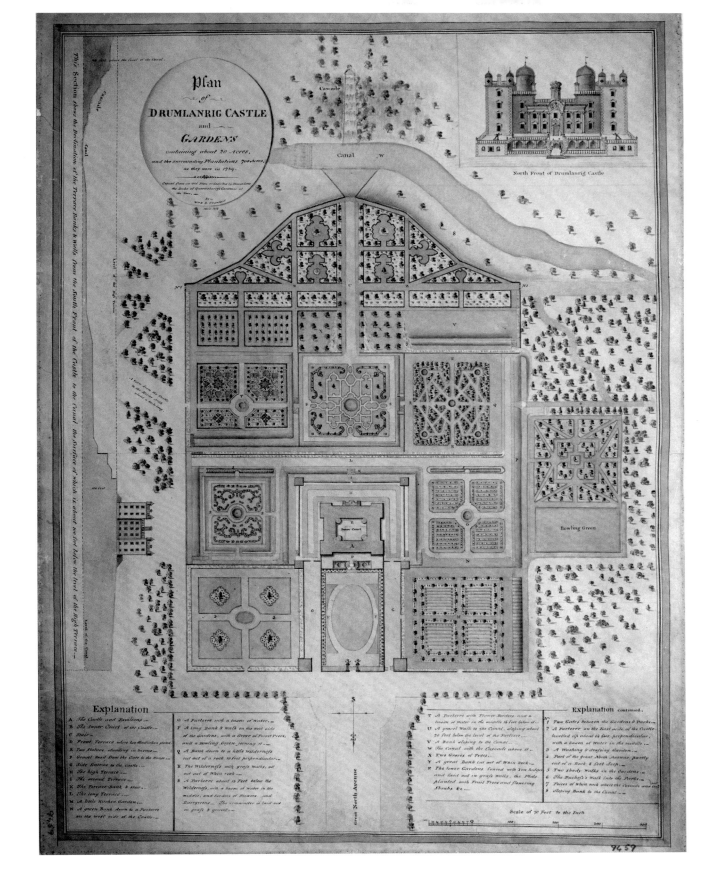

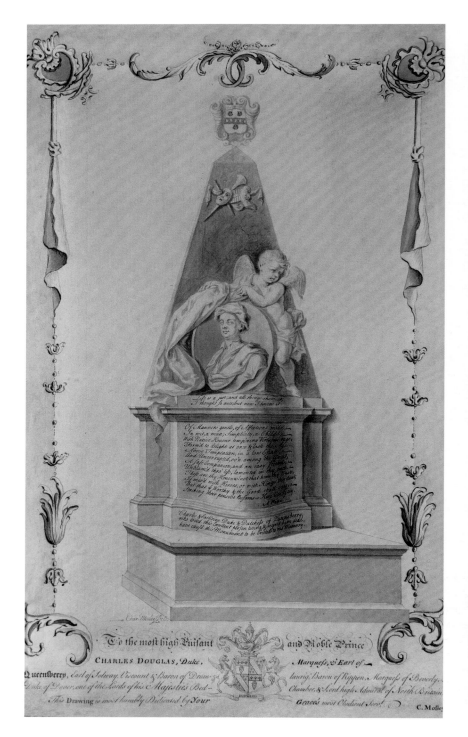

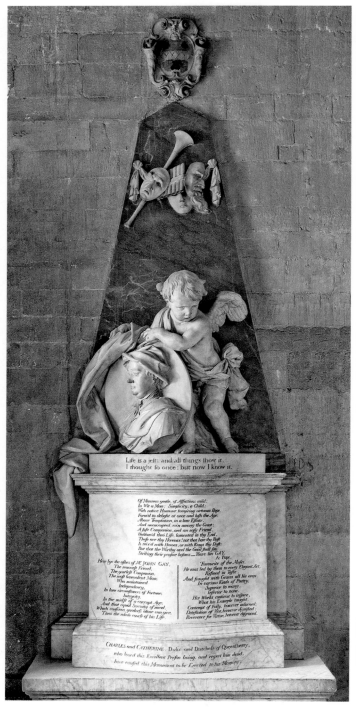

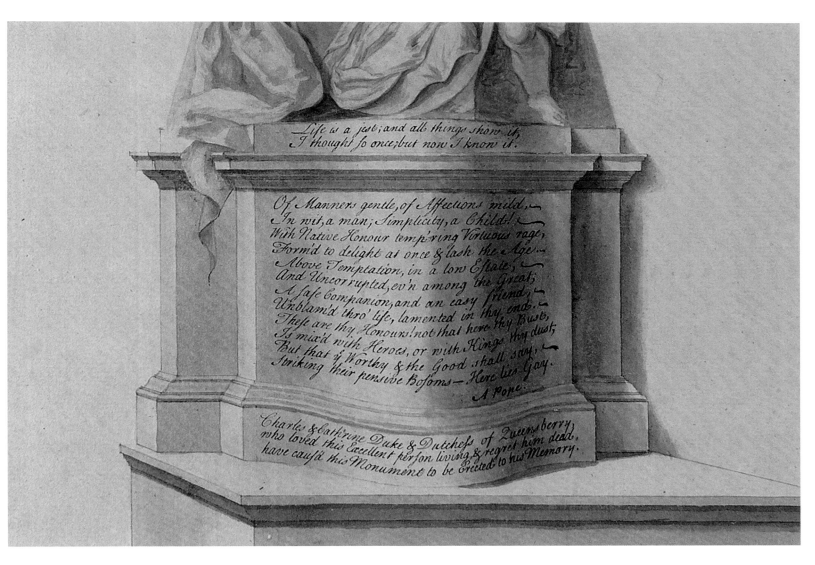

The following text appears within the monument drawing:

Life is a jest; and all things show it,
I thought so once; but now I know it.

Of Manners gentle, of Affections mild,
In wit, a man; Simplicity, a Child!
With Native Honour temp'ring Virtuous rage,
Form'd to delight at once & lash the Age,
Above Temptation, in a low Estate,
And Uncorrupted, ev'n among the Great;
A safe Companion, and an easy friend,
Unblam'd thro' life, lamented in thy end.
These are thy Honours! not that here thy Bust,
Is mix'd with Heroes, or with Kings thy dust;
But that of Worthy & the Good shall say,
Striking their pensive Bosoms — Here lies Gay.
A. Pope

Charles & Cathrine Duke & Dutchess of Queensberry,
who loved this Excellent person living, & regret him dead,
have caus'd this Monument to be erected to his Memory.

LEFT THE QUEENSBERRY JOHN GAY MEMORIAL, WESTMINSTER ABBEY
This monument by John Michael Rysbrack, erected against the Abbey's south wall in 1732, is inscribed with Gay's own epitaph:
 Life is a jest; and all things show it,
 I thought so once; but now I know it.
Below it, a longer inscription, by Alexander Pope, extols Gay's 'native humour temp'ring virtuous rage, form'd to delight at once and lash the Age', while on the base is written: 'Charles and Catherine, Duke and Dutchess [sic] of Queensberry, who loved this excellent person living, and regret him dead, have caused this monument to be erected in his memory'
FAR LEFT AND ABOVE
The design for the monument, engraved by Charles Mosley (c. 1720–1756)

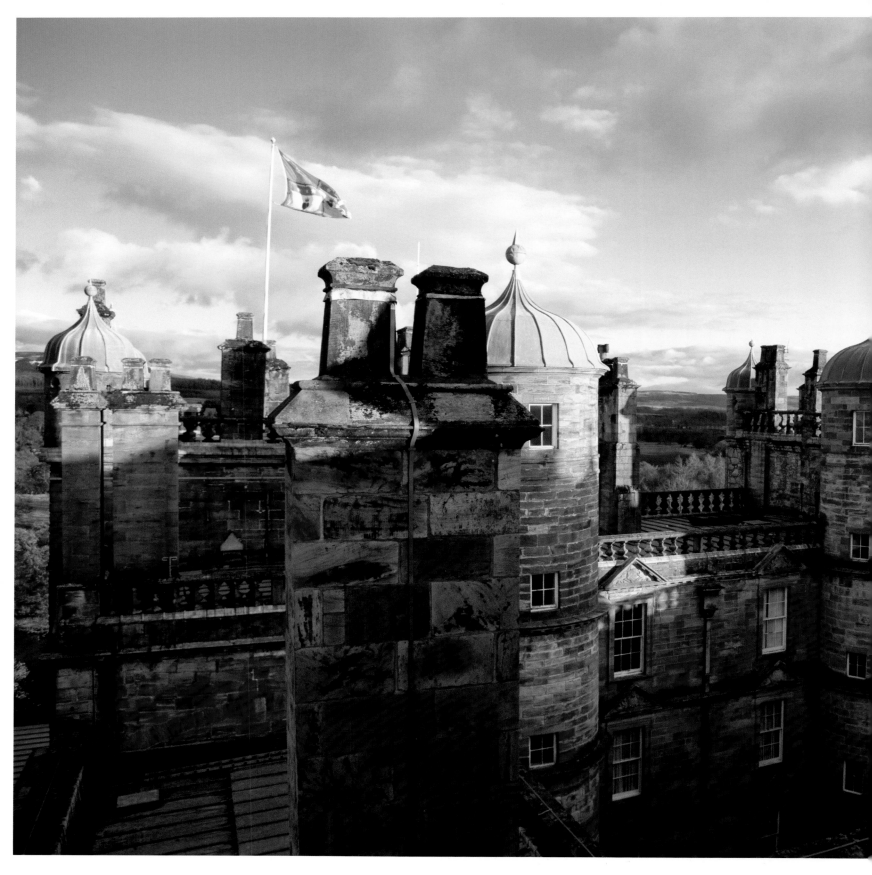

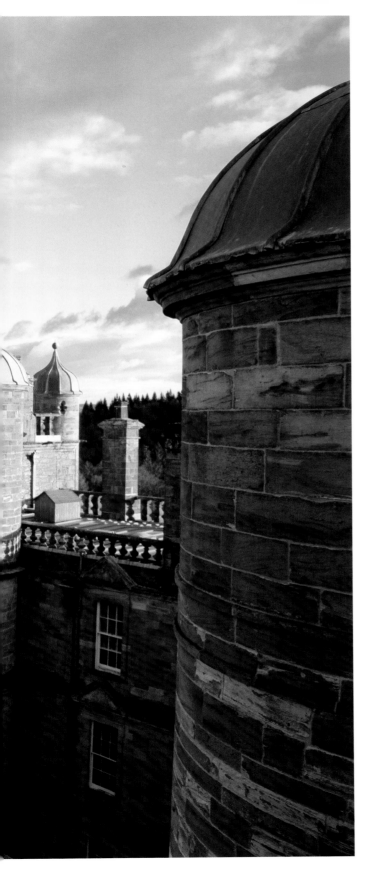

Hidden realms

The top of the house is a world of turrets, passages and bedrooms with glorious views. The Basement is a misnomer, being a light and airy space actually on the ground floor

Drumlanrig's roofline is unforgettably defined by the multiple turrets with their pointed ogee domes: three small ones for each of the four towers and a larger one above each of the four circular staircases that ascend five flights from the Basement. The Clock Tower completes the picture, affording support for a great ducal coronet carved in stone. The family standard used to fly above it but was moved to the Northeast Tower, where the banner billows more freely.

In all there is almost an acre of lead roofing, including the flat roofs that link the four towers. Fortunately, the 1st Duke was able to draw on his own lead mine. Its story dating back to the 16th century – when gold and silver were also found – is told in the fascinating Mining Museum in Wanlockhead, Scotland's highest village, a few miles from the Castle. Sadly, the mine had closed by the time the lead came to be renewed by the present Duke's father in the 1970s.

Above Drumlanrig's three principal floors, each of the towers is a separate little universe of rooms, used long ago as sleeping quarters for the servants. Some are now restored as guest bedrooms, and others remain jumbled storage spaces that occasionally yield forgotten treasures.

One level down are the old bedrooms, off a Byzantine maze of passages that often leaves visitors lost and bewildered, despite helpful Victorian painted instructions. An eclectic mix, all the rooms offer views in every direction, sometimes with slightly alarming floor-to-ceiling windows.

LEFT UP ON THE ROOF
The Castle's myriad lead roofs and domes. The family standard flies in a cold north wind above the giant chimney stacks
ABOVE *A tower door gives useful directions for confused guests*

The Charter Room

After more than 300 years, the Charter Room still has its vaulted ceiling, iron door and oak-lined walls

A darkened oak door with no handle and a massive key gives entry to the small but vital space that is the Castle's Charter Room. Almost unaltered in over 300 years, with its original press, or cupboard, and deep drawers filled with historic documents that stretch back further centuries, it gives the impression even now of guarding the secrets of the past.

Until relatively recently, handwritten charters with their authoritative seals were the only way of proving ownership of the Castle and its extensive estates. Fire even more than theft was the danger, hence the thick walls and vaulted stone ceiling, not just here but

ABOVE AND LEFT *The 17th-century iron door of the Charter Room, designed to preserve the room's contents from fire* OPPOSITE *Inside the Charter Room, the groin-vaulted ceiling is in its original unplastered state. The room below, once the Duke's study, is also vaulted in stone*

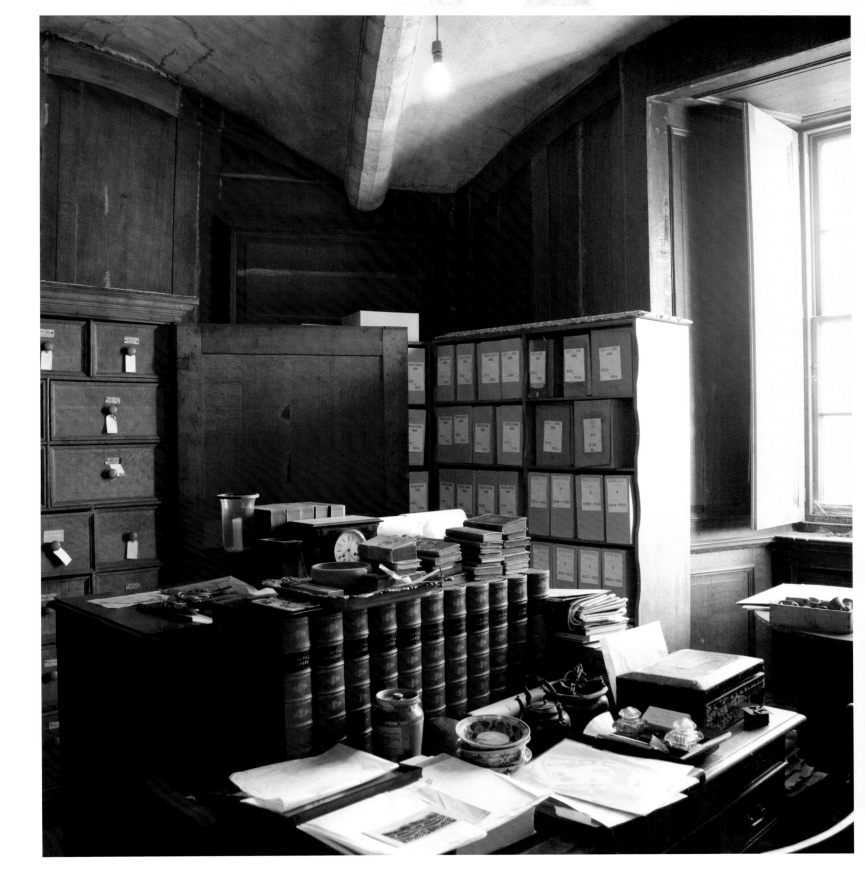

in the room directly below, and the second double door of 17th-century iron. Described in 1694 as 'my Lord Duke's Study' and strategically situated on the West Corridor that links the State Bedchamber (now Bonnie Prince Charlie's Room) with the impressive Gallery, which ran along the North Front, it must have been the nerve centre of the 1st Duke's growing property empire.

The Queensberry archives have lain more or less undisturbed since the 1st Duke, horrified by his own extravagance, wrote his famous curse on his rolls of accounts: 'The devil pike out his eye, who looks herein.' Still tied in bundles with their original playing-card labels, his accounts and receipts chart his spending from his time as a young man in France to the years he was rebuilding the Castle. The present Duke's Archivist has braved his grim warning – and they make fascinating reading. Periodic instructions to his workmen suggest that he was a micro-manager, ever fearful that his money was being spent recklessly.

Inventories of 1694 and 1712 fix the contents of the Castle exactly as the first two Dukes bequeathed them. Also in the Charter Room are their letters and political correspondence as the two most powerful men in Scotland. A volume of letters to the 1st Duke from the future James VII and II when he was Duke of York catches the eye.

The 2nd Duke and his brothers went on extensive Grand Tours as young men – their vivid journals, letters and accounts now live in the Archive.

The charters in the Charter Room still largely reside in the deep wooden drawers made to store them at the time the 1st Duke was rebuilding the Castle.

They cover the far-flung Queensberry estates in the borderlands of Scotland back to at least 1190. Through a marriage connection, they also include the English estates of the Hyde family, Earls of Rochester, in Middleton Stoney, Oxfordshire.

Drumlanrig Castle is first mentioned in a charter of 1429. The archive embraces many kinds of estate record. A fine series of maps and plans includes a few early-17th-century plans of the Castle as well as ambitious unfulfilled designs for rebuilding it in the 19th century by Charles Barry and Edward Blore. Probably the most unusual records relate to the lead mines at Wanlockhead, dating from the early 18th century onwards.

There are sadly few personal papers connected with Charles, 3rd Duke of Queensberry, or Duchess Kitty. Letters do survive from the Duke's chamberlain, along with papers relating to the gardens, such as John Rocque's plan of 1739. Even less survives from the notorious Old Q.

The archives resume when the 3rd Duke of Buccleuch assumes the Queensberry dukedom in 1810, with letters from French royal exiles and the future 4th Duke of Buccleuch from his travels abroad. It then becomes part of the wider Buccleuch archives, now shared between Bowhill, Boughton and the capacious Staff Hall at Drumlanrig itself. Some significant 19th-century collections have come to rest in the Charter Room, such as the 5th Duke's voluminous accounts with Garrard the jewellers, and the future 7th Duke's ships' logs. The estate papers continue in an unbroken line.

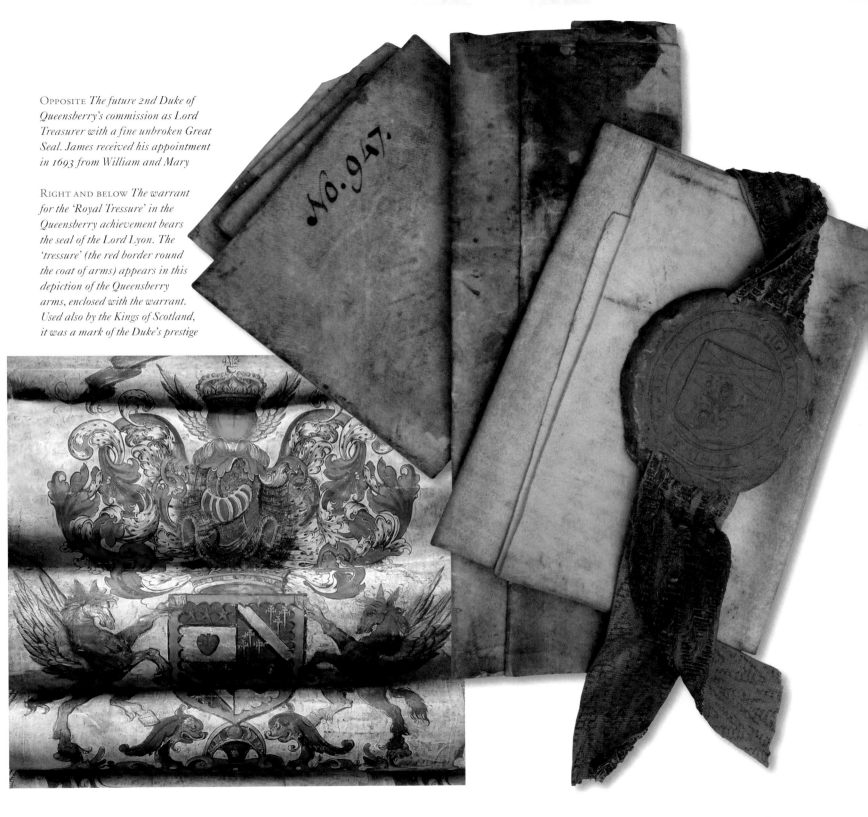

OPPOSITE *The future 2nd Duke of Queensberry's commission as Lord Treasurer with a fine unbroken Great Seal. James received his appointment in 1693 from William and Mary*

RIGHT AND BELOW *The warrant for the 'Royal Tressure' in the Queensberry achievement bears the seal of the Lord Lyon. The 'tressure' (the red border round the coat of arms) appears in this depiction of the Queensberry arms, enclosed with the warrant. Used also by the Kings of Scotland, it was a mark of the Duke's prestige*

RIGHT *John Hayes's bill for 'imbroidering'*
borders on 'a dark cloak' for the 1st Duke
OPPOSITE PAGE, TOP *Duchess Charlotte*
Anne was fortunately too busy rebuilding
Montagu House in London to agree to
Charles Barry's proposal for Drumlanrig
BOTTOM RIGHT *The 5th Duke's papers*
include volumes of Garrard accounts
BOTTOM LEFT *One wooden box is full of*
Ottoman pipe mouthpieces, possibly brought
home by the future 6th Duke. A fellow
traveller met the 21-year-old Lord Dalkeith,
as he then was, in Damascus in 1852 in a
rich merchant's house turned hotel, where
he and his party occupied the finest room

BELOW JACOB JACOBSZ DE WET II,
KNOWN AS JAMES DE WET (1641–97)
Lord George Douglas (1667/8–93), 1685
The subject of this portrait in the North
Passage was recently identified as the 1st
Duke's youngest son. The Duke also asked De
Wet to paint portraits of 110 Scottish kings
in just two years (1684–86), for Charles II's
Palace of Holyroodhouse, a rate of one a
week – 97 still hang in its Great Gallery

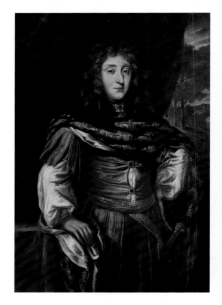

Work done for His
Grace the Duke of
Queensbury

By Order of Mr John Hayes.

For Imbroidering on a Dark
Collourd cloath for a Coat, with
a Broad border down each fore-
vent, and round the slitts, pockets
and facings, with a narrow border
upon each seam

£ β
10:17:06

9th July –

28 of December 1629
Rec'd then of ... Douglas
the Sum of ... nd pounds
in ffull of this Bill
& all accompts I say
rec'd ... mee

John Barber

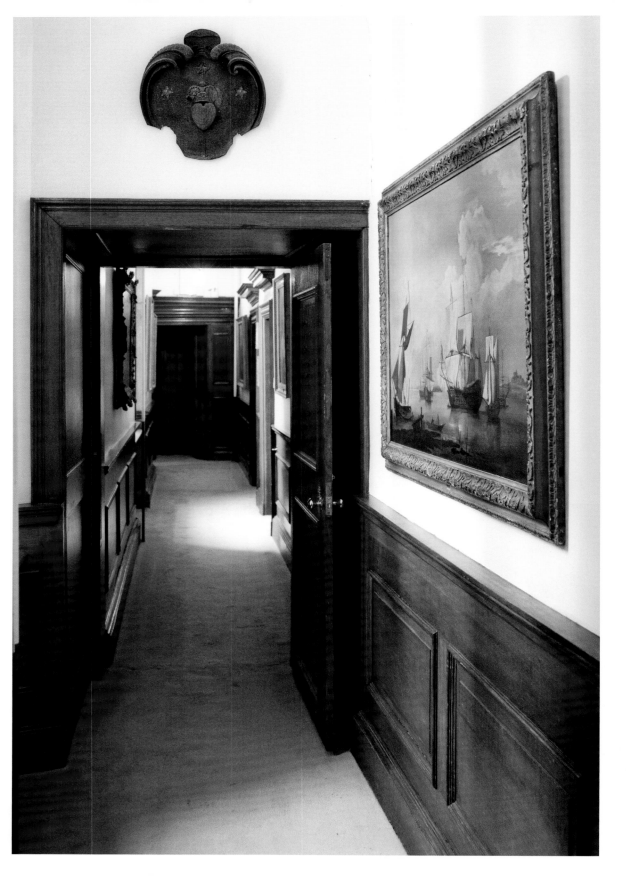

The West Corridor and North Passage

The passages and their bedrooms reveal a formidable cast of characters from the days of the 1st Duke

Moving from the West Corridor into the North Passage, a succession of doors leads into bedrooms of varying size and appeal, which would have been essential to the huge house parties of long-staying guests that characterised the Victorian era. The well-lit walls provide a good gallery for interesting 17th-century portraits, two of them recently attributed to the Scottish artist James Carrudus, and for watercolours by Clérisseau and 'Grecian' Williams.

Above this doorway is a 17th-century Douglas heart carved in wood. Out of sight is a brace of wooden partridges by the eccentric but talented Warwick carver James Morris Willcox, whom Ruskin compared to Michelangelo. His carvings were so lifelike he couldn't bear to part with one and kept it as a pet.

LEFT *The West Corridor once led from the state rooms to the Gallery. Peter Monamy's marine painting now hangs in the Boudoir (page 127)*
OPPOSITE SCOTTISH SCHOOL
James Drummond, 4th Earl of Perth, c. 1670
One of the founders of East New Jersey in 1681, Lord Perth is honoured there by a statue facing Staten Island. This portrait of the 1st Duke's fellow grandee, who would become a fierce rival, was hanging in the Castle in 1694

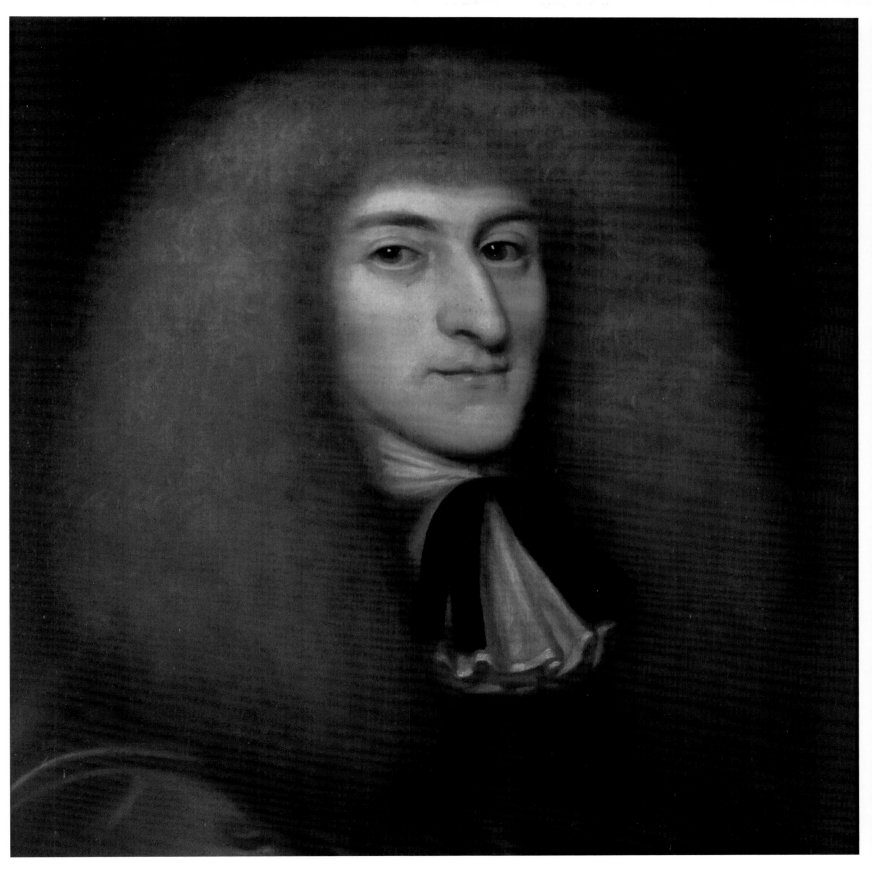

The portraits in the North Passage vividly bring to life the politics of Restoration Scotland. They include the Earl of Traquair by David Scougall and the Earl of Dumbarton by Scougall's son John; Lieutenant General James Douglas, the 1st Duke of Queensberry's brother (opposite) and John Leslie, Duke of Rothes (right), both by the little-known James Carrudus. These and other portraits were commissioned by the 1st Duke to hang in his Great Gallery on the first floor of the North Front (see overleaf).

James Carrudus (or Carruthers) is only now emerging from the shadows, thanks to a new book by the Dutch artist and art historian Carla van de Puttelaar, *Scottish Portraiture 1644–1714*. The Duke of Rothes' splendid portrait in the robes of the Lord Chancellor of Scotland came to Drumlanrig in return for the 1st Duke of Queensberry's gift of his own portrait by the artist, paid for in 1683, according to a bill in the Archives, but possibly painted as early as 1678.

Rothes was instrumental in the then Earl of Queensberry's appointment as Lord Justice General of Scotland in 1680, and Queensberry's portrait was a gift for Rothes's famous picture gallery at Leslie House, the grandest Restoration house in Fife, where it was still hanging in 1953. It has since disappeared from public view – luckily, as the house was gutted by fire in 2000. A Sotheby's photograph (far right) reveals the 1st Duke's attire to be identical to that of his brother James. Carrudus thought nothing of using it a third time in his painting of Robert Carnegie, 3rd Earl of Southesk.

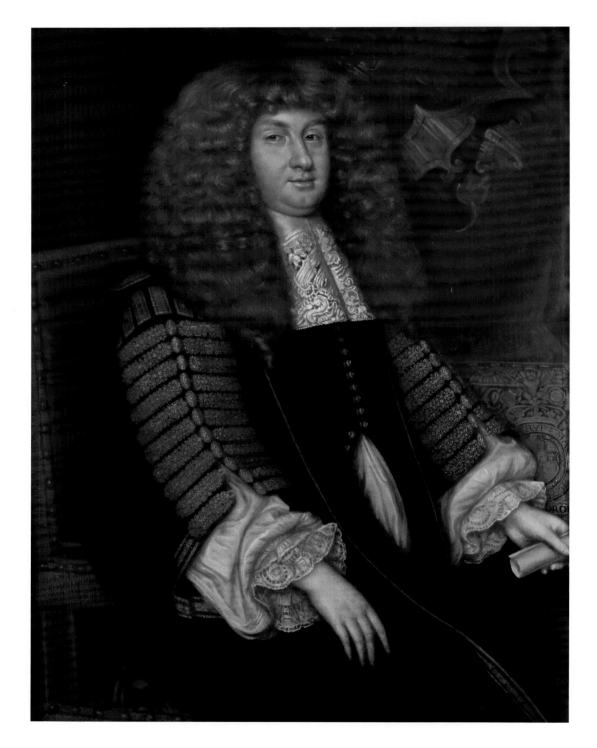

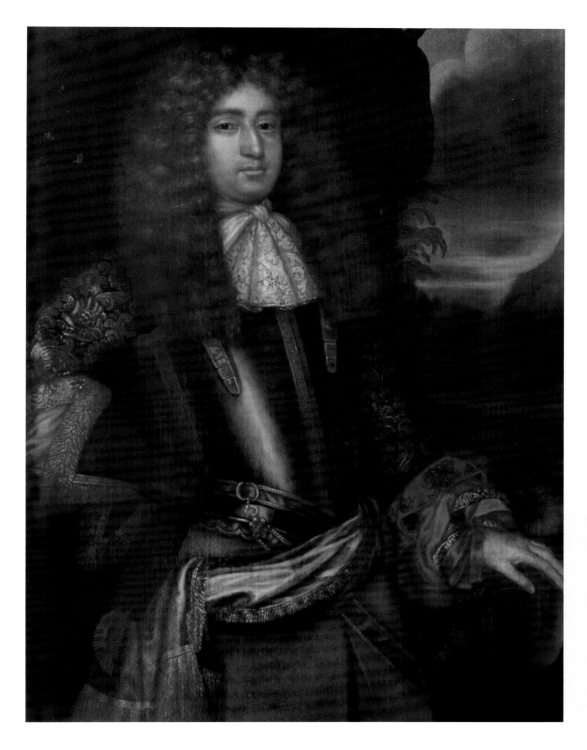

JAMES CARRUDUS (OR CARRUTHERS)
(ACTIVE C.1668–83 OR LATER)
OPPOSITE **John Leslie, 7th Earl and
1st Duke of Rothes (c.1630–81), c.1680**
*For all his grandeur, John Leslie, Earl
of Rothes's road to becoming Lord
Chancellor of Scotland and ultimately
Duke (a year before his death) was a
rough one. Orphaned at ten, he was
deprived of any education by the constant
wars of the period. At 21, fighting for the
King at the Battle of Worcester, he was
captured by the Roundheads and thrown
into the Tower of London. Allowed
back to Scotland on a rarely permitted
visit, he was committed to Edinburgh
Castle by Cromwell to avoid a duel
with Viscount Morpeth provoked by his
overattentiveness to the Viscount's wife*

LEFT **Lieutenant General the
Honourable James Douglas, 1681**
*All three of the 1st Duke of Queensberry's
brothers lost their lives in war, James
dying of a fever at the Siege of Namur in
the Spanish Netherlands in 1691*
BELOW *Carrudus' portrait of the
1st Duke of Queensberry in identical
attire. The portrait had been given to his
political patron, the Duke of Rothes*

The Queen's Bedroom

This airy, very feminine room houses a splendid canopied bed made for Queen Victoria

Just a few steps from the all-important if claustrophobic Charter Room lay the very opposite: an immense gallery running the full 154 feet of the North Front. With windows in every aspect – north, south, east and west – giving light all day long, it must have been an astonishing sight. Defoe called it 'a gallery of beauties, itself a beauty'. The family still have mixed feelings about the decision made on Sir Walter Scott's advice to divide it into bedrooms – the 9th Duke had plans drawn up in the 1980s to restore at least part of it. That said, as the Queen's Bedroom in the Northwest Tower and its counterpart occupying the whole footprint of the Northeast Tower show, there are compensations.

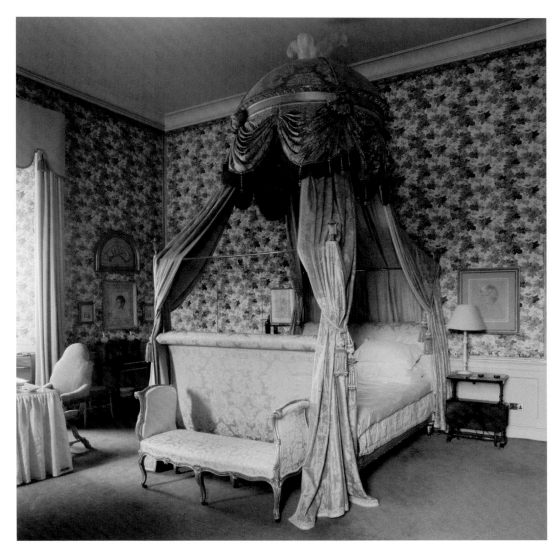

ABOVE *An airy, restful escape from the bustle of the house, the Queen's Bedroom takes its name from the ravishing four-poster bed made specially for Queen Victoria's visit to Dalkeith in 1842*
OPPOSITE *Above the fireplace is an extravagant 18th-century gilded mirror, possibly by John Thomson (see detail, page 139)*
LEFT *The frames of this pair of 19th-century fan designs echo the finesse of the mirror*

Picturesque ruins

The views of Classical ruins in the North Passage by the celebrated antiquarian Charles-Louis Clérisseau are another example of the Montagu legacy. Robert Adam records the artist showing his new drawings of 'Pola' (modern Pula) to Lord Monthermer, brother of Elizabeth, Duchess of Buccleuch, in Venice in 1760.

Hanging nearby are views by a Scottish artist, Hugh 'Grecian' Williams, whose watercolours of Italy and Greece inspired his nickname. The son of a sea captain, his remarkable life story began with his birth aboard a ship to the West Indies. Aged 9, he became ward of Louis Ruffini, an entrepreneurial Piedmontese in Edinburgh who was persuaded by the Duke of Buccleuch's factor in 1790 to open a muslin-embroidery factory in Dalkeith. Ruffini encouraged Hugh to become a painter. Duchess Elizabeth was an early patron.

CHARLES-LOUIS CLÉRISSEAU (1721–1820)
THIS PAGE **Views of ancient Pola, c.1760**
Clérisseau's knowledge of Classical architecture had a strong influence on Robert Adam.
His views of Pola on the Istrian peninsula in modern Croatia show (clockwise from top left) the Amphitheatre, the Temple of Augustus, the backs of the Temples of Augustus and Diana, and the Arch of Sergius Lepidus
OPPOSITE **Capriccio of Roman ruins**
Both draughtsman and architect, Clérisseau excelled in elaborate architectural fantasies

Above Hugh 'Grecian Williams' (1773–1829)
Bothwell Castle and the Clyde, 1799
These distinctive brown-wash drawings by one of Scotland's finest early Romantic painters include the ruins of Bothwell Castle in Lanarkshire (centre). Williams studied under Nasmyth and was patronised by Elizabeth, Duchess of Buccleuch, giving lessons to her daughter-in-law, Lady Jane Douglas. In February 1797 he was providing scenery for 'The Capture of the Cape of Good Hope', a musical performance the Duchess was supporting at the Edinburgh circus

Room 39

The Great Gallery's division in 1813 led to the creation of many curious rooms, none stranger than Room 39, beneath the Clock Tower

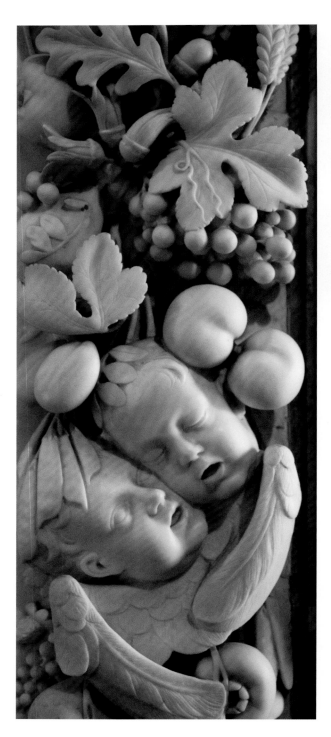

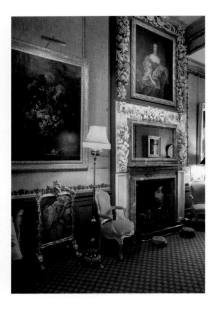

This odd but beguiling concoction of a sitting room with adjoining bedroom and bathroom gives commanding views to the north, thanks to its location under the protruding Clock Tower. In 1929 an exuberant but wildly out-of-proportion fireplace by Grinling Gibbons was brought from Dalkeith. With great imagination Jane, Duchess of Buccleuch, has echoed the room's Victorian splendour with rich teal and crimson fabrics.

On the desk beneath John, 7th Duke, is his daughter Alice, who married Prince Henry, younger brother of Edward VIII and George VI. A lively writer, in *Memoirs of Princess Alice, Duchess of Gloucester*, she describes a visit to her grandfather, the 6th Duke, in 1909, when she was 8 years old (she lived to the age of 102):

'My grandfather loved to have children around and Sybil and I were the lucky ones chosen to be with him during his stay at Drumlanrig… After tea the grown-ups would rush about with us in games of hide 'n' seek or pounce piggy, a Scott variation in which two people hid and ambushed the rest. They seemed to enjoy it as much as we did. The four towers of staircases and three floors of long passages gave plenty of exercise and we must have run miles.'

ABOVE *Room 39 retains its Victorian moiré wallpaper with its ivy-leaf border. A still life of flowers in a sculpted urn by the Huguenot artist Jean-Baptiste Monnoyer, c.1693, hangs next to a dramatic chimneypiece by Grinling Gibbons (1648–1721), the finest carver of his day. In 1929 it was brought from Dalkeith Palace, where it had been put together in stages between 1701 and 1707. The carved limewood surround framing a portrait of Margaret, Countess of Wemyss, Duchess Anna's half sister, had been removed from Moor Park, Anna's house in Hertfordshire and may date back to 1682* LEFT *Putti, plums and grapevines in the mirror's marble surround above the fire* OPPOSITE *Here a plaster profile of the great Victorian Duke, Walter Francis, faces Sir George Reid's portrait of his grandson John, 7th and 9th Duke, whose daughter Princess Alice, Duchess of Gloucester, can be seen in the photograph on the desk, next to a signed photograph of Queen Victoria*

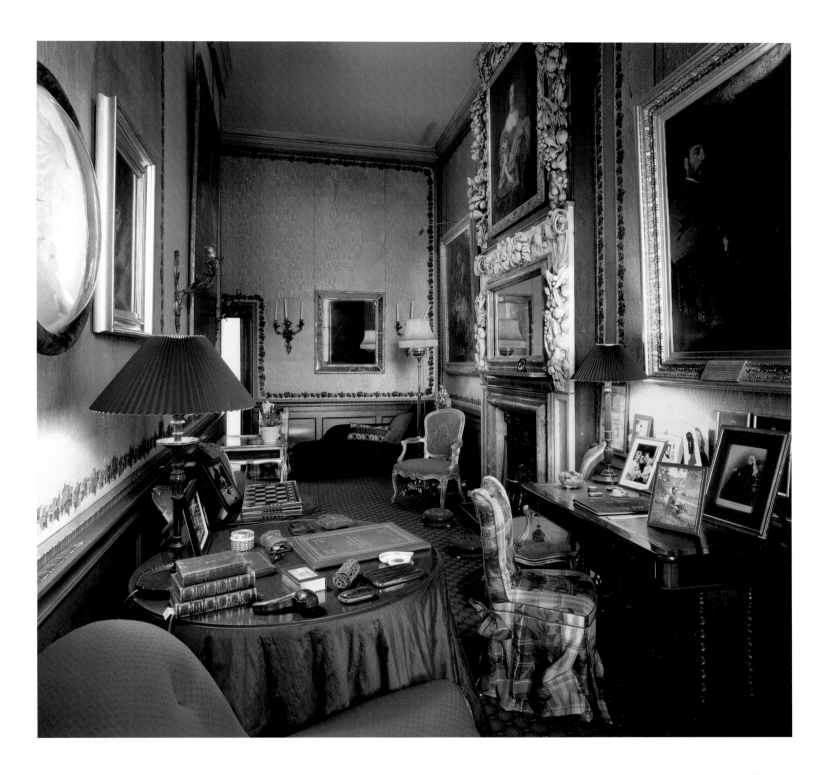

The High South Passage

A corridor of bedrooms makes a welcome eyrie

The bedrooms of the High South Passage seemed very remote before the days of mobile phones but they have always been favourite places with guests. Many have been redecorated in colours very far from Victorian taste – but still a good foil for the Castle's collection of engravings – and are bathed in light from the vertigo-inducing floor-to-ceiling windows, an essential feature of the design of the three garden façades. Wooden shutters need to be closed to prevent fading.

Guests often ask if Drumlanrig has ghosts. Well, no one alive has admitted to meeting the Yellow Monkey that children are told about. But the tradition is an old one. In her memoir, Princess Alice remembers finding a 'Yellow Monkey Room, or Haunted Room' in an old inventory. The Archivist has indeed found an 1811 inventory referring to a 'Blue Monkey Room 19 ½ square now the Yellow Room or Haunted Room' with 'a yellow four poster and Arras tapestries'. Someone has later written 'Court Room' on it in pencil. The dimensions are more or less right for the East Court Bedroom, directly above the White Bedroom.

OPPOSITE *The High South Blue Bedroom has a trellis-patterned blue wallpaper, which perfectly sets off a 1764 engraving from Joseph Vernet's series 'Les ports de France', with its characteristic 18th-century ebonised frame*
LEFT *All the High South Passage bedrooms and bathrooms have vertigo-inducing floor-to-ceiling windows with wooden shutters*
BELOW *Fairytale domes: the family standard flies above the Northeast Tower*
BOTTOM *The High South Victorian Bedroom with its fireplace. By 1691 the Castle had no fewer than '64 hearths'*

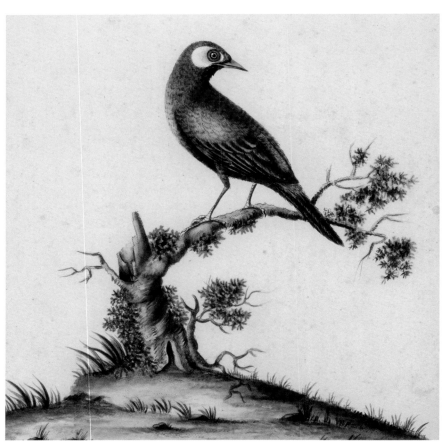

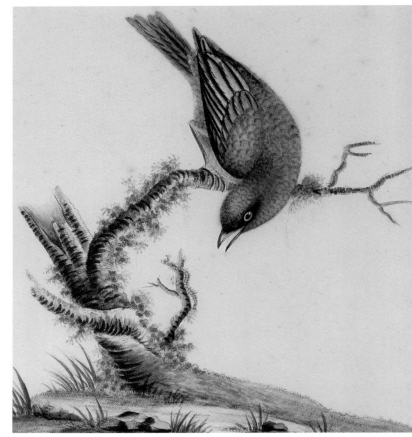

Flying colours: the exotic birds of William Hayes

Occasionally, guests are unnerved by the sound of 'snoring' owls (actually hungry chicks). Lucky ones share their rooms with exotic birds by the early bird painter William Hayes (1735–1802), an impoverished post-master. Several hang, appropriately, in what is still called Miss MacEchern's Room. The Duke's stalwart secretary for 50 years, the late Lorna MacEchern had a vast knowledge of the collection and was a well-travelled birdwatcher.

Hayes drew his 'portraits' from life, keeping some of his subjects in captivity

A 'VOLIÈRE' OF BIRDS
Generations developed particular passions at Drumlanrig, for instance the 43 ink and watercolour drawings by the pioneering William Hayes, who set his seven children to work colouring his 'bird portraits'
ABOVE *Hayes calls this bird a 'Brazilian finch', but it appears to be the African violet-eared waxbill or common grenadier, 'Granatina granatina'*
ABOVE RIGHT *A painted bunting, 'Passerina ciris'*
RIGHT *A wood duck, 'Aix sponsa'*
OPPOSITE *A red-legged partridge, 'Alectoris rufa'*

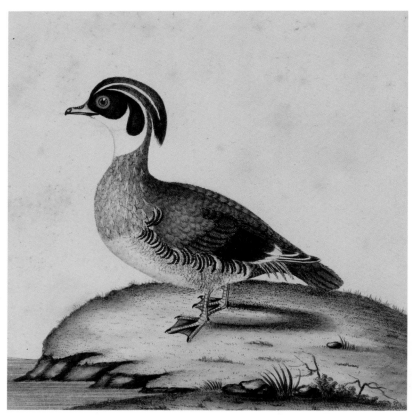

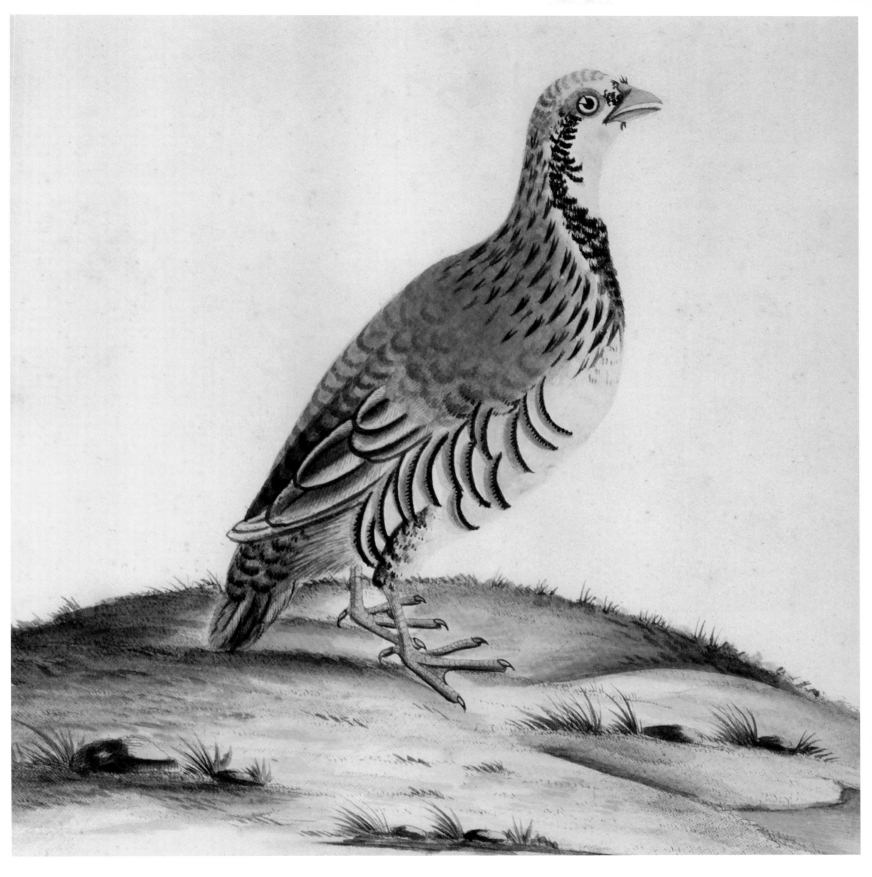

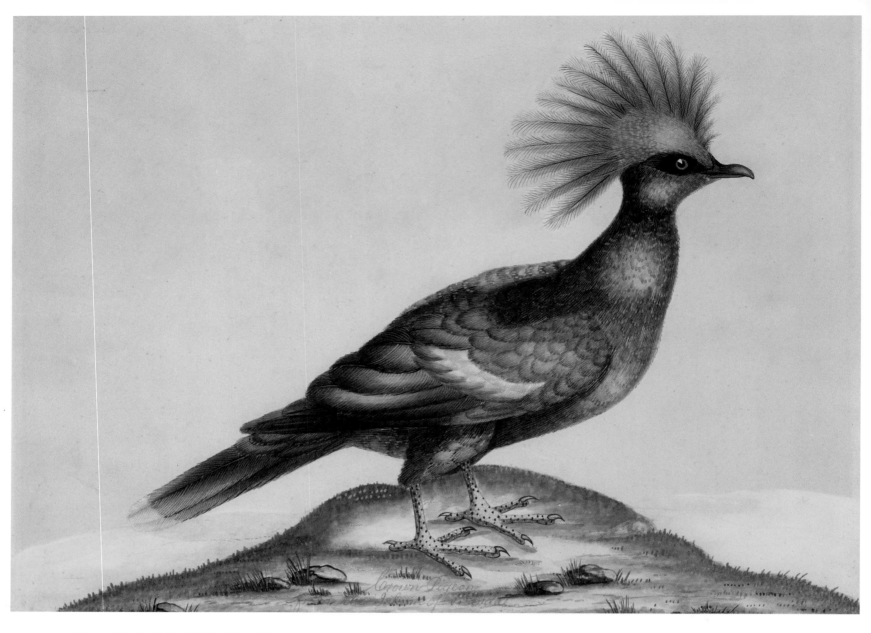

at home. He also visited the Duchess of Portland's birds at Bulstrode and Robert Child's aviary at Osterley, the basis of his book *Rare and Curious Birds Accurately Drawn and Colored from Their Specimens in the Menagerie at Osterley Park* (1794–99).

We know that a year before his first book, *A Natural History of British Birds* (1775), Hayes sold two pictures to the 3rd Duke of Montagu. Who bought the rest? Maybe

the Duke's daughter Elizabeth and her husband, Henry, 3rd Duke of Buccleuch, who had a menagerie at Dalkeith.

The 1st Duke of Queensberry had kept a *volière* (aviary) at Drumlanrig, employing a 'bird catcher', Herman van Hairson, who stayed six weeks in 1682. He returned to the city on a carriage horse provided by the Duke, and handed over the aviary key to the head gardener, James Wood.

ABOVE *This enormous pigeon 'from the Island of Bandai' is now known as the western crowned pigeon, 'Goura cristata'*
OPPOSITE, TOP *Linneaus formally named the Eurasian hoopoe 'Upupa epops' in 1758*
BOTTOM ROW, FROM LEFT *A female crossbill ('Loxia curvirostra'), a young common cuckoo 'Cuculus canorus'; and a Bohemian waxwing, named 'seider' by the artist, from the German 'Seidenschwanz'*

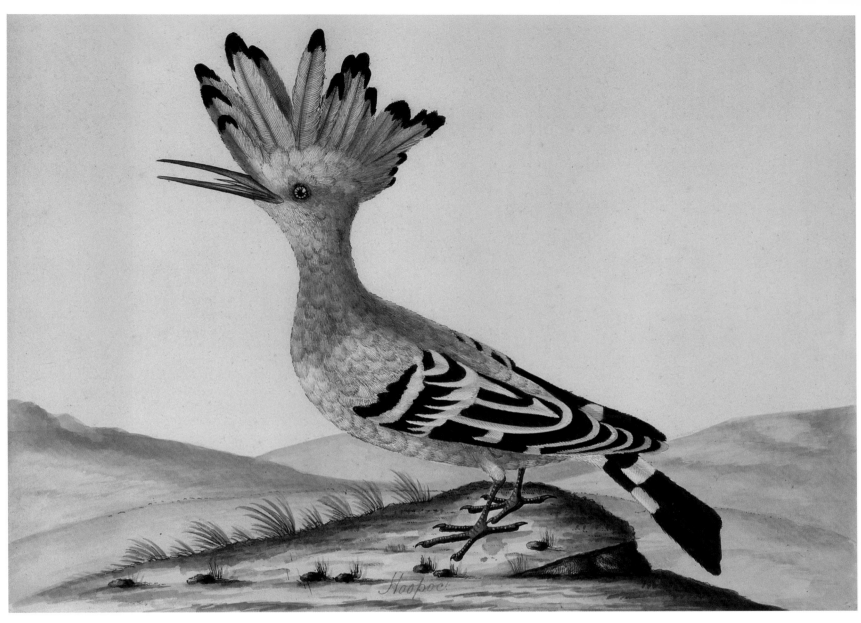

Hoopoe.

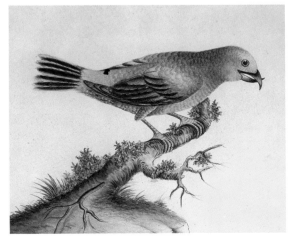

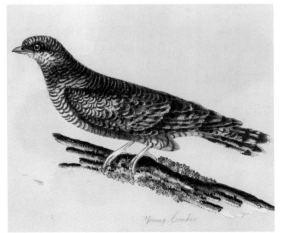

Young Cuckoo

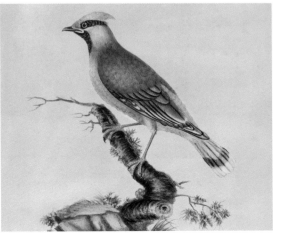

The Basement

Off the long Basement passage that encircles the entire Castle, some of it 16th-century, are rooms essential to the well-run household

D rumlanrig's ingenuity lies in its pragmatic floor plan: a simple square, hollow in the middle. The Basement has an uninterrupted passage all the way round, which gives it easy access to all four towers and the passages leading off them. The walls and vaulting often date from the time of the first two Earls if not before. Since the central Courtyard is now higher than the surrounding Basement, skylights are needed for the passage.

All manner of useful rooms open off the passage – the Kitchen, Scullery, Pantry, Flower Room, Linen Room, Brushing Room and a large Drying Room full of hot pipes, indispensable in Dumfriesshire. Most of these rooms have large windows and views over the parkland and woods.

LEFT THE BASEMENT PASSAGE
Betty Cook rounds a corner in the Basement passage, lit from behind by a glazed door to the garden, where herbs grow in a suntrap under the south wall. Generations of Scotts have been brought up on her legendary cooking. The indent in the passage marks the lower walls of the earlier 16th-century fortification

RIGHT THE LARDER
Bedroom candlesticks stand on a Regency pine table in what was once a kitchen, with its latched door and sturdy cupboards. An Arts and Crafts oak ladderback armchair stands in the corner

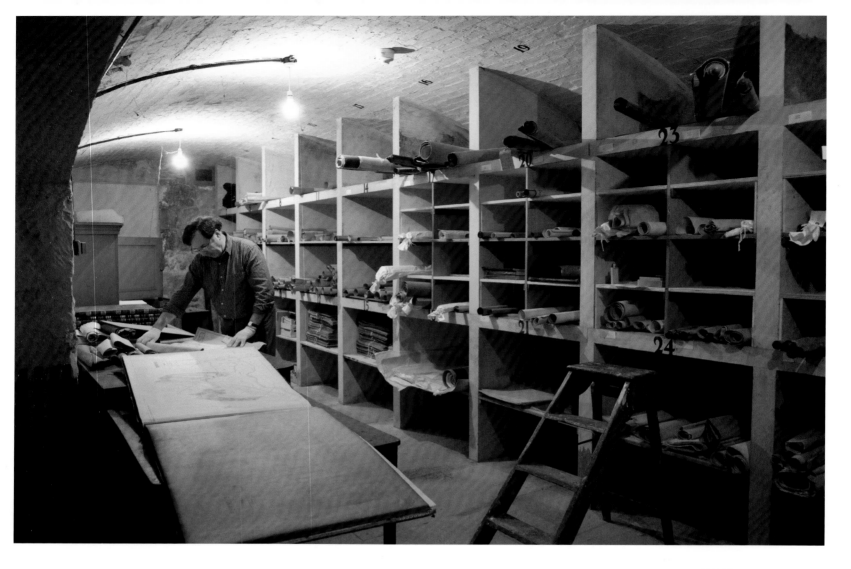

ABOVE AND FAR RIGHT
MAPS AND PLANS
*Each generation faces a new
challenge, and the Archives are
once more a priority. Here Dr
David Munro, director of the Royal
Scottish Geographical Society from
1996 to 2008, peruses maps in the
old wine cellar, where light and
humidity can be carefully controlled*

RIGHT CURTAIN RAILS
*Laid out on the threadbare carpet of
an old bedroom, ready to be reused*

ABOVE CHINTZ GALORE
Spoilt for choice, the interior designer Alison Graham sifts through two centuries of surplus chintz on the billiard table. The patterns offer an invaluable resource for contemporary designers

FAR LEFT AND LEFT KEYS TO THE PAST
Handsome armchairs and a Victorian daybed await the upholsterer. Old trunks often reveal surprises. One of these contained the riding clothes worn by Mollie, Duchess of Buccleuch, in Edward Seago's family portrait (page 220)

The Castle's new wings

In the 19th century, when the Dukes of Buccleuch inherited Drumlanrig, practical additions were called for, but pains were taken to retain the Castle's famous silhouette

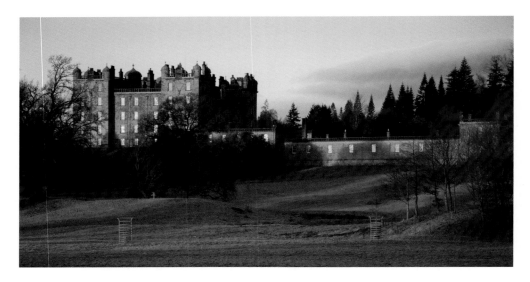

When, in the 1840s, the first substantial additions for 150 years were made to the Castle, they took the form of two extended arms reaching away from the North Front. These gave space for the practical needs of a large Victorian household, more accommodation for staff, and in particular more spacious kitchen areas to cater for the large parties of guests who might stay for days or even weeks during the autumn shooting season. Family, guests and staff might together involve feeding 60 or 70 people at every meal. The eastern arm embraced the Steward's Room and the Staff Hall, the wine cellars and the boilers, while the western arm accommodated the kitchen, the scullery and the larders, including several cooler storage rooms in the basement.

The kitchen range was coal fired, and to avoid the risk of smoke spoiling the atmosphere around the Castle, a tunnel nearly a quarter of a mile long was built, ending in a tall chimney hidden in the woods. At a similar distance in a different direction lay the 30-foot-deep Ice House, dug into a small hillock beside Slatehouse Loch (also known as Bridgeknowes), from where it could be replenished each winter, ice being vital to keeping food fresh in the days before refrigeration.

Nowadays the Castle's kitchen has returned to the main building, bringing it a great deal closer to where food will be eaten, and the Old Kitchen has become a Tea Room. It is decorated with a gleaming array of copper pots and pans of all sizes, and jelly moulds of fantastical forms for the mousses and blancmanges that featured regularly on the menus. Helping keep things to time is a remarkable longcase clock given to the 3rd Duke of Queensberry by its creator, the Rev. Peter Rae, the last minister of nearby Kirkbride, a parish that ceased to exist in 1732. The clock is a musical and astronomical instrument with a wheel that governs a particular star and is said to turn just once every 67 years. The minister courted controversy among his parishioners by running a printing press from around 1712 at Kirkbride and later at Dumfries, publishing the *Dumfries Mercury*, Scotland's first newspaper outside of Glasgow and Edinburgh. He also published his own writings, including a discourse against the Act of Union and, in 1718, 'A History of the Late Rebellion'. He named his eight-year-old son as the proprietor of the business in an attempt to divert criticism.

Particularly apparent from outside are the adjacent cavernous larders next to the Old Kitchen, with their tall, thin windows with wire gauze to keep out flies and to help keep the contents cool, dry and well ventilated (visible in a photograph of the old kitchen garden, page 187). In many respects the household was self-sufficient, milk being delivered daily from the home farm, exotic fruits and vegetables harvested from the walled gardens, but proper storage for the quantities of meat, game and fish consumed was also essential.

Back in the eastern arm, with staff levels nowadays numbered in single figures, the Staff Hall has become a substantial archive centre housing thousands of records, with a reading room for visiting researchers in the old Billiard Room.

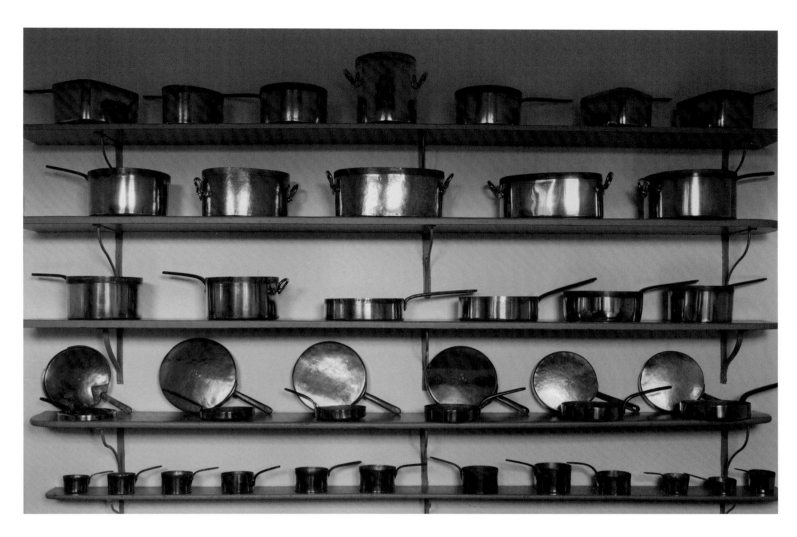

OPPOSITE *The Castle from the east. The new wings managed to be both practical and discreet*
LEFT *The Old Kitchen (now a Tea Room) has an 'astronomical chime clock' by the Rev. Peter Rae. One wheel inside it controls a particular star and is said to turn once every 67 years*
ABOVE *A grand array of copper pans. Many are initialed to show which house they belonged to: DC for Drumlarnig Castle, D for Dalkeith*
RIGHT *Chimneys in the woods drew smoke away from Kitchen and the greenhouses, where exotic fruits were grown on an industrial scale*

Natural wonders

*From Renaissance hanging gardens to Andy Goldsworthy's
Striding Arch, Drumlanrig's grounds continue to evolve*

S tairs lead down from the terrace
outside the Dining Room to
what was once a series of
Renaissance hanging gardens.
One was called 'Barbados', another
'Virginia', inspired by plant-hunting
expeditions to the Americas. It was the
1st Duke who, in the 1690s, undertook
the massive task of creating the terraces
we see today, supervised by his head
gardener, James Wood, who was sent to
London to train. Wood ordered plants
and trees through London nurserymen
such as Obadiah Gray and Francis
Weston, who had a shop on the Strand
with the unlikely name of 'The Flower
de Luce against the May Pole'. Bought
for Drumlanrig were Virginia tobacco,
Pyracantha, *Phillyrea*, lupins, *Amaranthus
tricolor*; double African marigolds and
mimosa, a 'sensible and humble plant'.

The fortunes of the gardens – spread
across the great natural amphitheatre on
the south side of the house, across which
a small river, the Marr Burn, winds its
way – have waxed and waned over the
centuries. At their boldest, thanks to the
vision of the 3rd Duke and Duchess, a
radiating web of avenues extended half
a mile up the hill opposite the ▷*p.178*

ABOVE *Mollie, Duchess of Buccleuch,
on the Sundial Terrace in 1950, with
her cocker spaniel Fancy, forebear of
generations of Buccleuch spaniels*

RIGHT *The bronze sundial by Henry
Wynne is dated 1692 and inscribed with
the Queensberry crest and directions
to points from Dublin to Mecca. The
balustrade of thistles and roses was made
by James Horn of Kirkcaldy in the 1680s*

FOLLOWING PAGES *Drumlanrig's
gardens have always combined the wild
and the formal. The patterns of mown
grass today follow the outlines of the
parterres in the Victorian Low Garden*

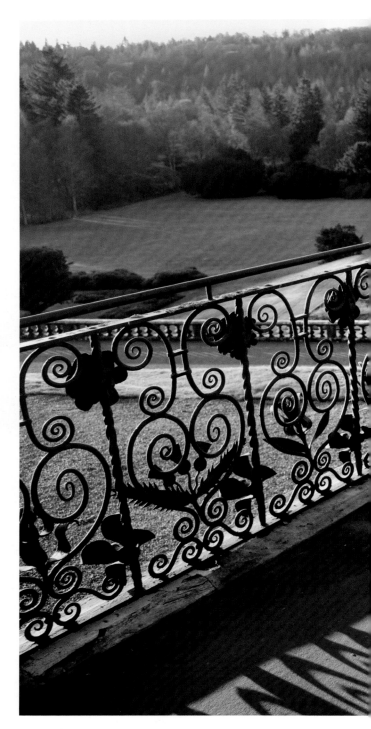

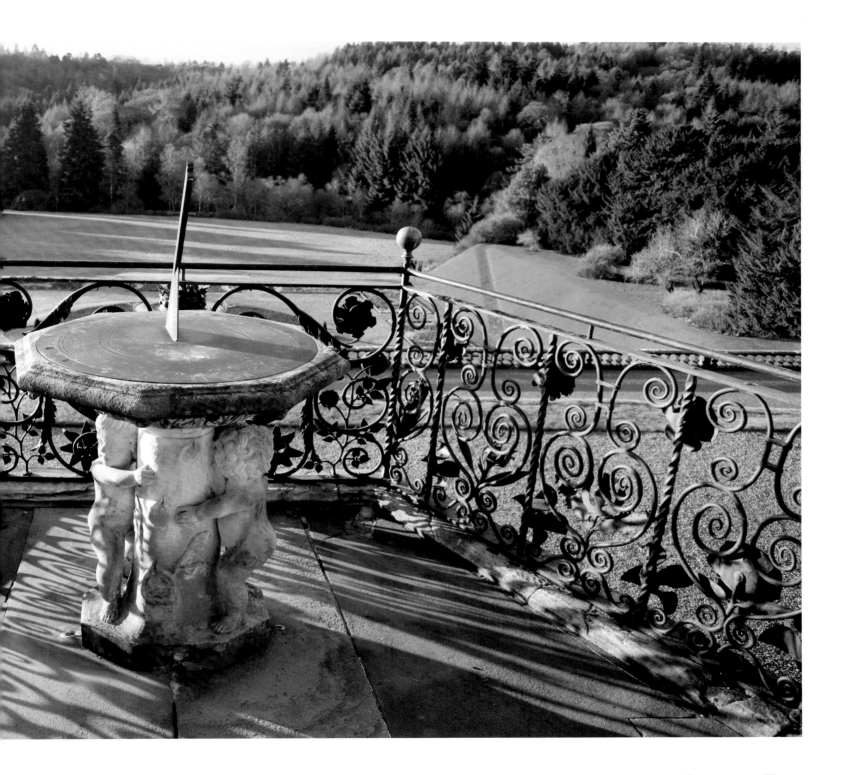

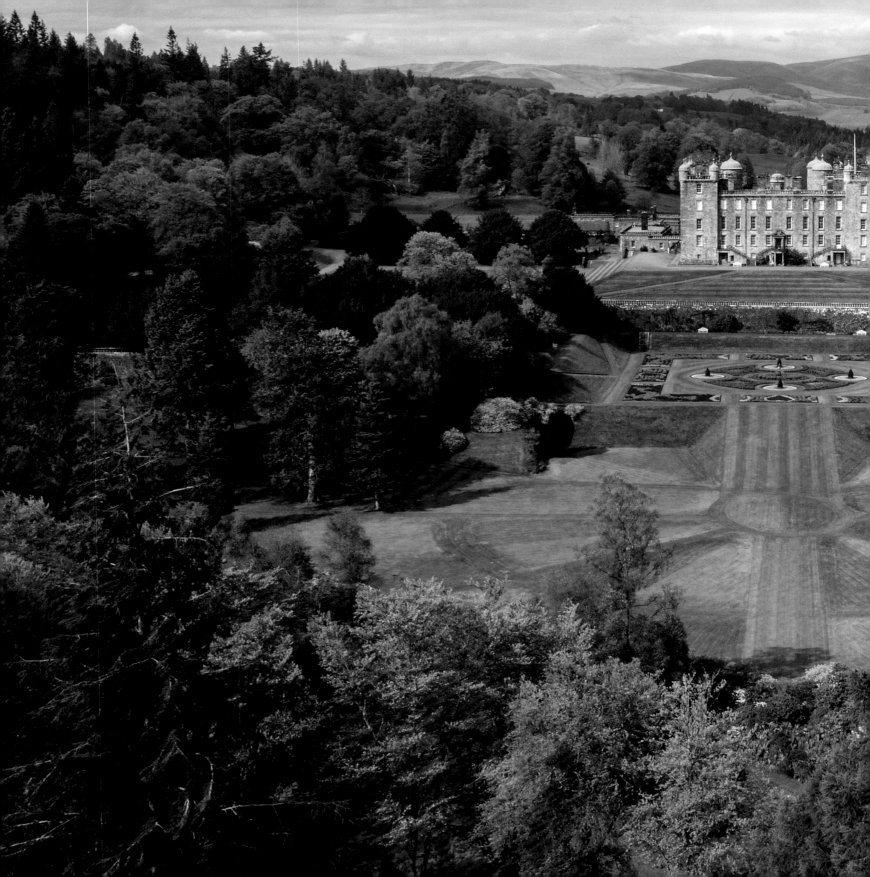

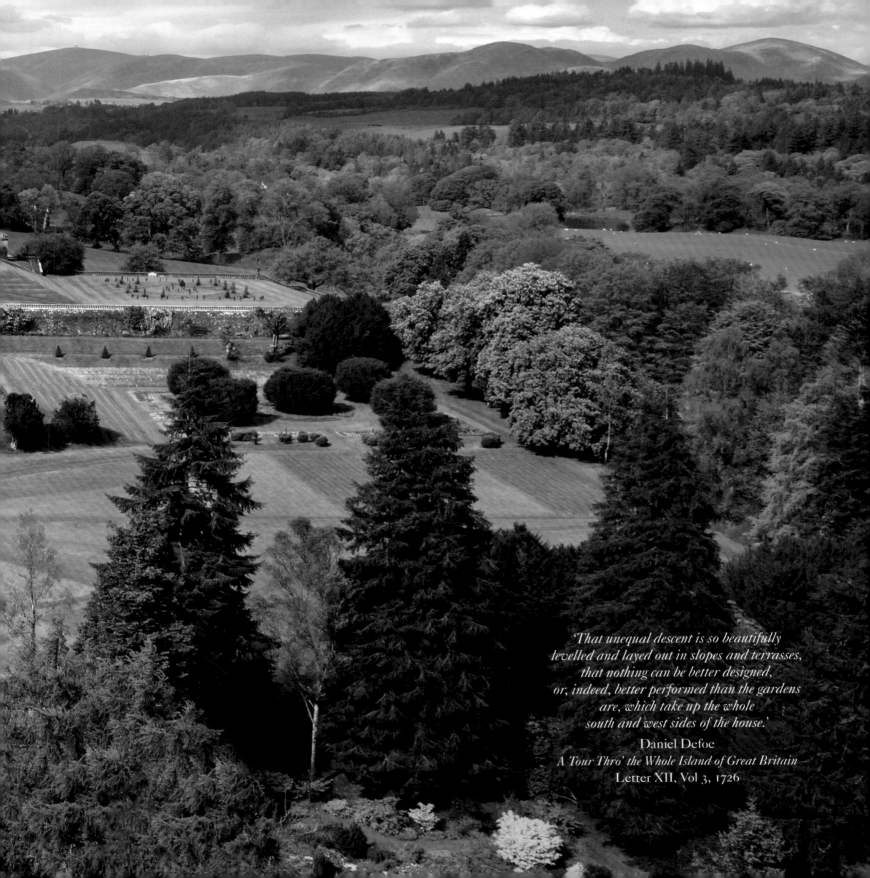

'That unequal descent is so beautifully
levelled and layed out in slopes and terrasses,
that nothing can be better designed,
or, indeed, better performed than the gardens
are, which take up the whole
south and west sides of the house.'

Daniel Defoe
A Tour Thro' the Whole Island of Great Britain
Letter XII, Vol 3, 1726

Castle, while a magnificent cascade of water diverted from the burn tumbled down into a great basin with fountains.

Much of that disappeared as a consequence of Old Q's neglect. The revival of the formal gardens was begun by the 4th Duke of Buccleuch and his head gardener, James Hannan, but they were elaborated and developed by the 5th Duke and his Duchess. The great earth ramp to the middle parterre was created soon after they married, in 1831.

Walter Francis and Charlotte Anne would bring a different 19th-century aesthetic. They preferred to leave the hillside facing the Castle as a natural bridge to the wider countryside, and their gardens extended over a slightly smaller footprint. The elaborately patterned parterres that they created, interwoven with miles of gravel paths and box hedges, turned into annual riots of colour with bedding plants produced in industrial quantities in acres of greenhouses a discreet distance downriver. The pattern of one border, planted with cotoneaster, a red-berried, ground-hugging shrub, was based on Charlotte Anne's wedding shawl.

Renowned head gardeners were employed, such as James McIntosh and David Thomson, who led an army of gardeners numbering over a hundred at times. Not all the gardens were formal. In 1853 James's brother David McIntosh, head gardener at Dalkeith, describes a 'rootwork garden' in the ravine of the Marr Burn in *The Book of the Garden*: 'Like everything about that ducal residence, it is upon a large scale. The roots of trees, dug from some neighbouring peat-bogs, and of huge dimensions, are scattered about in tasteful confusion, or piled up into most grotesque forms.'

The 20th century brought retreat once more, particularly following the dreadful loss of life in the First World War and straitened economic times. A large area was fenced off for the family ponies to graze, and a veritable wilderness smothered gentle woodland walks. Now, thanks to the vision and determination of the head gardener Robbie Black and his dedicated team, the gardens are once again becoming a source of wonder and beauty.

They still owe much to the legacy of previous generations, not least the 1st Duke's huge 30-foot-high wall that still runs across the entire terrace front on which the castle rests, a distance of 200 yards, an extraordinary feat of late-17th-century building.

Subtler are the charming Victorian summer houses, with their varied forms and intricate designs of heather, larch lap and stone patterning dotted around the gardens and woods.

But in several ways Drumlanrig's gardens are in the early stages of a new era. A long-term project with the Royal Botanic Garden, Edinburgh, has led to the planting of numerous rare, exotic conifers, fitting companions to the great Douglas fir, grown from one of the first seeds brought over to Scotland in 1827.

Slowly, too, an ambitious planting programme for rhododendrons and azaleas over the past 20 years is showing its potential glories. There is every chance that Drumlanrig's gardens will once more be the stuff of legend, as they were in centuries past.

RIGHT *The East Terrace, once the 4th Duke of Buccleuch's 'American Garden', was replanted in 1978, following Charles and Kitty's 1739 plan. Box blight called for replanting once again in 2021*

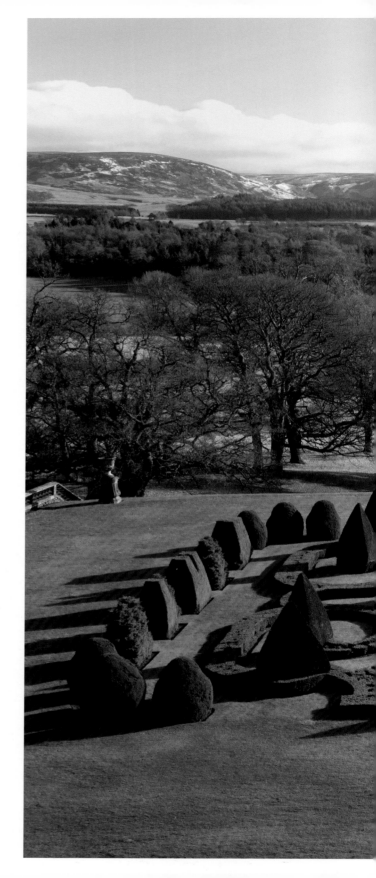

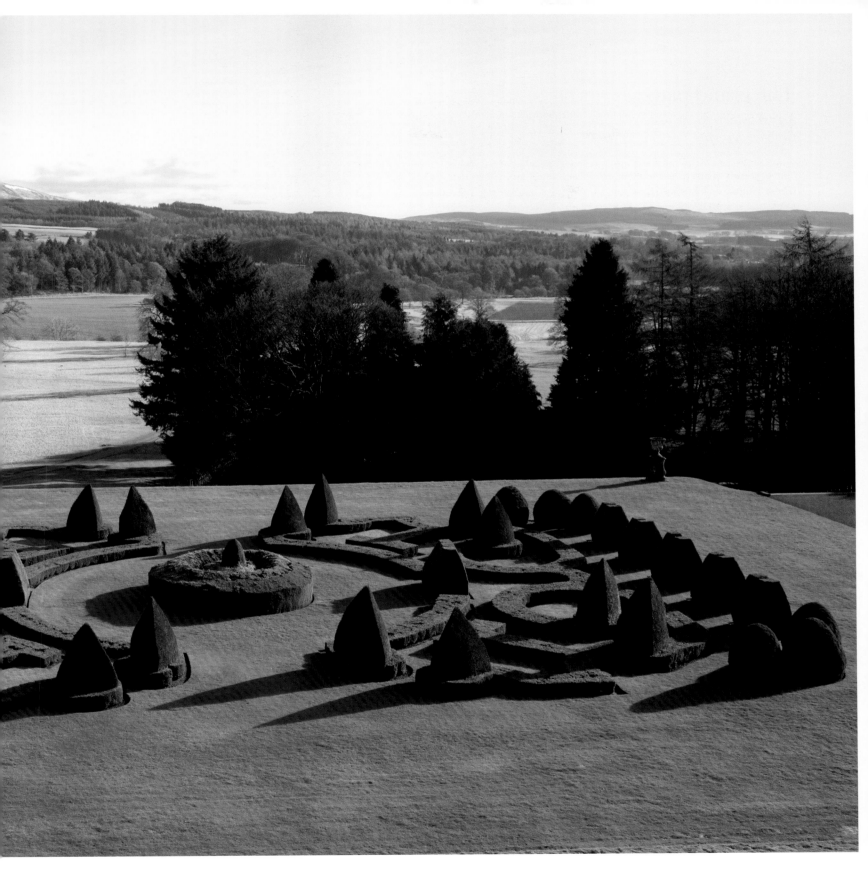

The grand plan

A 17th-century palace in a Georgian paradise

The best early visual record of the Castle, by the Huguenot John Rocque, was published in 1739 in Volume IV of Colen Campbell's *Vitruvius Britannicus*. The gardens created by the first three Dukes, abandoned by Old Q, included the 3rd Duke's cascade on the hill to the south. Fed by an aqueduct two miles long, it flowed down in steps into a canal in full view of the Castle. The 1st Duke had ordered lead statues from Richard Osgood for the North Front, its forecourt neatly contained by balustrades (below). Ogee-roofed pavilions flanked the South Front.

RIGHT AND BELOW JOHN ROCQUE (c. 1704–62)
A Plan of ye Garden and Plantation of Drumlanrig, 1739
With South at the top, Rocque's plan maps out avenues radiating from all four fronts
BELOW RIGHT WILLIAM REID
Drumlanrig Castle, 1913
Bold bedding dominates the West Parterre

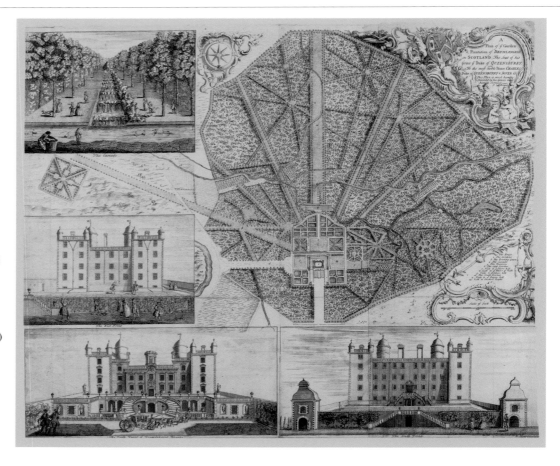

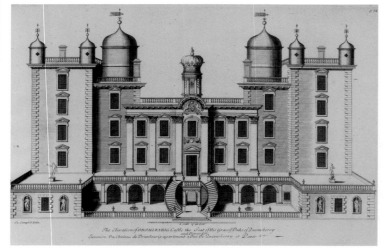

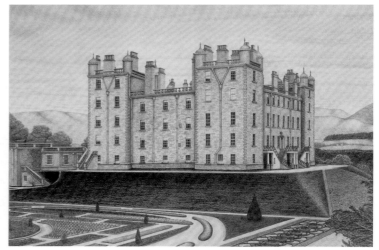

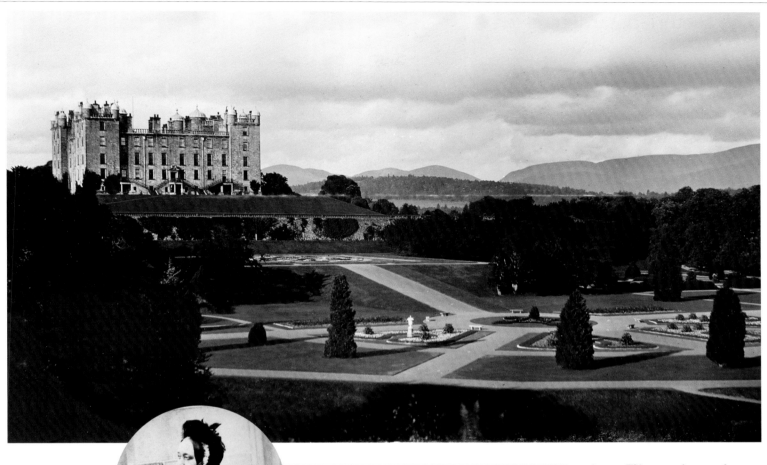

INSET *Duchess Charlotte Anne dressed for all weathers in 1865, from one of her daughters' albums*

RIGHT *The High White Garden, photographed in 1872, is still known as 'The Shawl', its design inspired by the embroidery on Duchess Charlotte Anne's wedding shawl. Copious quantities of white sand were used between the beds*

ABOVE *This 1901 photograph shows Drumlanrig with its formal Victorian flowerbeds and radial pathways, tended at the time by more than a hundred gardeners. The earth ramp was built in 1831, when Walter Francis, 5th Duke, and Charlotte Anne were newly married. It created a dramatic ascent from the Low White Garden to the High White Garden. 'The Gardener's Magazine' considered it a 'preposterous undertaking'*

The Victorian garden

When the gardens were revived in the 19th century, their footprint was slightly diminished, but the gardeners were still kept busy satisfying a love of flowered parterres and the demand for exotic fruit

A group of early hand-coloured photographs brings the Victorian gardens to life
LEFT *The glasshouses, where pineapples and other exotic fruits were grown, as well as flowers. Duchess Charlotte Anne insisted excess produce be sold at Covent Garden*
BELOW LEFT *A 'moss house' with its own cottage garden*
BELOW *Ladies in crinolines and bustles can be made out among the flowers*

ABOVE *The Castle from the southeast, 1869*
RIGHT *In this plan by McCallum and Dundas from 1848–49 the cascade has vanished and the Marr Burn returned to its natural course. Added to the 5th Duke's parterres are woodland areas, with summer houses marked in red: the one on the far right here is shown on page 190. The one on the far left is the Heather House, page 193*

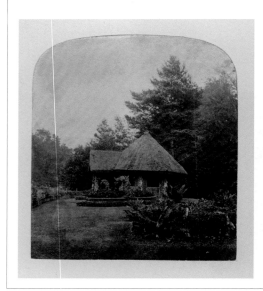

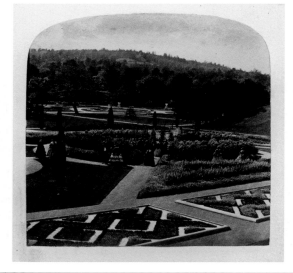

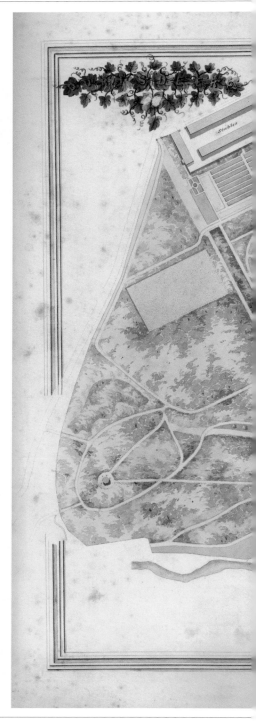

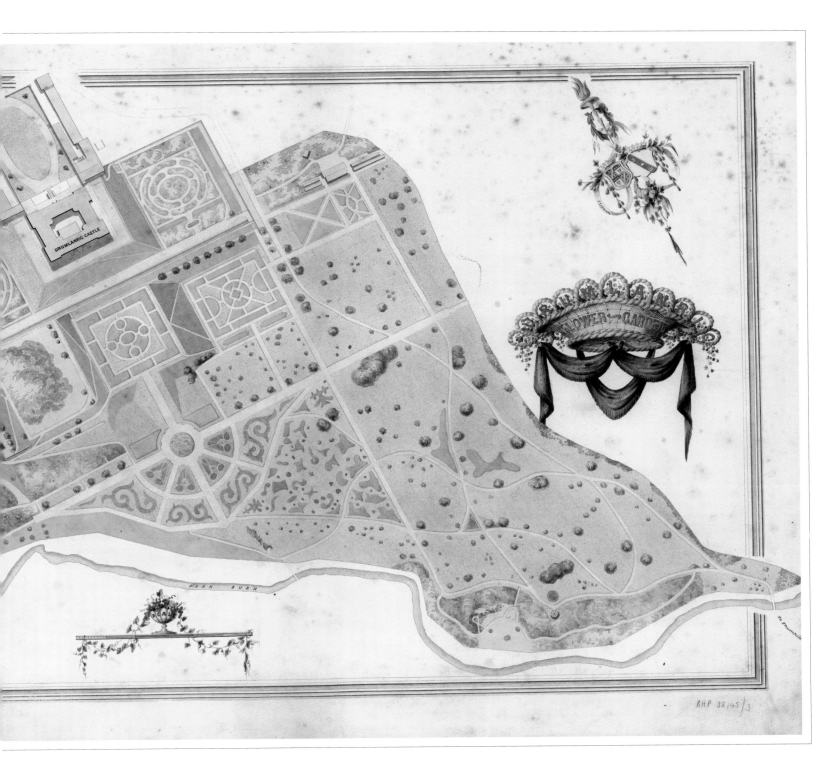

DRUMLANRIG CASTLE

DRUMLANRIG FLOWER GARDEN

PARK BURN

RHP 38/45/3

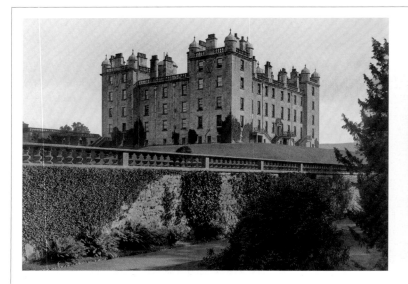

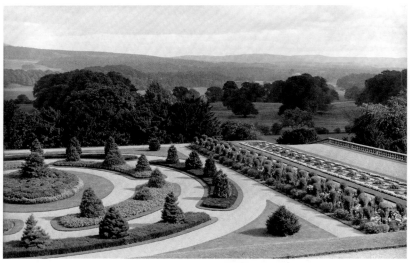

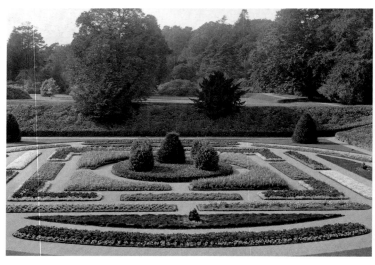

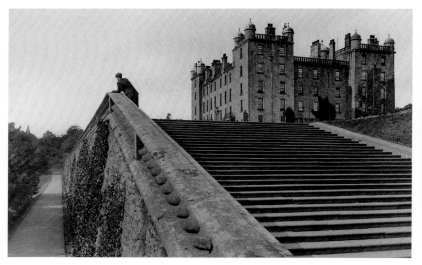

When *Country Life* visited in 1902 the head gardener was David Inglis, who followed a distinguished roll call of gardeners going back to the 17th century. They included James Wood, creator of the 1st Duke's terraces, David Low, who built Charles and Kitty's gardens in the 1730s, and prodigious Victorian plantsmen: James Hannan (1814–41), James McIntosh (1846–68) and David Thomson (1868–97). Among gardeners' letters in the Archives is one to Hannan from James Collins, head gardener at the Buccleuch villa in Richmond-on-Thames, reporting: 'I received a letter from Portsmouth to say there are some plants arrived from South America for the Duke from Capt. Tait.'

Many of the head gardeners, both at Drumlanrig and Dalkeith, were household names. David Thomson's *The Handy Book of the Flower Garden* went through several editions. In it he describes the Upper White Sand Garden as 'densely formed patterns of the

THE DRUMLANRIG GARDEN, 1902
The gardens in all their Victorian glory, photographed by 'Country Life'
TOP LEFT *The Castle from the southwest*
TOP RIGHT *The East Terrace, still known in 1902 as the 'American Garden'*
ABOVE LEFT *'The West Garden' was 'a fine formal parterre, laid out gaily'*
ABOVE *'The great and stately ascent'*

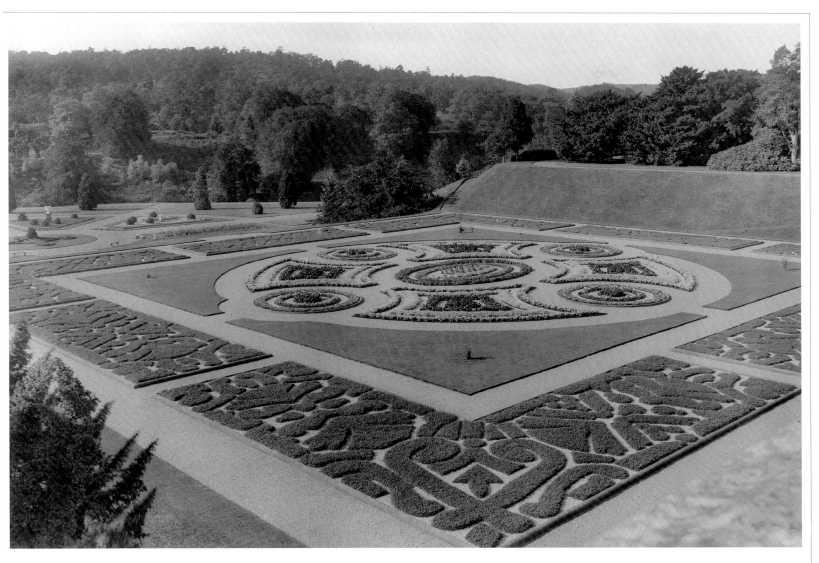

common wild heath[er] rising about two inches above the sand and as close and even as a well kept lawn'.

The head gardener would have three foremen, 15 under-gardeners and many apprentices. John Ross, who emigrated to Australia in 1863, becoming head gardener at Ballarat Hospital, recalls life as 'very hard work with little reward'. But another Antipodean gardener, Charles Weston, head forester of Canberra, praised Thomson for pressing him to 'observe, experiment and learn'.

David Thomson took education very seriously, establishing the Drumlanrig Gardens Mutual Improvement Association, which met for lectures on winter evenings. Topics included 'alpine plants', 'the formation of pleasure grounds' and 'the general treatment of stove plants'. Extracurricular events included 'a dancing party' in the Flower Garden Bothy. *The Gardener's Chronicle* tells us that on Thomson's retirement a presentation was made by 76 of his foremen, all of whom he had 'placed in good situations scattered all over the world'.

ABOVE *'Country Life' praised the Upper White Sand Garden as 'a purely formal parterre in the grand manner', and admired the way the woodland 'enframes' the gardens. Later editions of the head gardener David Thomson's 'Handy Book of the Flower Garden' include a diagram of the beds with suggestions for seasonal flowers*

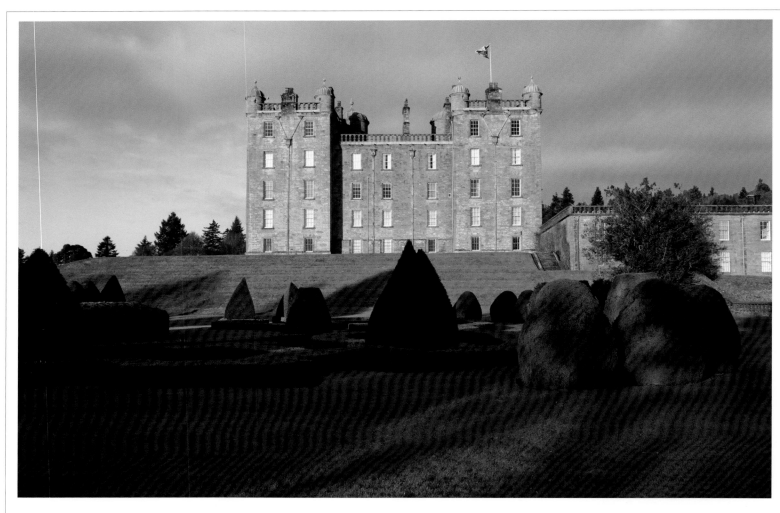

The gardens revived

The fortunes of the gardens have ebbed and flowed. Long forgotten are the 1st Earl's Renaissance hanging gardens. The 3rd Duke's cascade defied a curse on 'he who alters the course of the Marr Burn' – and Old Q duly abandoned it. After the Great War the Victorian gardens shrank. In the Second World War potatoes and hay came first. Today a revival is gaining momentum in the hands of Robbie Black and a small band of fellow gardeners.

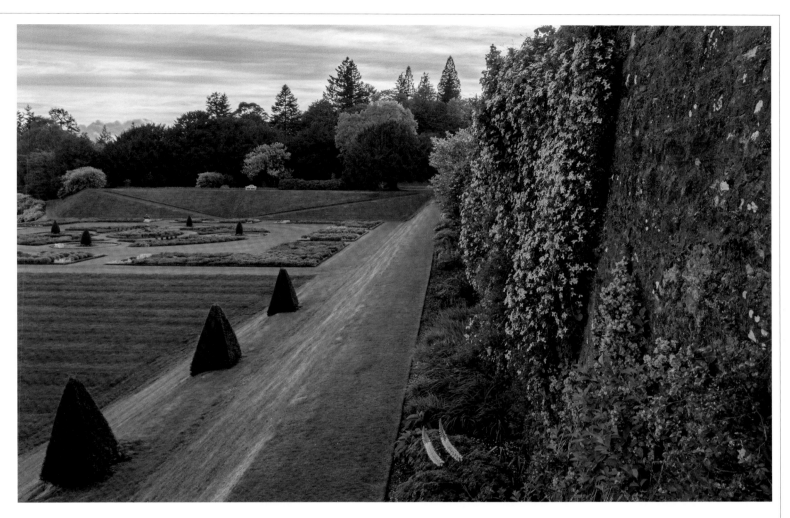

ABOVE LEFT *The formal East Terrace*
ABOVE *The garden known as the Shawl and the 17th-century Long Wall covered in 'Clematis montana' and 'C. wilsonii'*
RIGHT *Azaleas and rhododendrons include the fragrant white Loderi King George (top right), a splash of Loderi Pink Diamond (centre), and yellow 'R. luteum'*
FAR RIGHT *1952: the old kitchen garden*
FAR LEFT *The present Duke's father collecting hay in the Low Garden in 1940*
LEFT *By 1960 the Low Garden had been turned over to grazing ponies*

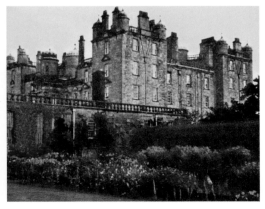

The family trees

Miles of leafy rides lead through woods that have taken two centuries to reach their prime

It was Sir Walter Scott's friend Charles, 4th Duke of Buccleuch, who set about replanting the Drumlanrig woods in 1813. Scott had strong views on forests: they should appear to be without end and imitate the shadows of clouds. Already in 1826, just six years after Charles's death, the author recalls 'a quiet ride round the princely demesnes where about 1200 acres of plantations are speedily repairing the devastations of Old Q. If Drumlanrig has not quite recovered her gown of green she has at least got a sleeve of it and makes a very different show from this time eleven years ago when I first knew her.' Rides still wind their way through the woods up to Starn Loch. The naturalness of the planting makes it easy to forget the constant work needed.

The present Duke's grandfather and father were passionate foresters and used the view from the Sundial Terrace to plot the next planting or thinning. Relative newcomers are stands of giant sequoia, the tallest tree in the world, with bark so soft that it is punchable. They have resisted the gales so far, already add splendid vertical touches to the view – and they are still young.

Favourite walks are to the viewpoint of Mount Malloch across the Marr Burn, and beyond to Starn Loch for a picnic. Another dramatic ride follows the Nith upstream from the Drumlanrig Bridge.

RIGHT *The Heather House, one of four Drumlanrig summer houses that have survived annual bouts of vandalism by nest-building birds*
BELOW *A carpet of bluebells*

A ll Scottish gardens had their summer houses. The poet and friend of Walter Scott, the Rev. John Marriott, who was tutoring one of the Duke's sons, describes how the days passed at Dalkeith in 1805: 'We live in a most comfortable way. The weather has been very fine and we have generally dined in the Great Hall with the doors wide open, so as to be almost in the open air; and we often drink tea in one of the Moss Houses of which there are many in different parts of the pleasure grounds.'

The Drumlanrig summer houses were probably built by Walter Francis and Charlotte Anne, who mentions putting one up 'for the children' at Bowhill in 1851. Each house is different, a pleasing blend of larch, hazel and white birch, decorated with moss and heather. But slate roofs have replaced the thatched roof seen in the moss house on page 182.

LEFT *The Victorian Summer House has ample trefoil windows. The wood retains its bark both inside and out*
RIGHT *The elaborate patterning of its ceiling recalls a medieval vault*
ABOVE RIGHT *This bold ceiling of thatch and wood belongs to a modest, steep-roofed summer house high in the woods*

Unlike Victorian moss houses, the summer houses at Drumlanrig today stand in natural settings, without their Victorian cottage gardens (page 182). To reach the most spectacular one on the Castle side of the Marr Burn, the Heather House, you follow mown grass paths through a wild garden of shrubs and exotic trees – one, a flourishing red oak, was planted by the astronaut Neil Armstrong in 1972, while a great copper beech shades the dogs' graveyard.

Next to the Heather House (right) is one of Drumlanrig's natural wonders, the Douglas fir, *Pseudotsuga menziesii*. One of the oldest, and largest, in Europe, it was planted in 1829 by John Douglas, master of works at Drumlanrig, whose brother, the famous botanist and explorer David Douglas, had brought the seed back from the Pacific Northwest of America in 1827, and gave the fir its popular name. While John Douglas lies in Durisdeer (page 204), poor David died while plant-hunting in Hawaii in 1834 after falling into a wild-cattle trap.

Top left *Grass paths weave their way through the wild gardens on the Castle side of the Marr Burn*
Centre left *The Victorian Summer House, with its intricate walls, stands in a sheltered dell surrounded by old beeches*
Right *The Heather House was built for its spectacular view, especially when the Marr Burn is in full spate a hundred feet below. The giant tree trunk belongs to the splendid Douglas fir planted in 1829*
Bottom left *The Heather House's playful heather ceiling*

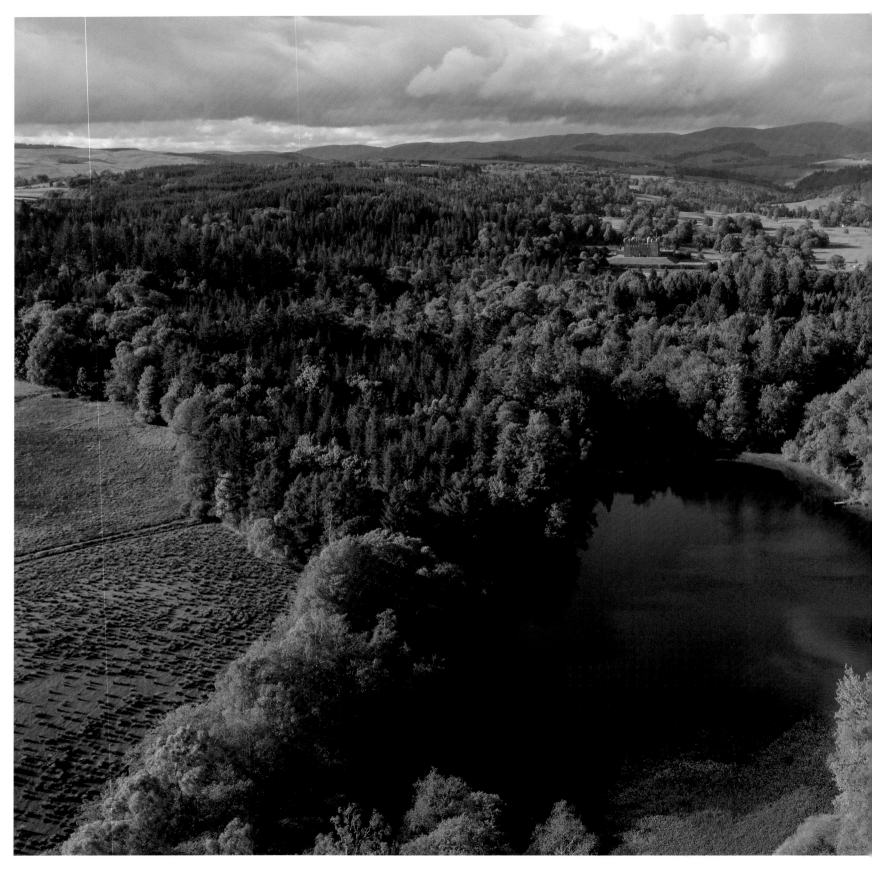

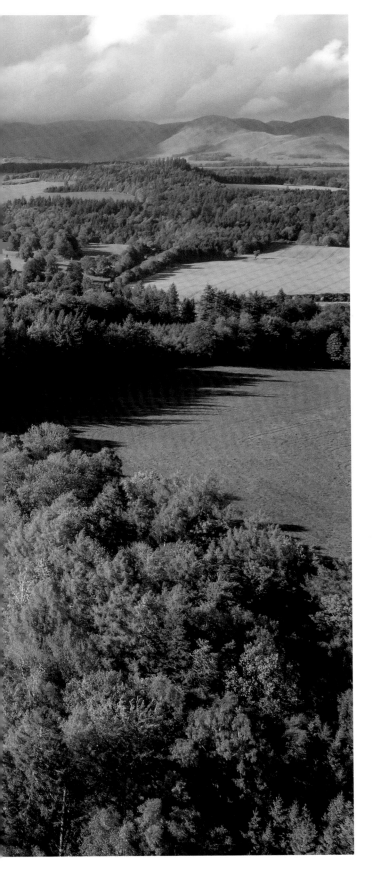

Watery worlds

Drumlanrig's woods abound with peaceful places in which to unwind, listen to nature and catch a trout

The woods are dotted with man-made lochs, peaceful places to fish for trout or watch for herons, dippers, little grebes and kingfishers. Here Starn Loch is seen with the Castle's Park in the distance, where Slatehouse Loch was created to supply the Castle with ice – a letter in the Archives also records that it was 'made picturesque' in 1746. A herd of wild cattle of 'primeval savageness' was reportedly roaming there in 1770.

Guests in pursuit of bigger fish take a rod down to the Nith at the end of the park, where salmon run early in the year and sea trout appear in quantities in May. Upstream from the Drumlanrig Bridge the upper beat ends in the Ivy Lie, after which the Nith grows craggy and spectacular, but hard to fish. Downstream it broadens into a gravelled riverbed, with pools and long reaches in full view of the Castle.

Woods, parkland, farmland, lochs and river together create a paradise of biodiversity. Oystercatchers, lapwing, and green woodpeckers all breed here, and barn and tawny owls nest. Otters fish the lochs. Badgers, roe deer and red squirrels rule the woods.

LEFT *An aerial view of Starn Loch*
RIGHT, FROM TOP *A young Richard with a Starn Loch trout, 1963; his brother Damian in 1984 with an 11.5lb salmon caught in the Nith's Willowholm pool; and their father, aged 11 in 1935, net at the ready at Slatehouse Loch*

Modern landmarks

Andy Goldsworthy's installations

Andy Goldsworthy, the acclaimed sculptor, lives in the area, and his work can be found across the Nithsdale landscape. Created to mark the new millennium, this sandstone cone, the *Penpont Cairn*, guards the road to the village of Penpont. In 2009 he built one of his *Striding Arches* out of the Castle's pink sandstone in the middle of the Marr Burn, hidden from sight in the Drumlanrig woods.

Into the landscape

The dukedom of Queensberry took its name from one of the hills to the east of the Castle. The wildness that so appalled Daniel Defoe is captured here in all its beauty by Walter, the present Earl of Dalkeith. Stretching across Nithsdale, the Queensberry Estate yields many surprises – from the family mausoleum at Durisdeer to the ruins of Morton Castle and cosmic land art in Sanquhar

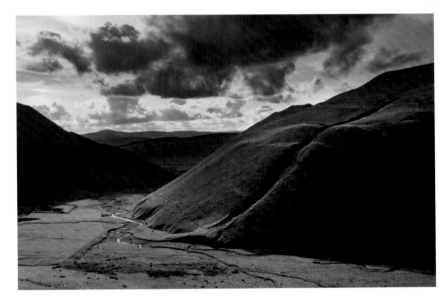

ABOVE THE DALVEEN PASS
As the Edinburgh road drops down to the Nith Valley, it clings in twists and turns to the glacier-carved sides of the Dalveen Pass – weary drivers beware

LEFT *Sheep dot the magnificent rolling Lowther Hills, once a valuable source of gold, silver and lead, much of it mined around Wanlockhead and Leadhills, the highest villages in Scotland*

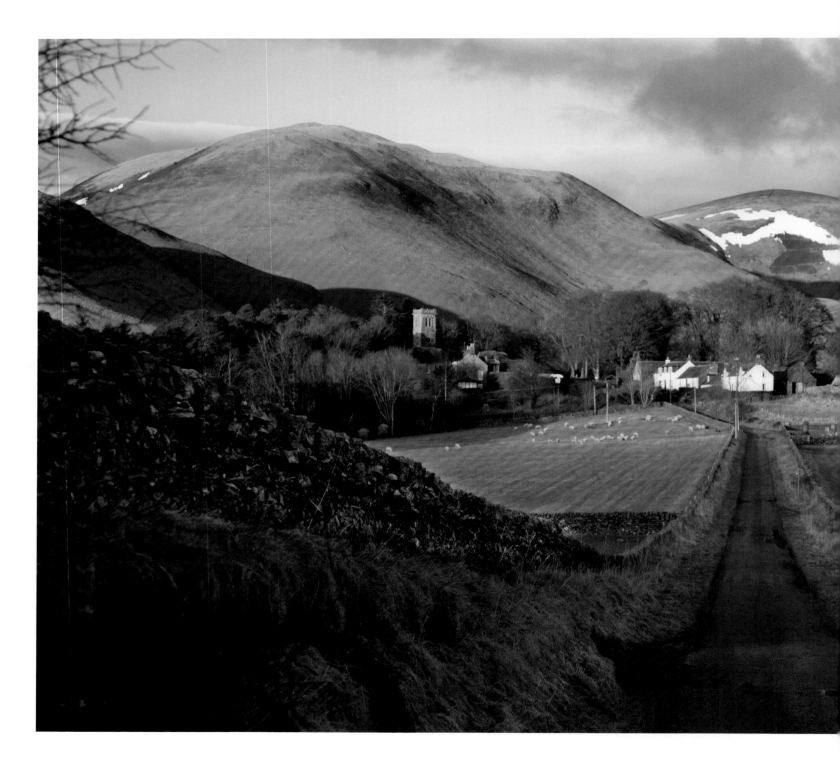

Durisdeer and the Queensberry Aisle

Drumlanrig Castle stands in the parish of Durisdeer, whose elegant early-Georgian church hides an astonishing family mausoleum

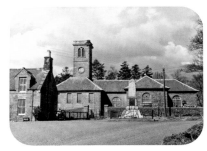

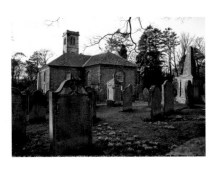

wo miles from the Castle, the parish church of Durisdeer is in a village on the old road to Edinburgh, near the site of a Roman fort. Behind it the pass known as the Wald Path gave marching legions access to the central Lowlands. The original medieval church was rebuilt by the 3rd Duke sometime after 1716. Adjoining it is the earlier chamber known as the Queensberry Aisle, beneath which the first three Dukes are buried. Modest in size, it is magnificent in concept.

FAR LEFT *The village of Durisdeer. Its Gaelic name, meaning 'Gate to the Forest', appears in 1328 records as a stop on a royal pilgrim way from Edinburgh to the shrine of St Ninian at Whithorn. It was also on a busy drove road, and an early minister complained of the noise*
TOP LEFT *Under the belfry, now without its 'stately steeple', is the Duke's Apartment, which a contemporary, the Rev. Peter Rae, in his unpublished history of the county, described as 'almost Fifty foot Long', with 'five Fire Rooms, and one for a Session-House'. It is now used for Sunday school*
TOP RIGHT *Large sash windows light a simple whitewashed cruciform hall of box pews and galleries. Most of the graves date to the 17th or 18th century*
ABOVE LEFT *June 1954: the Queen Mother with the Rev. James W. Scott, a kind, wise man who retired in 2008 after 55 years as minister. His wife, Nester, turned the manse into the centre of the community. The church was famous for its Sunday cream teas*

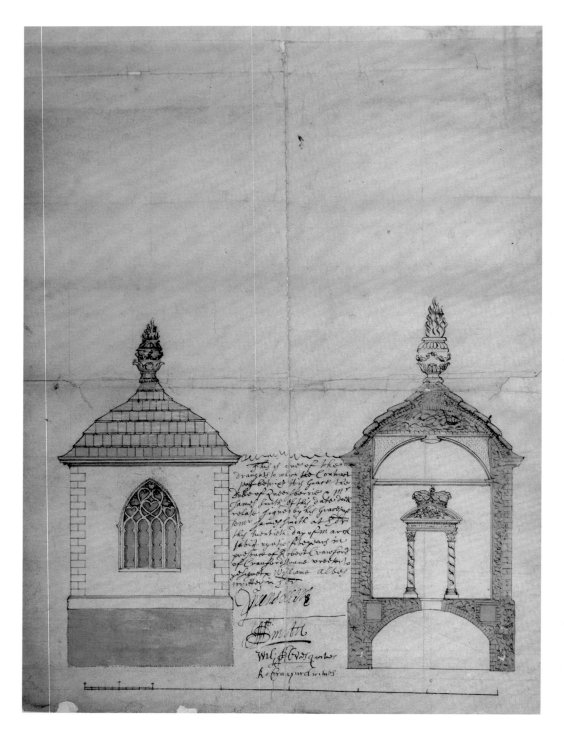

A WONDROUS MONUMENT

Unusual in Presbytarian Scotland, the elaborate mausoleum at Durisdeer known as the Queensberry Aisle is a legacy of the 1st and 2nd Dukes of Queensberry, and an example of how they straddled the divide between kirk and court. As one enters from the simple country graveyard, the monument comes as a complete surprise. Inspired by Bernini's barley-sugar columns in St Peter's, which his sons would probably have sketched on their Grand Tour, the 1st Duke ordered this baldachin in 1694, a year before he died. It frames the fanciful later memorial to his son James, 2nd Duke, and Duchess Mary, James's wife, erected in 1713. The sculptor, John van Nost the Elder, was paid a princely £400 for the remarkably lifelike statues

LEFT **James Smith's contract for the Queensberry Aisle, March 20, 1695**
This contract, preserved with the architect's accounts in the Charter Room, shows the elevation and baldachin of the aisle. When finally completed in 1708, the ogee roof, with its flaming urn, was covered with lead from the mines at Wanlockhead instead of the agreed thackstone tiles. In 1711 the Gothic window with its tracery of Douglas hearts made way for Van Nost's memorial

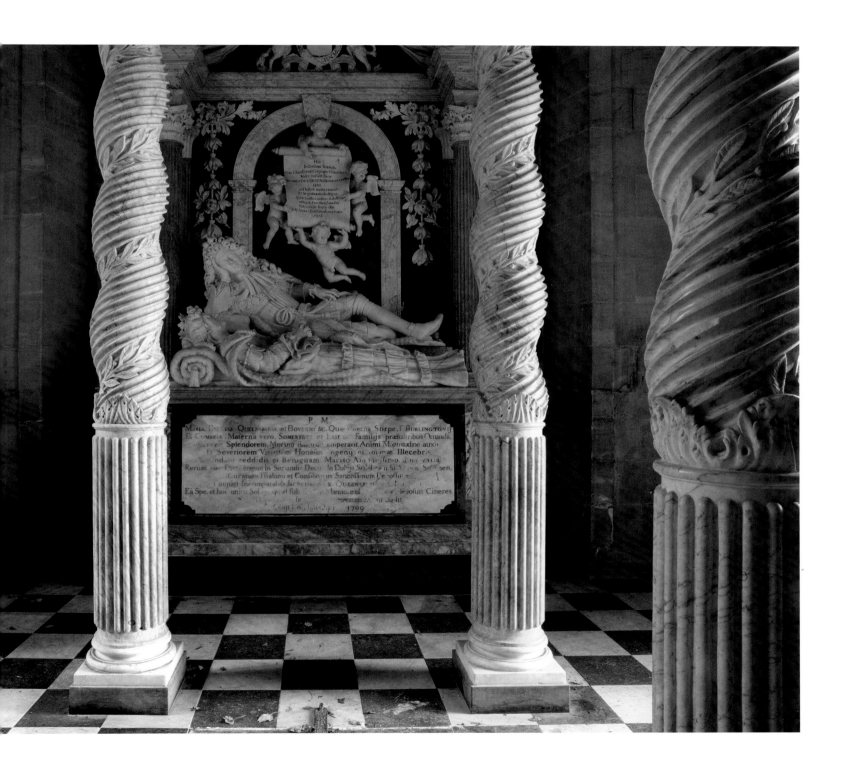

The Durisdeer gravestones

In one of Scotland's most romantic country graveyards, a relief created in 1685, long before his death, shows the figure of William Lukup, the master builder of the 1st Duke's Castle

Among the 355 graves at Durisdeer, each recorded by the Dumfries and Galloway Family History Society, one fine small stone stands out. Raised in 1685 to the memory of three children, it shows a man holding a chisel and mallet: he is William Lukup, their father, builder of the 1st Duke's Castle. Next to them lies a later clerk of works, John Douglas. In 1828 his brother brought the seed of the great Douglas fir back from America.

Follow the track from the graveyard to the old Roman road, the Wald Path, and climb up a short way for a fine view of the Nith Valley. As you leave Durisdeer, pause at the new graveyard to salute the ballerina Moira Shearer, famed for *The*

Red Shoes, and her husband, the writer and broadcaster Ludovic Kennedy. They often stayed at the Castle and chose this magical landscape for their resting place.

OPPOSITE, TOP RIGHT *William Lukup wrote on his children's gravestone: 'Heir lyes Andro, Patrik Georg and Rebecka children to William Lukup, Master of works in Drumlanrig 1685'. The builder himself is depicted in a grand doorway* TOP LEFT *Duchess Mollie reads the words* BOTTOM ROW *Moss covers the naive figure of a woman and a skull and crossbones* ABOVE *Ludovic Kennedy and Moira Shearer, guests at Drumlanrig, 1951*

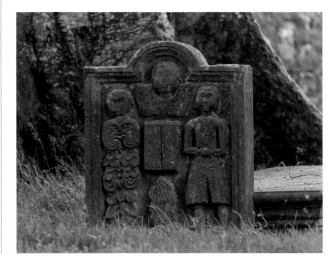

Shades of Dalgarnoch

A graveyard and a Burns song about a jilted lover are the last vestiges of a medieval town

Dalgarnoch Tryst, by St Ninian's Well, was the market where Robert Burns's heroine 'glowr'd' at her 'fine fickle wooer as I'd seen a warlock'. In 1610 the 1st Earl of Queensberry moved the market to the flat hilltop of Thornhill, but Darlgarnoch's kirkyard remained in use. Beeches shade curious gravestones: pagan 'earth spirits' mingle with Christian symbols of mortality – bones and skulls, and the open book of the Day of Judgement. Tools such as a tailor's sheers and a brewer's spade (for turning grain) reveal the trades of the deceased. A memorial lists the 57 Nithsdale Covenanters who died in the religious conflict of 1679–88 known as the 'Killing Time'.

THE GRAVESTONES OF DALGARNOCH
TOP *Two graves, one respectably Christian, the other distinctly pagan*
ABOVE LEFT *A carving of 'the truly pious James Gilchrist, schoolmaster in Glencairn', who died aged 19 on December 24, 1758*
LEFT *'John Nivison, churigeon [surgeon] in Thornhill' died in 1732 and was buried with his family. A winged soul, an open book and a flaming torch are flanked by two bizarre figures: on the left a female head on a floating torso of leaves with arms that become hair framing another face; on the right a man with legs ending in roots that flow into the earth, pagan symbols of rebirth – this is the world of the Green Man*

MORTON. No 12.

To Morton Church

EAST MORTON STREET

Bowling Green

From Glasgow

NORTH DRUMLANRIG STREET

SOUTH

From Kirk Bridge

BACK

NEW STREET

WEST MORTON STREET

PLAN

OF THE VILLAGE

of

THORNHILL

TOWN HEAD

From Penpont

EXPLANATIONS

The small figures written on the houses thus 33 are intended to correspond with those to be painted on the doors.
The red figures indicate the areas of the respective divisions in Square Yards.
The possession of each individual is distinguished from the adjoining properties by a different shade of colour.
All dwelling houses are ruled with faint parallel lines from East to West, and outhouses from North to South.
Where the house and garden of any individual are detached, the No. of the house and the initial letter of the street are marked in the garden.

The making of Thornhill

A passion for 'improvements' was not confined to the Castle. The nearby town of Thornhill grew up along a fine tree-lined road built in 1714 by the 3rd Duke of Queensberry. This plan from the 1850s shows the addition of a bowling green, still much used. Gone, however, are the Victorian gasworks

Thornhill, the nearest town to Drumlanrig, first appears on a map in Timothy Pont's survey of 'Nithia' (1583–96). Its antiquity was stressed in 1905 in *Thornhill and its Worthies*, by Joseph Laing Waugh, a local historian and decorator with a wallpaper shop in Edinburgh.

The 'auld toon' stood on a ridge of hawthorn above an important crossing on the Nith. Originally there was a ferry, and thanks were given for safe passage at a large Celtic cross. On the evening of Candlemas Fair, February 23, 1773, tragedy struck. The boat capsized and six people drowned – three men called James and three women called Jean. In 1777 the Duke built a fine stone bridge.

LEFT A PLAN OF THORNHILL, c.1850
The extensive collection of maps and plans of the Queensberry Estate have been the subject of a decade-long study by Dr David Munro. This plan is by the Edinburgh civil engineers McCallum and Dundas, whose 1845–57 surveys saw in a flurry of improvements by the forward-thinking 5th Duke. Bound in six volumes, they record the many fragments of property spread over Nithsdale and beyond. The gasworks, school, church and bowling green were recent additions. In 1844 the Duke wrote to his chamberlain about the estate's earlier 'wretched state' and the 'immense sums' he had spent on it
BELOW *Thornhill's Mercat Cross, crowned by a figure of Pegasus, was erected in 1718*

The process of change had begun when Dalgarnoch's fairs, mentioned by Burns, moved to old Thornhill's hilltop green in 1610. In 1664 a charter granted to the 2nd Earl of Queensberry elevated Drumlanrig to 'a burgh of regality whose principal burgh town was New Dalgarnoch, *alias* Thornhill'. In 1714, the 3rd Duke built a road bypassing old Thornhill, along with a courthouse, jail, inn and, in 1718, a market cross. A new settlement soon straddled the road. The old and new villages later merged, and the name New Dalgarnoch was abandoned. In 1850, a railway station arrived. It closed in 1965 but may reopen.

With easy parking on its avenues, today Thornhill is quietly thriving. Here you'll find Marchbanks, the best bakers in the land, the Drumlanrig Café, famed for Fusi's cappuccinos, and Thomas Tosh for a great lunch (miso mushrooms highly recommended). You can stay at the Danish-owned Thornhill Inn, or at the Buccleuch & Queensberry Arms, built by Charles Howitt, the clerk of works who restored the Horseshoe Staircase. Renwick the butchers make a fine haggis, and a Ferry Fish van comes up weekly from the Solway Firth. Then, who could resist buying a hammer or hoe from the ironmongers Hillhouse & Hunter or a party frock at 101 Boutique?

Thornhill's ancient Nith Cross, also called the Boatford Cross, carved with Celtic animal symbols in the late 9th or 10th century

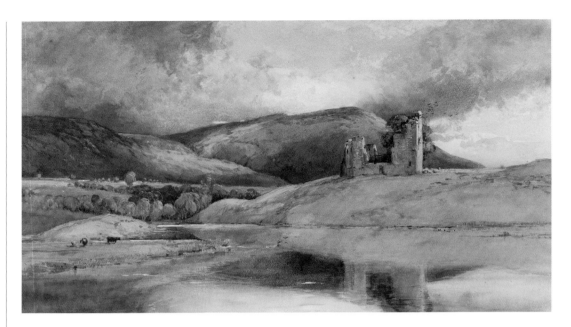

A 'most perfect ruin'

Morton Castle, on the edge of the hills and encircled on three sides by water, never fails to thrill

Family albums are full of picnics and trout-fishing at Morton, always a favourite place to visit. The castle stands on a steep promontory above a man-made loch and was built as early as 1300. Sadly, only the great hall and parts of a gatehouse survive.

Like many Scottish castles, Morton is a mystery. Was it a defensive keep or a grand 'hall house'? And did it get pulled down as stipulated in the Treaty of Berwick with Elizabeth I in 1557 – one of the 13 Nithsdale castles listed to be demolished – or did the bluff simply give way? Last used in 1714 as a hunting lodge, its romance lives on.

'Not more than half of the original structure now exists,' writes the parish minister the Rev. David Smith in 1845, yet it is the 'most perfect ruin of the kind in this part of the country'. Smith traced its origins, perhaps fancifully, back to Hugh de Moreville. In 1106 Prince David of Scotland received the Cotentin Peninsula in Normandy, including the town of Morville, from Henry I of England, and it was with Hugh de Morville's help that David secured Cumbria, southern Scotland and, eventually, the Scottish throne.

Since 1390 Morton has been in Douglas hands. Robert the Bruce's grandson Robert II wanted to wed his daughter to the 'handsomest man in the kingdom'. William Douglas, natural son of the Earl of Galloway, was chosen. Unfortunately, he was soon assassinated by a jealous English rival in Danzig on his way to Prussia to fight Baltic heathens with the Teutonic Knights.

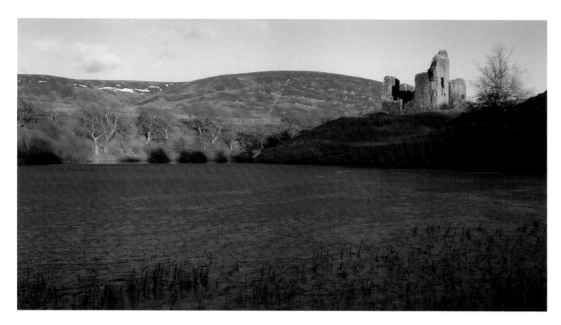

Morton Loch

Opposite Philip Sheppard (1838–95)
View of Morton Castle, 1858
*This watercolour in Drumlanrig's East
Corridor captures Morton in autumn.
The castle is surrounded on three sides by
a deep natural hollow, dammed, possibly
in medieval times, to create a loch*

Left *A winter view of the castle today*
Below, top row *Album photographs
include a moody 19th-century view; Earl
Haig fishing, 1939; Douglas Fairbanks
with his wife, Mary Lee, 1950*
Bottom row *Duchess Mollie with a
guest; the present Duke's father with
Duff Cooper; Alexander McEwan, whose
rendition of 'There was an old lady who
swallowed a fly' was unforgettable*

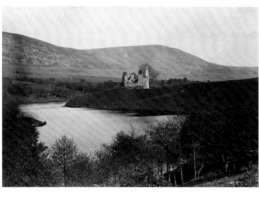

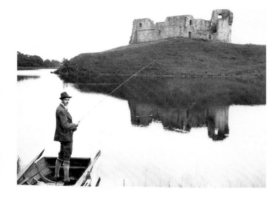

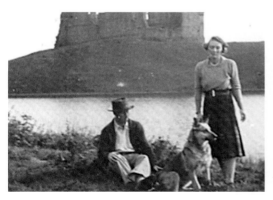

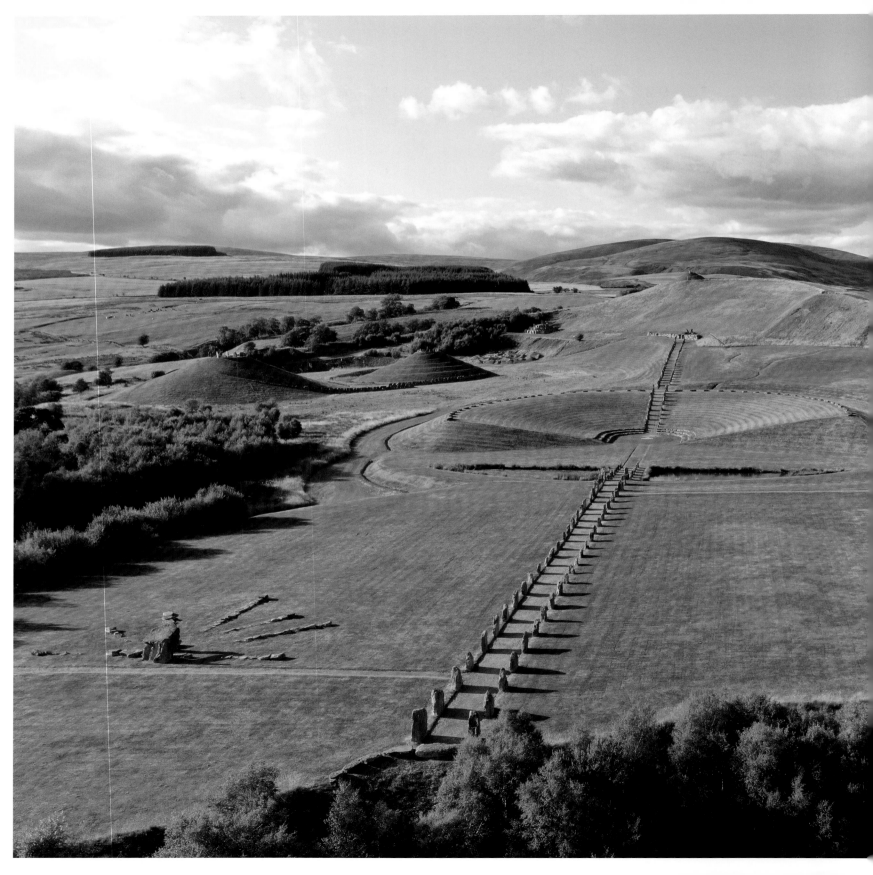

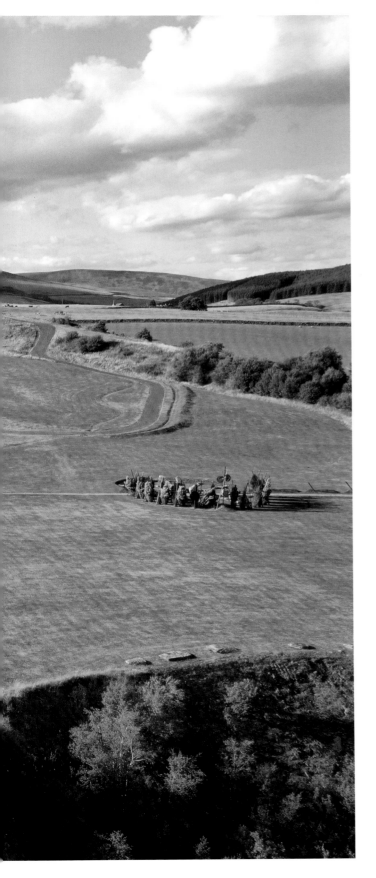

The Crawick Multiverse

*Land art on a grand scale. How the architectural
historian and designer of cosmic gardens
Charles Jencks put Sanquhar on the galactic map*

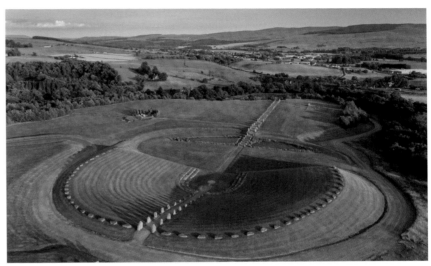

Threlated transformation of
a desolate, neglected
open-cast coal-mining site
into a representation of
our cosmos, the Crawick Multiverse
is the extraordinary creation of the
distinguished American land artist
the late Charles Jencks, who worked
with eminent scientists including
Martin Rees, the Astronomer
Royal, to explore ways to represent
the unimaginable vastness and
complexities of our universe.

The commission from his friend
Richard, 10th Duke of Buccleuch, in
2005 would take a decade to complete,

LEFT *A bird's-eye view of the Multiverse*
TOP *The Amphitheatre*
ABOVE *Mission Possible. Charles Jencks
(1939–2019) with the Duke after completing
one of Britain's largest modern artworks*

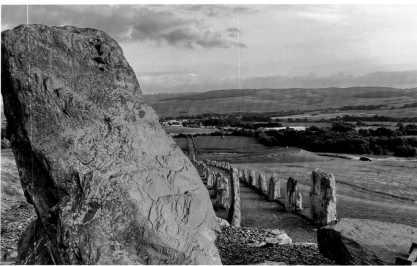

during which time tens of thousands of tons of earth and mining residues would be fashioned by giant diggers into forms representing galaxies, comets, a supercluster and the multiverse itself. More than 2,000 giant boulders had to be located, many of them half-buried. Two long rows of them now form the north-south axis linking the giant Amphitheatre and the highest point of the Multiverse, the Belvedere.

Set in a natural bowl of high surrounding hills, between the communities of Sanquhar, Kirkconnel and Kelloholm at the head of the Nith Valley, Crawick today is attracting land art enthusiasts from all over the world. At the same time it has settled into the rhythms of local life as a place for exercise, quiet contemplation and study of the natural environment.

Meanwhile the Crawick Multiverse Trust (crawickmultiverse.co.uk) is organising a range of live performances – from rock and reggae to folk and opera – in the Amphitheatre. As Charles Jencks planned, Crawick can accommodate 10,000 people without feeling crowded. Whatever the weather or season, or even the time of day, Crawick is a place of irresistible atmosphere and magic.

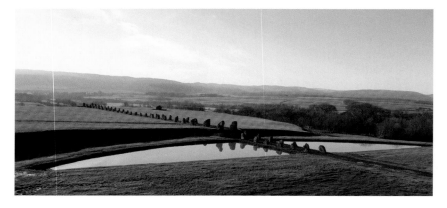

TOP LEFT *Andromeda and the Milky Way are represented by two towering spiral mounds. Unlike the other billion gallaxies, these two are heading towards each other and set to collide in 4 billion years*
ABOVE LEFT *The view from 'Omphalos', the mythical 'navel' of the world*
LEFT *The 400-metre-long 'North-South Path', viewed from the Amphitheatre, splits the site down the middle*
RIGHT *'Andromeda' from above. The spiral continues in the boulders*

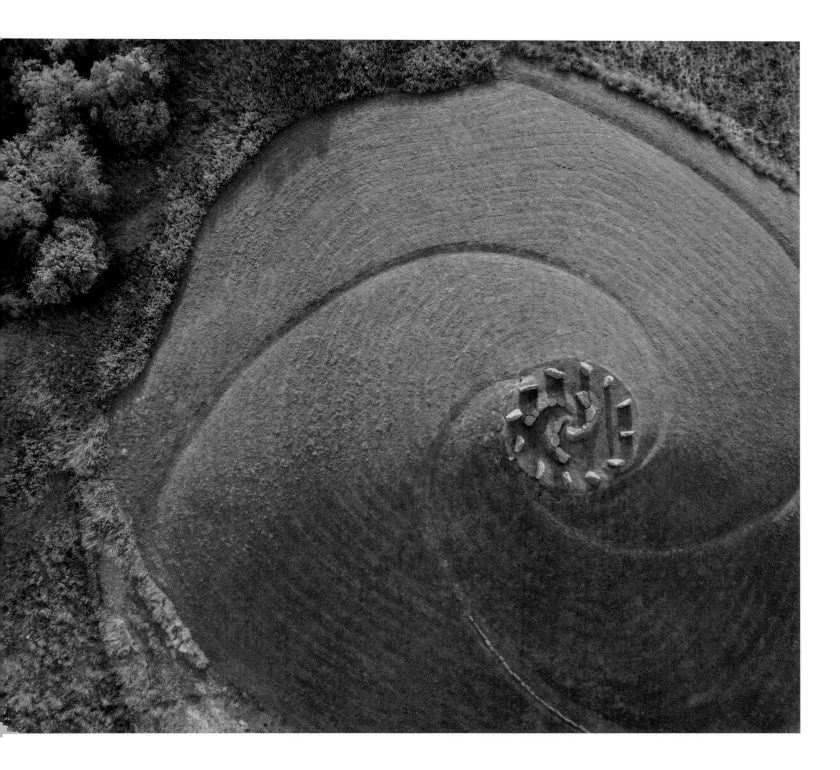

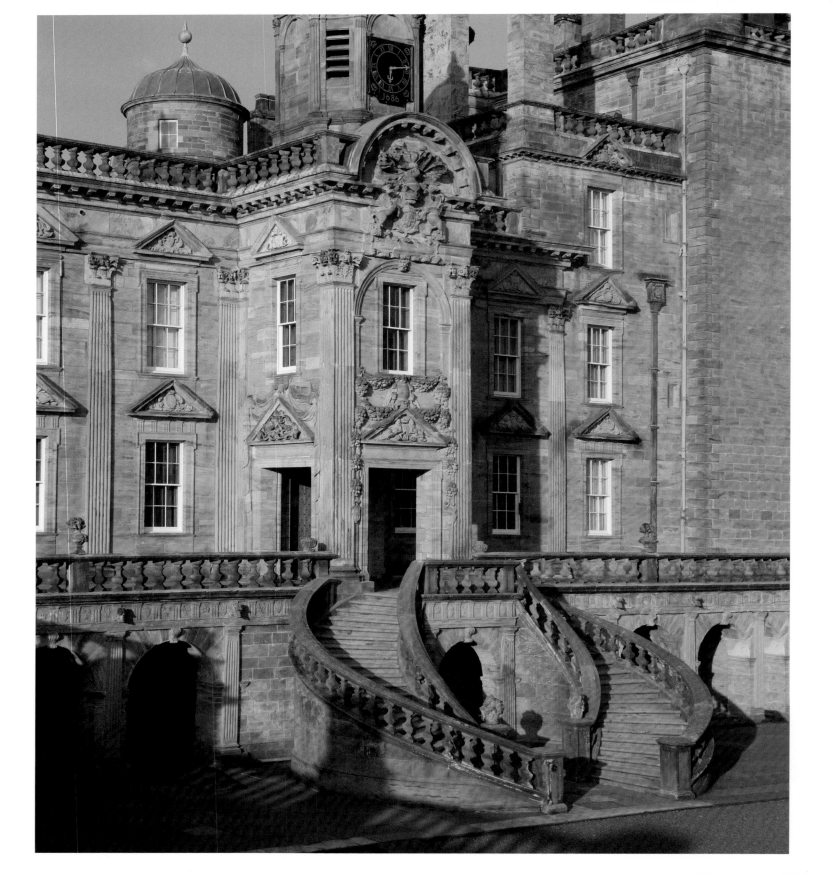

A dramatic arrival

Our grand tour comes full circle as we return to the richly carved North Front

Almost all the visitors recorded in the family albums will have experienced 'gravel fever' as their carriage or car drew up to the Castle's splendid North Front, 'the showpiece of the house' as Mark Girouard called it in *Country Life* in 1960.

He marvelled at its 'great sprouting Queensberry coat of arms' and 'display of Renaissance ornament as wild as it is lavish' – all carved for the 1st Duke by Peter Paul Boyse and Cornelis van Nerven by around 1686. Swags of fruit tumbling over the arches and spooky faces looking down from above the windows add to the drama.

This book's final pages illustrate a small selection of the vast collection of family photographs, which take us on a journey back across a century and a half of comings and goings.

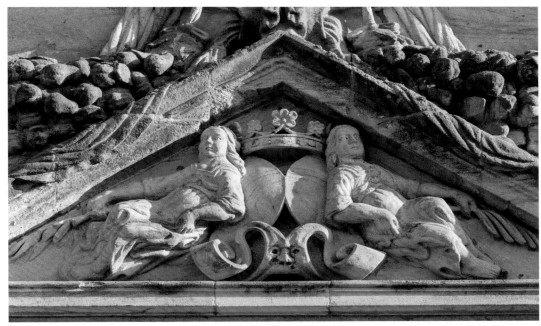

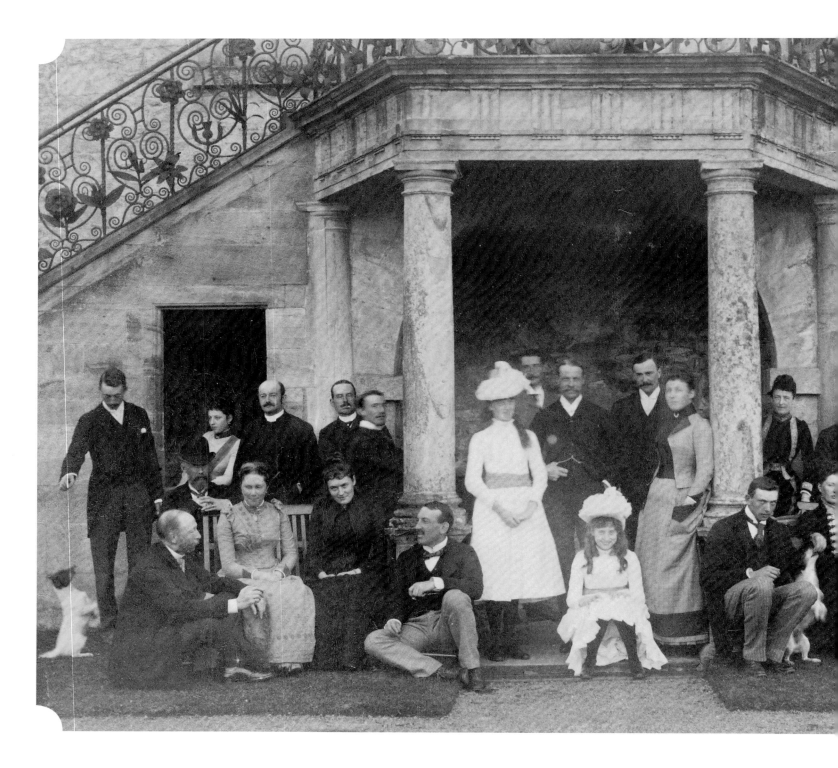

The family albums

Since the early days of photography, 6,000 pages of albums and visitors' books have charted the family's high days and holidays. They contain a rare record of life at the Castle over the years – the people and dogs, the voices, laughter and chitter-chatter – with a distant echo of momentous events

ABOVE 1972: *The future Duke Richard about to head off to Oxford and read history*
ABOVE LEFT 1952: *Richard's aunts, Caroline Gilmour and Elizabeth Northumberland, and Peppermint. Caroline had been a pupil at St Denis, which moved to the Castle in the war*
LEFT 1948: *Sir Malcolm Sargent, newly appointed chief conductor of the Proms, with a first edition of 'The Beggar's Opera'. Ducchess Mollie's spaniel Fancy is by his side*
OPPOSITE 1889: *A family group chatting below the Dining Room in a photograph taken by Lady Florence Duncombe (née Montagu), aged 21. William, 6th Duke (with a stick), is seated far right with his Duchess, Louisa Jane. Far left is their son Herbert, later chairman of Rolls-Royce, with his Jack Russell*

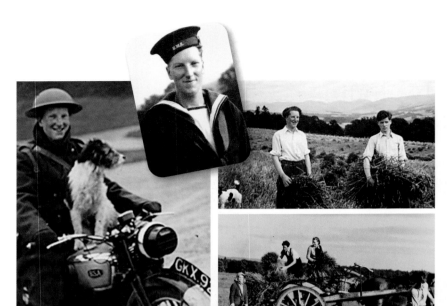

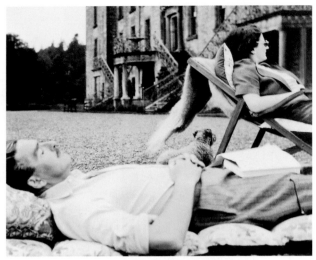

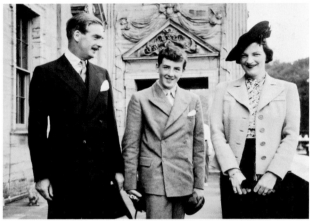

THE WAR YEARS

RIGHT AUGUST 1940: *The gardens have been turned over to hay and potatoes*
ABOVE CHRISTMAS 1941: *Home from Eton, Johnnie, future 9th Duke, is a messenger in the Carronbridge Home Guard platoon*
TOP *At 19 he joins the Navy. He and his sister Elizabeth both serve in the Atlantic*

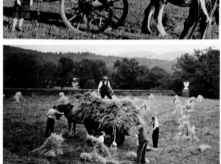

TOP AND ABOVE 1938: *Anthony Eden unwinds after resigning as Foreign Secretary; and with his wife, Beatrice, and son Simon, who would go missing in action in Burma in June 1945*
LEFT 1937: *Noël Coward with Mary Newell, Alan Webb and Alison Morrison. 'He shakes like a jelly at one's jokes', wrote Nancy Mitford*
BELOW 1960: *Nuri Birgi, Turkey's ambassador*

ABOVE 1939: *Johnnie, Harry Brown, Euan Wallace (then Minister of Transport), who lost both his sons in the war, and Prince Frederick of Prussia* ('Fritzy') *on the accordion. Interned in 1940–45, Fritzy gained British citizenship in 1947 thanks to his descent from Sophia of Hanover, George II's wife*

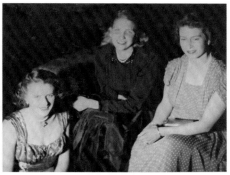

Royal visits

ABOVE AUGUST 21, 1963: *A birthday portrait of Princess Margaret with Lord Snowdon and her hosts, the Dalkeiths*

ABOVE RIGHT 1950: *A fetching Princess Margaret in the rain on the hills at North Sanquhar*

RIGHT 1963: *Enough gravitas*

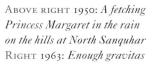

ABOVE 1949: *Princess Elizabeth (right) with Richard's Aunt Caroline (left), and the American ambassador's daughter Sharman Douglas, who became a confidante of Princess Margaret*

BELOW 1939: *Richard's irrepressible Aunt Elizabeth gives a salute*

BOTTOM 1949: *Princess Elizabeth, Mark Bonham Carter and Caroline enjoy a shooting lunch in the shelter of a Lea-Francis 'Woody' shooting brake*

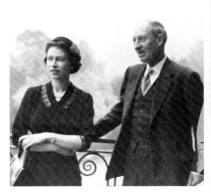

ABOVE NOVEMBER 1954: *The Queen with Richard's grandfather, Duke Walter*

RIGHT JUNE 26, 1954: *The Queen Mother on the Horseshoe Staircase with Duchess Mollie and Duke Walter, on her way south. Newly widowed, she had bought the Castle of Mey in Caithness in 1952 and was busy restoring it*

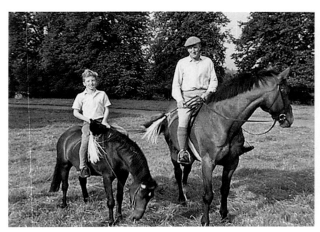

On the hoof

ABOVE 1964: *Richard on Merrylegs and his father on Tulamet, arriving at Drumlanrig after riding 70 miles from Eildon Hall, in the Borders, where Richard and his siblings grew up*
BELOW RIGHT 1936: *Duchess Mollie with her three children*
BELOW AND CENTRE RIGHT 1937: *The artist Edward Seago sketches Mollie and Duke Walter*
BOTTOM 1938: *Seago's completed portrait with Drumlanrig in the distance*

LEFT 1932: *Johnnie, future 9th Duke, a born inventor, with a trailer of his own design – ideal for transporting little sisters*
BELOW LEFT 1932: *Elizabeth trout fishing at Slatehouse Loch in the park at Drumlanrig*
BOTTOM 1932: *Elizabeth, Johnnie and Caroline with Dushka, the Duke of Kent's German shepherd, in the Scaur Water, still a favourite burn for a swim*

ABOVE RIGHT
1963: *Richard aged 9, holding his spaniel Sammy's tiny daughter*
1965: *A barbecue with the Gilmour cousins at Kettletonhead, near Durisdeer*

LEFT AUGUST 1939: *Aunt Elizabeth dancing with Osla Benning, soon to become a colleague at Bletchley Park*
BELOW 1980: *Duchess Jane's father, John McNeill, QC, reads a paper in the sunshine*

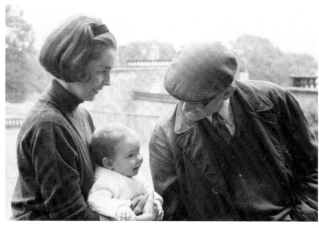

ABOVE 1968: *Richard's sister, Charlotte Anne, with her mother and Uncle Hughie*

RIGHT 1955: *Richard's first visit to Drumlanrig, at the age of 18 months*

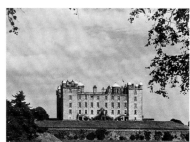

LEFT GUESTS GALORE 1956: *Impressions of a lively house party. Robin McEwan with a twin-lens Voigtländer; his wife, Brigid; laughing merrily is David Ormsby-Gore, envoy to Washington; Uncle Hughie smoking. Below him the artist Derek Hill talking to Richard's mother, Jane Dalkeith. Clare Keswick with her arm round daughter Maggie. Top right: 007's creator Ian Fleming drinking with choreographer Frederick Ashton. In the heather are Lady Carey Coke and Lt-Cdr Buist. Duchess Mollie and daughter-in-law Jane are pictures of elegance (bottom right)*

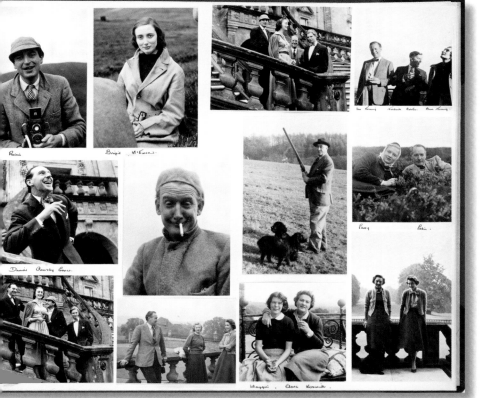

ABOVE 1949: *Princess Margaret and Princess Elizabeth in deckchairs with Anne Cavendish, Caroline and besuited friends*
TOP ROW: 1939: *Mollie with Nicky of Yugoslavia.* 1953: *Duke Walter with Harold and Dorothy Macmillan, Mollie's sister, Diana Daly, and Mary Crawford*
RIGHT 1959: *The Prince de Chimay and Duke of Gloucester bid farewell to Johannes Schwarzenberg, Austrian ambassador, his wife Coliene and their Vauxhall Cresta*
FAR RIGHT 1953: *Yehudi Menuhin's after-dinner performance in the Drawing Room*

ABOVE LEFT 1936: *Johnnie Dalkeith with his Aunt Alice outside the Great Oak Staircase Hall, the year after her marriage to the Duke of Gloucester*
ABOVE 1958: *The McEwan brothers Alexander and Rory dressed for the moor*
LEFT 1951: *Princess Margaret and Mollie greeting the Australian Pipe Major at Drumlanrig before the Gathering of the Clans in Edinburgh*
FAR LEFT 1969: *Drum Major John Haining, fondly remembered in the household, with son John, ready to march through Thornhill at the head of the town's pipe band on Remembrance Sunday*

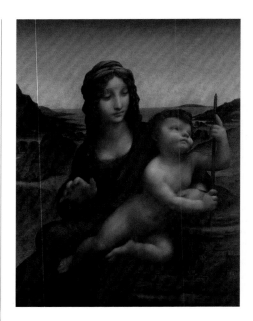

The Buccleuch Leonardo

Long a family favourite that used to travel from house to house with the 8th Duke, Leonardo's 'Madonna of the Yarnwinder' was dramatically stolen at knifepoint in 2003. Recovered by the police, it is now on loan to the National Gallery of Scotland

Leonardo da Vinci's sublimely beautiful *Madonna of the Yarnwinder* made headlines for the wrong reasons when it was stolen from the Staircase Hall of Drumlanrig Castle in a daylight smash-and-grab robbery in August 2003. Thanks to determined and courageous detective work by the police, it was recovered, undamaged, four years later, in October 2007, and now hangs on long-term loan in the National Gallery of Scotland in Edinburgh.

The painting was bought by the Montagu side of the family at the Duc de Tallard's sale in Paris in 1756 and over the centuries has been the subject of intense art-historical discussion and scientific investigation.

Thanks to the scholarship of Professor Martin Kemp, it is now known to have been created in Leonardo's workshop in the early years of the 16th century, alongside a second version containing the same underpaintings and *pentimenti*. While the sky and background are almost certainly the work of another hand, Leonardo's own miraculous technique is wonderfully apparent in the painting of the Madonna and the Child and the foreground rocks.

The work was shown in the Louvre's 500th-anniversary exhibition *Leonardo da Vinci* in 2019–20, and before that in *Leonardo: Painter at the Court of Milan* at the National Gallery of London in 2011–12.

Famously, earlier generations of the family considered the picture so precious that it used to travel with them so that it could be enjoyed in their various homes. The journey was often an adventure in itself. On one occasion it was left on the train at Thornhill. Duke Walter's chauffeur, Mr Anderson, managed to catch up with it at Sanquhar, the next station.

The Buccleuch Houses

Drumlanrig: The Castle, its People and its Collections
2nd edition (Caique Publishing, 2016)

Drumlanrig: The Castle, its People and its Paintings
3rd edition (Bellendaine Books, 2022)

Boughton: The House, its People and its Collections
2nd edition (Bellendaine Books, 2022)

This book, now in an enlarged second edition, explores the Northamptonshire home of the Duke of Buccleuch and Queensberry, 'the English Versailles'. It was the dream of the Duke's ambitious forebear Ralph, 1st Duke of Montagu, to transform his ancestral home in the heart of the countryside from a Tudor manor house into a grand seat with the majesty that had so impressed him at Versailles when he was Charles II's envoy to the court of Louis XIV. Behind his imposing North Front, however, lies a very English country house that grew up round a maze of 16th-century courtyards.

The book showcases Boughton's celebrated art collection, with its magnificent tapestries and Sèvres porcelain. There are striking portraits of Elizabeth I and Charles II; a gigantic equestrian painting of his son the Duke of Monmouth hangs above Shakespeare's eye-catching muse, the Countess of Southampton. Van Dyck's friends and contemporaries cluster in the Drawing Room.

A grand tour takes in the formal State Rooms and the Tudor Great Hall, with their painted Baroque ceilings, before moving to the park, with its avenues of soaring limes and network of lakes.

Bowhill: The House, its People and its Paintings
2nd edition (Caique Publishing, 2018)

Bowhill, in the Scottish Borders, started life as a modest Georgian villa, but grew into a huge mansion. The art collection was consolidated when Henry, the enlightened 3rd Duke of Buccleuch, and his wife, Elizabeth Montagu, united the dukedoms of Buccleuch and Queensberry in 1810, thereby bringing together the families of Montagu, Douglas and Scott.

The austere greywacke exterior of Bowhill belies rich interiors filled with treasures – the 4th Duke's Library, with its views of the Ettrick Valley so dear to Sir Walter Scott, the Drawing Room's masterpieces by Claude and Ruysdael, the Boudoir and its Chinese wallpaper, the Dining Room with its Canaletto of the Thames at Whitehall, the Mortlake tapestries of Mantegna's *Triumphs of Caesar*, and the Buccleuch collection of miniatures.

ACKNOWLEDGEMENTS
This portrait of Drumlanrig is primarily the work of the renowned Fritz von der Schulenburg, who photographed the Castle with customary energy and vision in the winter of 2010. When ill health prevented his return in 2022, David George took on the mantle, charting changes inside the Castle and capturing the exterior in all its springtime beauty. Matthijs de Vos added a new dimension – high summer – with his aerial views of the gardens and woods, as well as images of the Castle's stonework and the graves of Durisdeer and Dalgarnoch. Walter, the present Earl of Dalkeith, caught the essence of Upper Nithsdale, where he grew up, in epic landscape photographs. Mike Bolam documented the Crawick Multiverse. Special thanks also to John McKenzie, who turned 160 years of photo albums into a unique archive.

The emerging history of Drumlanrig and its collections owes much to tireless archival research by Crispin Powell and the scholarly insights of Bruce Bailey, Jeanice Brooks, Ian Gow, Fiona Jamieson, Neil Jeffares, Rainald Lamb, Philip Lindley, David Munro and Craig Thomas.

PHOTOGRAPHIC CREDITS
All photographs are by Fritz von der Schulenburg unless otherwise stated. Paintings photographed by Richard Shellabear / Todd-White Art Photography. Album images by John Mackenzie. Map by Susanna Hickling

Asher, Mark 63, 67, 71
Helen Barrington 191, 192 (bottom), 193
Walter Baxter (cc-by-sa/2.0) 208 (bottom)
Crawick Multiverse Trust / Mike Bolam 212–215
Richard, Duke of Buccleuch 12–13, 29 (right), 214–215
Country Life NIS UK 40, 184–185
Walter Dalkeith 8, 189, 197–199
Calum Flanders 104
Matthijs de Vos 26, 28 (left), 29 (left), 40 (bottom right), 41 (top), 173 (right), 176, 187, 188,192 (top and centre), 194, 204–205
David George 10, 17 (left) 22, 28, 30 (left), 33–35, 37, 39, 42, 43, 62, 68, 73, 78, 80–81, 93, 94, 95 (top), 121, 124, 127,128, 132, 133, 148, 149, 150, 151 (top and right), 156, 157 (top), 173 (top and left), 190 (right),
192 (top and centre), 203
Patrick Lichfield 103
Scott Macdonald / Sarah Cross 49
Metropolitan Museum 136
National Museums of Scotland 44 (top)
St Andrews Library 14 (top)
Sotheby's 155 (right)
Dean and Chapter of Westminster 142 (right)
Yale Center for British Art 18

WITH SPECIAL THANKS TO:
Colin Bevan, Sandra Howat, Karen Howes, Angela von der Schulenburg, Robbie and Jozien Black, and to Gernant Magnin for identifying Hayes's birds. Also to Orhan Gündüz, Niyazi Karıksız, Işık Yüceoral and their colleagues at the printers Ofset Yapımevi

Chronology of key events

AD 78 Nithsdale joins the Roman Empire, as forts and camps are built at Tibbers, Drumlanrig and Durisdeer.
1330 Sir James Douglas (the Black Douglas) falls fighting the Moors on his way to the Holy Land with the heart of Robert the Bruce. 'Forward, Brave Heart', he cries, hurling the casket into the mêlée.
1330 David II of Scotland confirms Sir William Douglas as Baron of Drumlanrig.
1429 First mention of the Castle in a charter.
1567 Mary, Queen of Scots is deposed, denouncing the Drumlanrigs as 'hellhounds, bloody tyrants, without souls or fear of God'.
1603 James VI of Scotland is crowned James I of England, uniting the monarchies
1608–18 Sir William Douglas, 9th Douglas in succession to live at the Castle, draws up plans to turn the keep into a courtyard palace with corner towers and pointed turrets.
1617 Visit by King James.
1633 Sir William is made Earl of Queensberry.
1641–52 The 2nd Earl sides with the King in the Civil War.
1649 Charles I is executed.
1650 Sir Gilbert Kerr's Parliamentary Army sets fire to the 2nd Earl's Castle.
1660 The Restoration and Charles II's enthronement.
1671 William (later 1st Duke) succeeds as 3rd Earl and starts to rebuild the Castle in 1675.
1680 He is appointed Lord Justice General. His sons Lord Drumlanrig (later 2nd Duke) and Lord William start their Grand Tour.
1682 The 3rd Earl becomes Marquess of Queensberry, and replaces the Duke of Lauderdale as Scotland's most powerful man.

1684 He is made 1st Duke of Queensberry.
1685 The rebel Duke of Monmouth and Buccleuch is beheaded by James II. Anna Scott remains Duchess of Buccleuch in her own right.
1688 Lord Drumlanrig greets William of Orange at Torbay, the first Scottish noble to join the Glorious Revolution.
1689 The 1st Duke finishes work on Drumlanrig.
1693 Lord Drumlanrig becomes Lord High Treasurer of Scotland.
1695 James Smith starts work on the Queensberry Aisle.
1695 Lord Drumlanrig becomes Keeper of the Privy Seal in Scotland and succeeds as 2nd Duke.
1697 He builds the Great Oak Staircase.
1700–02 The 2nd Duke is Lord High Commissioner to the Scottish parliament and made a Knight of the Garter.
1702 Queen Anne succeeds William III; the Duke is Secretary of State for Scotland.
1707 The Duke is a key figure in the Act of Union, uniting the parliaments of England and Scotland, and is made Duke of Dover (1708).
1711 Secretary of State for Scotland since 1709, he dies in London and is buried with his wife, Mary, in Durisdeer.
1720 Charles, 3rd Duke, marries Kitty Hyde. His sister Jane Douglas marries the 2nd Duke of Buccleuch.
1728 John Gay's *Beggar's Opera* opens at the Lincoln's Inn Fields Theatre.
1745 Bonnie Prince Charlie and his Highland army sleep at the Castle, uninvited.
1756 The 3rd Duke and Duchess of Montagu buy Rembrandt's *Old Woman Reading* in London, and

Leonardo's *Madonna of the Yarnwinder* in Paris.
1767 Elizabeth Montagu weds Henry, 3rd Duke of Buccleuch – she becomes the Montagu heiress when her brother, Lord Monthermer, dies in 1770
1778 William, Earl of March (Old Q), becomes 4th Duke of Queensberry.
1810 Henry, 3rd Duke of Buccleuch, inherits as 5th Duke of Queensberry
1813 Charles, 4th and 6th Duke, begins to restore the Castle and gardens. The Great Gallery is subdivided.
1831 The earth ramp is added.
1840–42 Service wings are added to the Castle; the Great Oak Staircase is realigned.
1860–63 The Horseshoe Staircase is restored and 'Jacobean' plaster ceilings are added to the main rooms.
1902 The Castle's exterior is photographed by *Country Life*.
1914–18 Drumlanrig serves as an auxiliary hospital.
1916–29 The contents of Montagu House and Dalkeith Palace are moved to Bowhill, Boughton and Drumlanrig.
1939–45 St Denis Girls' School moves into the Castle
1972 Neil Armstrong, the first man on the moon, is made the first Freeman of Langholm, home of his forebears, and plants a tree at Drumlanrig.
1975 The Castle opens to the public for the first time.
1978–83 After 150 years, the lead roof is renewed.
1984 Drought reveals a 3-acre Roman fort in the grounds.
2003 Theft of the Leonardo, which is recovered in 2007.
2015 Charles Jencks's Crawick Multiverse opens.
2014–19 The Electric Fields Festival held in the Park.
2021 Thousands of trees are blown down in Storm Arwen.

Bibliography

Architecture
Gifford, John *Dumfries and Galloway: The Buildings of Scotland* (Yale University, 2002)
González-Longo, Cristina *The Architecture of Scotland (1660–1750)* (Prestel, 2014)
Gow, Ian and Rowan, Alistair, ed. *Scottish Country Houses, 1600–1914* (Edinburgh University Press, 1998)
Knox, James *The Scottish Country House* (Vendome Press, 2012)
Montgomery-Massingberd, Hugh Sykes, Christopher *Great Houses of Scotland* (Laurence King, 1996)
Wemyss, Charles, *Noble Houses of Scotland* (Prestel, 2014)
The Collection
Murdoch, Tessa ed. *Boughton House: The English Versailles* (Faber & Faber / Christie's, 1992)
History
The Manuscripts of His Grace the Duke of Buccleuch & Queensberry K.G., K.T., preserved at Drumlanrig Castle (Historical Manuscripts Commission 15th Report, appendix, part VIII, 1897)
Biddulph, Violet *Kitty, Duchess of Queensberry* (Ivor Nicholson & Watson, 1935)
Blyth, Henry *Old Q: The Rake of Piccadilly* (Wiedenfeld & Nicolson, 1967)
Borthwick, Alan R., MacQueen, Hector L. *Law, Lordship and Tenure: The Fall of the Black Douglases* (Strathmartine, 2022)
Brown, Michael *The Black Douglases: War and Lordship in Medieval Scotland, 1300–1455* (John Donald, 2001)
Dalrymple Hew H. ed. *Memoires of my Lord Drumlangrig's and his brother Lord William's travells abroad for the space of three years beginning Septr 13, 1680*, privately printed, T. and A. Constable, 1931
Fraser, Sir William *The Scotts of Buccleuch* (2 vols, Edinburgh University Press, 1878)
Kelly, W. A. *The Library of Lord George Douglas: An Early Donation to the Advocates Library* (LP, 1997)

McKay, Collins *The Duke of Queensberry and the Union of Scotland and England: James Douglas and the Act of Union of 1707* (Cambria Press, 2008)
Ramage, Craufurd Tait *Drumlanrig Castle and the Douglases, With the early History and Ancient Remains of Durisdeer, Closeburn, and Morton* (1876), Grimsay Press, 2010, Hansebooks 2016
Waugh, Joseph Laing *Thornhill and its Worthies* (Robert Dinwiddie, 1905)
Wood, Rog *Upper Nithsdale Folklore* (Creedon, 2011)
Paintings
Jeffares, Neil *Dictionary of Pastellists before 1800* (Unicorn Press, 2006)
Puttelaar, Carla van de *Scottish Portraiture 1644–1714: David and John Scougall and Their Contemporaries* (Brepols, 2021)

ARTICLES AND PAPERS
Anon. 'Drumlanrig Castle', *Country Life*, Aug. 23, 1902
Girouard, Mark 'Drumlanrig Castle, Dumfriesshire: A seat of the Duke of Buccleuch and Queensberry', *Country Life*, Aug. 25, Sept. 1 and 8, 1960
González-Longo, Cristina 'The transformation of Drumlanrig Castle at the end of seventeenth-century', *First Construction History Conference*, Cambridge 2014
Jeffery, Sally 'Grinling Gibbons's Chimneypieces for the Duchess of Buccleuch', *The Georgian Group Journal*, XXXIV, 2016, pp. 1-22
MacKechnie, Aonghus 'Durisdeer Church', *Proceedings of the Society of Antiquaries of Scotland*, 1986
Gordon, J. ed. 'Parish of Morton' by the Rev. David Smith, *The New Statistical Account of Scotland* (Vol 4) 1999
Thompson, Colin 'Drumlanrig Castle', *Connaissance des Arts* No. 298, Dec. 1976
Weaver, Lawrence 'Drumlanrig Castle, Dumfriesshire' *Country Life*, March 15, 1913

Index of artists

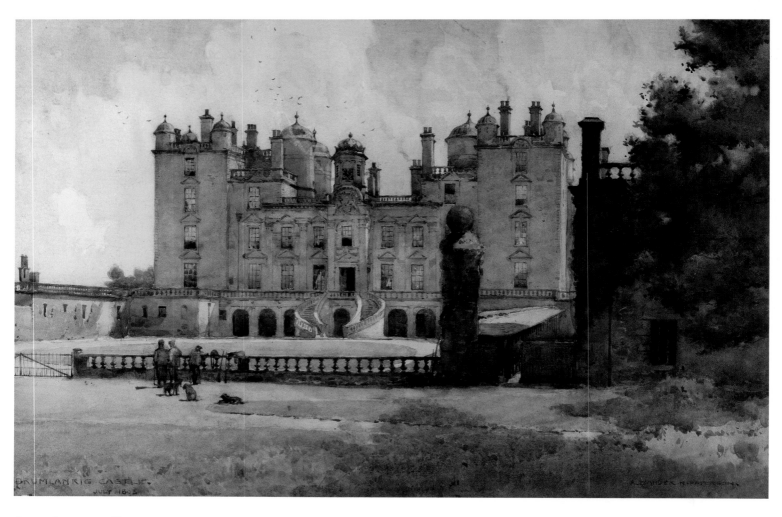

ABOVE ALEXANDER NISBET
PATERSON (1862–1947)
Drumlanrig Castle, July 1893
*Some of the profuse greenery has been
removed and the window frames
painted white, but little else has
changed since this watercolour of the
North Front was painted by a
Glasgow architect who studied at
the École des Beaux Arts in Paris
and was a master of perspective*

First published in 2010
Second edition 2016
Third edition 2022
© Buccleuch Living
Heritage Trust (blht.org)

PUBLISHED BY
Bellendaine Books,
an imprint of Caique
Publishing Ltd,
PO Box 13311,
Hawick TD9 7YF, Scotland
Hardback 978-0-9957566-9-4
Softback 978-0-9957566-3-2

PRINTED IN TURKEY
by Ofset Yapımevi,
Istanbul; ofset.com

BUCCLEUCH LIVING
HERITAGE TRUST

Responsibility for the
Buccleuch Art Collection
and the properties that
house it lies with the
Buccleuch Living Heritage
Trust. The charity's goals
include education, and
preserving, protecting
and improving, for
public benefit, buildings
and chattels of national,
historic, architectural
or artistic interest.
For visitor information,
go to the houses' websites.

DRUMLANRIG CASTLE
Thornhill, Dumfries and
Galloway DG3 4AQ
drumlanrigcastle.co.uk
BOUGHTON HOUSE
Kettering, Northants
NN14 1BJ
boughtonhouse.co.uk
BOWHILL HOUSE
Selkirk, Scottish Borders
TD7 5ET
bowhillhouse.co.uk
DALKEITH COUNTRY PARK
Restoration Yard, Dalkeith,
Edinburgh EH22 1ST
dalkeithcountrypark.co.uk